innovative printmaking

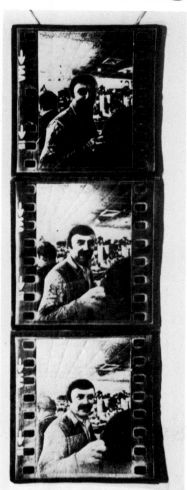

Thelma R. Newman
has authored and coauthored
eighteen other books.

THELMA R. NEWMAN

innovative printmaking

THE MAKING OF TWO- AND THREE-DIMENSIONAL PRINTS AND MULTIPLES

CROWN PUBLISHERS, INC., NEW YORK

To my two eggs(heads), Jay and Lee Newman

All photographs by the author unless noted otherwise.

Designed by Laurie Zuckerman

Inquiries should be addressed to Crown Publishers, Inc., One Park Avenue,
New York, N.Y. 10016
Printed in the United States of America
Published simultaneously in Canada by
General Publishing Company Limited

Library of Congress Cataloging in Publication Data

Newman, Thelma R.
Innovative printmaking.

Bibliography: p.
Includes index.
1. Prints—Technique. I. Title.
NE850.N47 760'.2'8 77-3011
ISBN: 0-517-515989 (cloth)
0-517-515997 (paper)

"What is needed is not a definition of meaningful imagery, but the development of our perceptive potentialities to accept and utilize the continual enrichment of visual material."
—RICHARD HAMILTON,
from catalog of
"This is Tomorrow"
Exhibition, 1956

Contents

Acknowledgments ix

Artists Whose Work Is Included ix

Introduction xi

The Roots and Flourishing of Printmaking 1
Printmaking: a Definition 1
Traditional Printmaking Processes 1
History of Printmaking, Encapsulated 2
Woodcuts 2
Engravings 4
Etching 7
Lithography 13
Photography 17

New Styles and New Directions 19
A Survey 19
The Limited Edition 20
Etching to Intaglio 22
Lithography—Planographic Variations 29
Silkscreen/Serigraphy 38

New Views toward Innovation 51

A Brief Look at the Techniques and Influence of Commercial Printmaking 53
Offset 53
Offset Duplicator 54
Photo-offset 54
Spirit Duplicating 54
Photogelatin Process—the Collotype 54
Screen Process Printing 55
Electrostatic Screen Printing 58
Letterset Printing, or Dry Offset 59
Intaglio Printing, Gravure, Photogravure, Rotogravure 63
Typesetting 63

A Renaissance 65
Photography 65
Photo-Silkscreen 67
The Direct Method 69
The Indirect Method 79
Photoetching for Intaglio 79

Procedures for Photoetching Using Kodak Ortho Resist 79
 Preparing the Plate 79
 Sensitizing the Plate 80
 Film Work 81
 Exposing the Plate 82
 Developing the Plate 83
 Washing Out Plate 84
 Staining the Plate 84
 Second Washout 85
 Inspection and Correction of Plate 85
 Aquatinting the Plate 85
 Biting the Plate 86
 Stripping the Plate 87
 Inking the Plate 87
 Printing the Plate 87
Photolithography 92
The Collotype—a Photogelatin Process 96
The Photogram Collage and the Collage Print 102
Non-Silver Photosensitive Printmaking 105
The Gum Print 105
Blueprinting (Ferroprussiate) 108
 Sensitizing for the Blueprinting, or Ferroprussiate, Process 108
Cyanotype, or Gum-Iron, Process 112
 The Cyanotype Process 114
The Kallitype, or Brownprinting 116
 The Kallitype Process 116
 Salt Printing for Brown Tone Images 116
GAF and Rockland Surface Sensitizing 119
 Rockland Surface Sensitizing 119
 GAF Template Emulsion 120
Photogravure 122
Photogravure Using McGraw Colorgraphy Carbon Tissue 122
 The Basic Chemistry 122
 The Film Positive 122
 Preparing the Plate 123
 Sensitizing the Carbon Tissue Paper 124
 Exposing the Resist 125

Making the Resist Adhere to the Plate 125
Developing the Resist 126
Biting the Plate 127
Removing the Resist from the Plate 127
Printing the Plate 128
The Dye Transfer Process 129

The Print Gone Soft 135
A Survey 135
The Processes 145

The Print in Relief 153
Embossing 153
The Collagraph 156
The Process 162

The Great Departures: the Print as Cast Paper 163
The Process 175
Using a Laid-Line Screen 175
Paper Casting with a Screenless Mold 181

The Great Departures: The Print as Three-Dimensional Form 195
About Lead Casting 211

The Great Departures: The Print as a Multiple 213

Perceptual Effects: Optical and Transparent Imagery 221
About Light 221
Printing on Plastic 224
Serigraphy 224
Stencil Spray Painting 224
The Optical Illusion 225
Vacuum Forming 231
Procedures for Creating a Vacuum-Formed Screenprint 233
Plastics and Perceptual Effects 234
Printing a Transfer Element, or Decalcomania 244
Radiography 248

Facsimile Printmaking: Photosensitive Systems—Electrophotography 251
Xerography 251
Wire Photo 259

After the Great Departures: Computer Art 263
Mural-sized Graphics 277

Appendix: Constructing a Vacuum-Forming Machine 281

Bibliography 295

Supply Sources 297

Index 301

Acknowledgments

It is a fact that, without the contributions of first-rate artists, this book could not have been written. Among those people, I owe very special thanks to Randy Sprout, Darla Masterson, Sheila Pinkel, John Risseeuw, Vida Hackman, John D. Whitesell, Jeff Gates, Charles Hilger, Claire Falkenstein, Walter Askin, Tyler James Hoare, Roslyn Rose, Marion Baker, Earl D. Klein, A. E. Moll, Mary Van Stelle and Pat Mansfield, Naomi Savage, Bong Tae Kim, Dr. Kenneth Knowlton at Bell Labs, Dr. Ernest L. Hall at U.S.C., Andrew Stasik at Pratt Graphic Center, and Jason D. Wong at the Herbert F. Johnson Museum of Art at Cornell University.

Very special thanks go to Richard Royce at Atelier Royce, Ken Tyler at Tyler Graphics, and Rosamund Felsen at Gemini G.E.L. for their generous supply of patience and photographs.

I am ever grateful to my son Lee who helped me do my research and to my son Jay who took on the prodigious job serving as a pre-editor—as well as my husband, Jack, who carried on as quartermaster general.

Deep appreciation is also reserved for Norm Smith for his first-rate photo processing and for Patricia Weidner for her behind-the-typewriter assistance.

T.R.N.

Artists Whose Work Is Included

Josef Albers	Gay Burke	Claire Falkenstein
Jessie Allen	Patricia Jean Burg	Jean Honoré Fragonard
Karel Appel	Jacques Callot	Jeff Gates
Walter Askin	Wendy L. Calman	Paul Gauguin
John Babcock	Giovanni Antonio Canaletto	Géricault
Marion Baker	Kathleen Caraccio	Joe Goode
John Battenberg	John Chamberlain	Francisco de Goya
Aubrey Beardsley	Jules Chéret	Vida Hackman
Jacques Bellange	Judy Chicago	Betty Hahn
Alberto Biasi	Ronald Davis	Susan Haller
Annette Bird	Edgar Degas	Andre Haluska
Laura Blacklow	Sonia Delaunay	Richard Hamilton
William Blake	Catherine De Lattre	Jo Hanson
June M. Bonner	Jim Dine	Suzuki Harunobu
Abraham Bosse	Albrecht Dürer	Stanley William Hayter
Stanley Bowman	Fred Eversley	Charles Hilger

Lida Hilton
Tyler James Hoare
Katsushika Hokusai
Fritz Hundertwasser
Carol Hurst
Jasper Johns
Wassily Kandinsky
Franz Kempf
Ed Keinholtz
Bong Tae Kim
Helmmo Kindermann
Earl D. Klein
Vivian Kline
Gordon Kluge
Warren Knight
Kenneth Knowlton
Brooke Larson
Catherine Jansen Larson
William Larson
Les Levine
Golda Lewis
Roy Lichtenstein
Linda Lindroth
Jean Locey
Marvin Lowe
Janet B. Mackaig
Lyn Mandelbaum
John P. Martineau

André Masson
Darla Masterson
Jerry McMillan
Dean Meeker
Robert Motherwell
Louise Nevelson
Claes Oldenburg
Nathan Oliveira
Gerald Oster
Eduardo Paolozzi
Henry Pearson
Matt Phillips
Pablo Picasso
Sheila Pinkel
G. B. Piranesi
Jackson Pollock
Marcantonio Raimondi
Robert Rauschenberg
Odilon Redon
Pierre Auguste Renoir
Rembrandt
John L. Risseeuw
Charles J. Roitz
Clare Romano
Roslyn Rose
John Ross
Richard Royce
James H. Sanders III

Naomi Savage
Martin Schongauer
Lillian Schwartz
Debra Seeman
Sylvia Seventy
Ben Shahn
Shigeko Spear
Randy Sprout
Andrew Stasik
Frank Stella
Ann Sutton
Pat Tavenner
Giovanni Battista Tiepolo
Henri de Toulouse-Lautrec
Garner Tullis
Kitagawa Utamaro
Robin Vaccarino
Stan Vanderbeek
Mary Van Stelle
Victor Vasarely
Melanie Walker
Ruth Weisberg
Benjamin West
David Whipple
James Abbott McNeill Whistler
John D. Whitesell
Mary Moor Winnett

Introduction

It never ceases to amaze me each time I write a book and it joins millions of others on library shelves that there are still new contributions to be made to the literature of the world. Besides different ways to look at a subject, and their different emphases, there are those serendipitous outcomes of research—the discovery of artists who have had little of the exposure that they deserve and of knowledge about which little or nothing has been written. That's what motivates me to write.

I discovered through my work with plastics and my writings about it the pervasive way plastics have permeated every aspect of printmaking—and along the way, I learned that there was much more innovation that needed to be recorded.

Early in this book significant aspects are taken of the history of printmaking so that it can be examined for meaningful patterns of innovation—essentially to make a case for open-mindedness. Then, in a description of some of the potential of contemporary technology, more specifics are given about process—some methods are completely new, others are basically variations on familiar themes, more are revivals of methods practiced before and since forgotten.

As I gathered material and tried to classify it and give it some sense of order, I was left with many basic but difficult questions, such as "what is a print?" and "what is a multiple?" At present there are no absolute definitions. Parameters are in flux; we are inundated with more ideas than we can process. Perhaps, in time, answers will become more apparent.

There are two voices—two levels of meaning here. You can read an essay that threads through the pages about the uneven but consistent path of innovation as it traveled via printmakers' efforts over the years or you can study the materials for processes and techniques. It is hoped, in either case, that *Innovative Printmaking* will inspire and motivate you.

Ch'ing dynasty (seventeenth century) rubbing of ink on paper is part of a tradition that dates back to at least the second century A.D. *Courtesy: The Metropolitan Museum of Art, Gift of Rosalie Slaughter Morton*

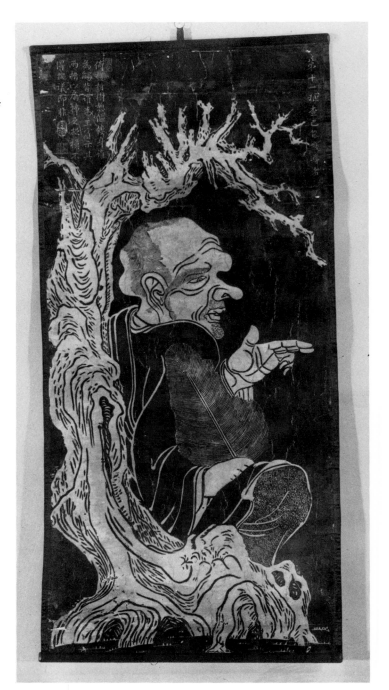

The Roots and Flourishing of Printmaking

The history of printmaking is the history of innovation in communication. Before the age of mass literacy, pictorial images played a particularly significant role in conveying ideas and traditions. Prints were relatively inexpensive, and many people could afford them. Artists found, through the print, a means of increasing both their output and their audience. Because the printed picture was the most potent mass communication tool of those times, there was a continuing need to reproduce images more accurately and efficiently. That demand spurred innovation in materials and techniques.

Printmaking: A Definition

Traditionally, prints have been viewed as multiple images produced from a plate. The plate is an intermediary—a flat, hard, rigid surface that contains the picture or message. This image receives ink and the inked image is transferred to the paper by pressure. The process can be repeated many times to produce nearly exact copies.

For half a millennium this definition remained valid, but contemporary developments have stimulated a much more expansive view of the meaning of printmaking. Today, a print is more likely to be defined as a two- or three-dimensional image or form made by a process or combination of processes that may be repeated to produce multiple copies or even unique pieces.

Traditional Printmaking Processes

Although great advances have been made in the technology of printmaking, more "efficient" printmaking processes have not displaced older techniques. Even though photomechanical and computerized processes can guarantee exact duplication of images, artists still employ "handmade" techniques because these often allow a greater range for personal expression.

The basic range of printmaking processes had not expanded much beyond the relief, intaglio, planographic techniques, and paper stencil until the second half of the nineteenth century; these processes are still employed with vigor and variety today.

Relief is the carving away or eliminating of areas to leave on the block or plate a raised printing surface as in the wood block. Intaglio (gravure) is the scratching, cutting, and etching into a plate with tools and acid to create shapes and aggregates of fine lines or dots that are then filled with ink and printed on damp paper under pressure, as in etching and engraving. The damp paper "pulls" the ink from the minuscule cavities, depositing the ink on the paper. Planographic processes, such as lithography, are based on the principle that grease (the image and the ink) and water (the wet plate

or limestone) do not mix; when paper is placed on the stone and pressure is applied, only the inked image will attach to the paper where the drawing of waxy material attracted the greasy ink. The (paper) stencil is an ancient process that more recently evolved into silk-screen printing (serigraphy). Perforations, or holes, in the stencil permit the ink to be deposited on the printing surface when ink is drawn over it and the rest of the stencil blocks the passage of ink onto the surface.

But although those techniques do form the basis of contemporary printmaking in the second half of the nineteenth century, a revolution in communication—the advent of photography, wireless transmission, and motorized presses—stimulated great changes that dramatically affected the printmaking art. Before that time, printmaking was the only cheap mass market reproduction medium. Thereafter, the range and quality of visual media added many influences and variables.

History of Printmaking, Encapsulated

The earliest pictorial images were scratches or engravings on prehistoric bones, stones, and cave walls. Stones and bones provided the means, when the Sumerians became the first to duplicate images (c. 3000 B.C.) by engraving inscriptions on stone cylinder seals, which were then rolled over soft clay tablets and imparted identical impressions in relief. This probably was the first printing process.

The Chinese were said to have reproduced rubbings on cloth from wood blocks in the second century A.D., and by the ninth century A.D. they were using paper to make prints. The same process was reinvented much later in Europe. Even though the first Western woodcut is dated A.D. 1418, it is quite possible that printing on paper occurred much earlier and evolved from textile printing. Known examples of printed textiles date back to the sixth century A.D. Paper was made in Europe in 1151 in Xativa (Játiva), Spain, and the process quickly spread to France, Germany, and Italy. (The Fabriano Company, Italy, has been making paper since 1276.)

Woodcuts

Woodcuts were probably the first types of prints to be made in both Eastern and Western cultures. Wood was a familiar material—and one readily carved by skilled craftsmen. In fact, with the invention of paper, woodcuts—prints from wood plates —were a small step away from textile printing. Prints can be made from any carving by inking the wood, placing the paper over the inked surface (or vice versa), and applying pressure. Craftsmen began to use wood blocks to decorate playing cards in the fifteenth century. These were the first large-volume printings. The potential for reaching a mass market was recognized and woodcuts of the saints emerged. The repetitive subject matter of "holy" pictures led woodcutters to their first technical innovation: the "plug." Rather than repeat the carving of a uniform drapery for each saint, a hole was cut into the block around the head so that only that particular part needed to be recarved—and plugged into the larger wood block.

By the standards of fifteenth-century painting, woodcuts were extremely crude, but they made no pretense of being high art. Heavy lines dominated these early prints, and few, if any, artists were involved in using the process. Wood carving was the prov-

ince of guild craftsmen. Peasants bought the crudely painted woodcuts of their patron saints to ward off evil, ill health, and any other incipient calamity. The first wood prints were pinned to shrouds to carry to heaven or hell. Others were pasted on wafers and swallowed (like Risseeuw's edible prints, as we shall see later). Holy pictures proliferated. Only toward the end of the fifteenth century did artists begin to design wood plates to produce more sophisticated forms. A distinction was made between a designer and the cutter of wood blocks. The woodcut was a facsimile process in which the cutter copied drawings made by designers.

One impetus to finer woodcuts was the mass production of books. Although the first books of movable type used few or no illustrations, "block books" emerged. These were woodcuts in which both text and illustration were part of a single block. Stencils were used in conjunction with woodcuts to introduce color to certain areas. By the year 1470, however, woodcut illustrations were combined with movable type by locking the blocks into the same frame with the type and then printing them both in a single operation. If that particular procedure was used for only a brief period, at least the examples that survived give some indication of the development of the art—the use of single-point perspective and shallow space.

A set of two old rosewood printing blocks from India used for textile printing.

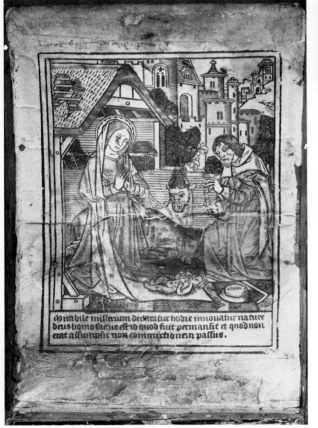

"The Nativity" is a French fifteenth-century woodcut that is colored by hand in red, purple, green, and orange. It was pasted inside the lid of a wooden dispatch or alms box. Both text and illustration are part of the same block. *Courtesy: The Metropolitan Museum of Art, Harris Brisbane Dick Fund*

Engravings

Engraving, as a printmaker's art, developed during the same period that woodcuts did, an independent craft stemming from different skills. Engraving was first employed by goldsmiths to decorate metal plates, armor, candlesticks, and jewelry. Those craftsmen first "pulled" prints from ink forced into the engraved lines in order to determine what work still needed to be done, to retain a record for the master craftsmen, and to create models for apprentices to copy.

Eventually those craftsmen created engravings that were meant to serve as printing plates. The early engravers produced playing cards and indulgences. And given the extreme paucity of visual information, early engravings often served as models for sculptors in the provinces. Nonetheless, at the early stages all engravings were probably produced for the upper classes, since the plate materials (gold and copper) were expensive and the craftsmen (goldsmiths) were highly paid and skilled. Fewer than three thousand fifteenth-century engravings are known to us today because these early prints were often mounted on walls with bits of wax—this was before the use of clear glass in picture frames.

Like woodcuts, engravings are dated primarily by subtle advances in style and skill and perception. From line figures, an artist called Master E. S. (1440—67) gave the art cross-hatching. But convincing forms and flesh eluded the first engravers.

Martin Schongauer further refined the art by introducing more complex levels of space and more successful renderings of figures. He was the first great engraver to have been a painter first and not a goldsmith. Although his style was essentially Gothic, he helped forge a transition to the Renaissance by dint of his style—a loosening of his subject matter from the constraints employed by fifteenth-century goldsmiths. His use of rhythmic lines was a powerful influence on the young Albrecht Dürer.

There were other highly skilled engravers who worked in the late fifteenth century.

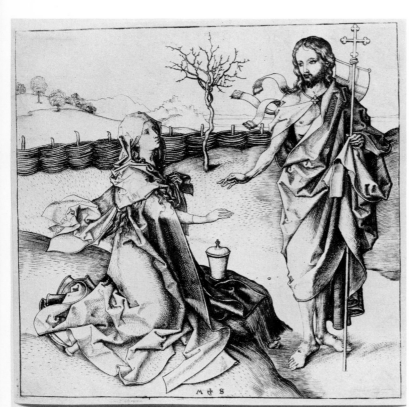

Martin Schongauer (ca. 1445—91), "Christ Appearing to Mary Magdalene." Intaglio. *Courtesy: The Metropolitan Museum of Art, Harris Brisbane Dick Fund*

Opposite page, left:
Brass rubbing from the tomb of Sir Thomas Bullen, 1538, from Hever Church, Kent, England. *Courtesy: Victoria and Albert Museum*

Opposite page, right:
Albrecht Dürer, "Four Naked Women." Engraving, 1497. 7⅝" × 5¹/₁₆". *Courtesy: The Metropolitan Museum of Art, Fletcher Fund*

Among them was Israhel van Meckenem, the great forger, who contributed charming engravings of commonplace scenes of daily life and the interiors of medieval homes.

But Albrecht Dürer raised the art to high perfection. Dürer created more than one hundred engravings, etchings, and drypoints—and more than three hundred woodcuts. In addition to his curiosity about nature and natural detail, expressed through texture, light, and shadow, Dürer brought his early training as apprentice goldsmith to his father. Those skills in toolmaking and engraving became the basis of his printmaking. With the ability to perceive and capture fine elements of anatomy and natural form, and the influence of models of earlier artists like Schongauer, Dürer was able to extend the quality of woodcuts and engravings. He expanded the tonal range more toward the middle grays with different patterns of cross-hatching; and he experimented with drypoint and etching as well. (Dürer dated his first print in 1497.)

Perhaps most significant, however, is Dürer's apparent recognition of the power of prints. He was famous during his own lifetime because tangible evidence of his skill circulated widely, since many, many multiple images could be created quickly by printing. Visual images could never have traveled as quickly if they needed to be drawn or painted.

Of course, Dürer probably had other influences as well. There is little doubt that he was aware of Antonio Pollaiuolo's work. In addition to making the first major advance in the study of anatomy, Pollaiuolo introduced several technical innovations to the engraver's repertoire. He employed bands of parallel lines, rather than cross-hatching. He interlocked figures, twisted their limbs at their extremities, and often attempted pivotal representations—showing the same figure from both front and back.

 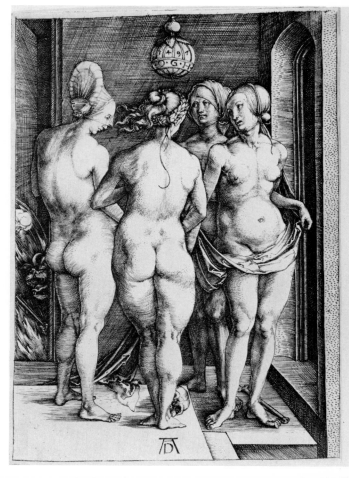

Another influential Italian engraver was Andrea Mantegna (of Mantua, Italy), whose fine, smooth lines, wide range of light and dark values, also threw figures into dark relief to highlight the forms. His was a painter's approach.

Although Dürer and Mantegna were well known and appreciated, it was Marc Antonio Raimondi who helped to disseminate their works. He systematized the copying of sculpture and other art by Dürer and others and sold these copies. Raimondi was a remarkable engraver who recorded works of others as a camera would and thereby served a valuable function.

The first artist to recognize the potential of collaboration was probably Raphael, who worked closely (and almost exclusively) with Raimondi and Raimondi's engravers. This approach influenced the direction of printmaking until the discovery of photoengraving.

Technical innovations occurred continually. Perhaps influenced by Dürer's sketches on colored paper, Lucas Cranach pioneered the introduction of color into the printmaking process. Cranach expanded upon the early painting of wood-block prints, first by printing on colored paper, then by experimenting with "tone blocks." Because of this, he is credited with the invention of chiaroscuro. Tone blocks of different shapes were printed separately in different colors of ink. They allowed for further accentuation of color and the addition of new colors to the print.

The addition of tone blocks in themselves represented a contribution, but more important was the technical solution to the particular problem in registering many blocks on the same print. They had to align accurately.

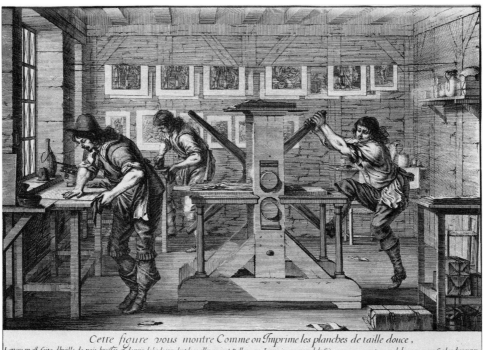

Abraham Bosse, "Scene from a Printing Shop—The Plate Printers." Etching and engraving, seventeenth century. *Courtesy: The Metropolitan Museum of Art, Rogers Fund*

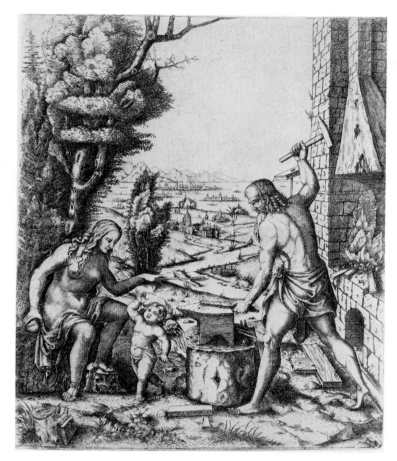

Marcantonio Raimondi, engraving of "Venus, Cupid and Vulcan." Early sixteenth century. *Courtesy: The Metropolitan Museum of Art, Harris Brisbane Dick Fund*

Etching

Parmigiano (Girolamo Francesco Maria Mazzola of Parma, Italy) took another small step in the progression by combining both woodcut and etched elements in single prints. He has been credited with being the first Italian to practice etching. He used the etching needle as if it were a pen and he also experimented with acid to bite the lines further.

But it was Jacques Callot, called the father of French etching, who is credited with a significant technical advance. In etchings, the waxy varnish applied to the copper plate at that time was generally a soft ground, which often flaked off in the acid and ruined the work. The plate, therefore, could be placed in the acid only once; otherwise the acid would eat through the ground entirely. Callot introduced a harder ground (made of mastic and linseed oil) that allowed several dips to be made—making extremely fine lines possible. It is thought that he might have learned the varnish formulation from musical instrument makers. The harder the varnish, the finer the line that can be etched.

Callot also used, and may have invented, the *échoppe,* which allowed the etcher to produce in one continuous stroke a swelled line like an engraving. It looked like the

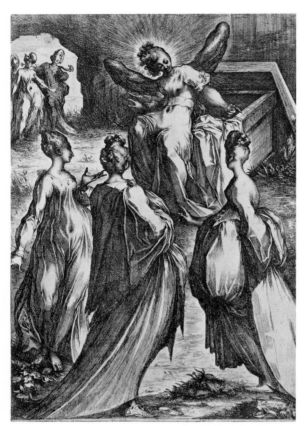

Engraving by Jacques Bellange, "Les Trois Maries au Tombeau." Early seventeenth century. *Courtesy: The Metropolitan Museum of Art, Harris Brisbane Dick Fund*

Jacques Callot (1592—1625) was known as the father of French etching. His "Temptation of St. Anthony" is an engraving and etching. $14^1/_{16}"$ × $18^1/_8"$. *Courtesy: The Metropolitan Museum of Art, Gift of Henry Walters*

graver's line with its thick and thin areas. Callot also enlarged the subject matter of art by recording the scenes of life around him. Also in this period, there was a recurrent combination of etching and engraving in a single plate.

During the sixteenth and seventeenth centuries, etching was largely a means of imitating engravings, and few original works were produced by this method. Rembrandt (Harmenszoon van Rijn) changed this completely. He was the first great artist to master pure etching. He abandoned engraving and experimented with different inks, papers, and techniques for creating lines, such as drypoint. He used Oriental papers imported through Amsterdam. And in later years he used absorbent papers, which gave a softer line—a chiaroscuro-like effect. He used a soft ground rather than a hard varnish, and his lines took on a rapid character. He heavily worked the plates and used light and shadow rather than line to define his forms. In some cases, rather than wiping a plate completely clean, he left the surface partially inked and each impression would differ. Rembrandt was also interested in natural light sources and strong contrast between light and dark. He could print shadows with the qualities of a halftone. Rembrandt also added a yellowish wash to the paper before printing in some cases, and he used oatmeal and colored paper too. He also allowed the process to dictate the result.

Unlike many artists who marketed their serious art to the masses by making prints that copied their paintings, Rembrandt never reproduced his paintings. He treated prints as independent and important works of art in themselves by viewing etching as another aspect of his career, experimenting and exploring the medium. Some of his plates were printed until 1906—for nearly three hundred years.

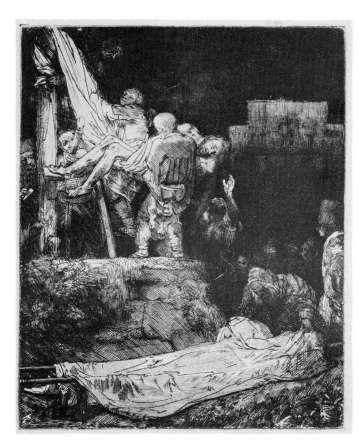

Rembrandt, "Descent from the Cross by Torchlight." Etching, mid-1600s. *Courtesy: The Metropolitan Museum of Art, Gift of Felix M. Warburg*

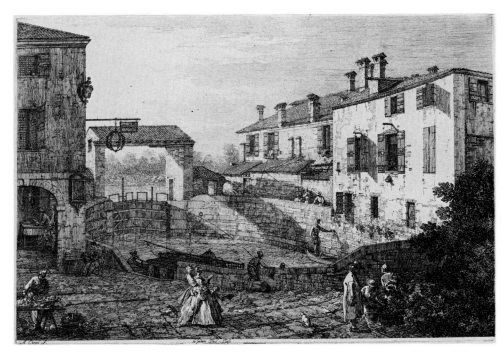

Giovanni Antonio Canaletto, "Le Porte del Dolo." Etching, early eighteenth century. *Courtesy: The Metropolitan Museum of Art, Rogers Fund*

Giovanni Battista Tiepolo, "Le Mendiant Assis et Vu de Dos." Etching, early eighteenth century. *Courtesy: The Metropolitan Museum of Art, Harris Brisbane Dick Fund*

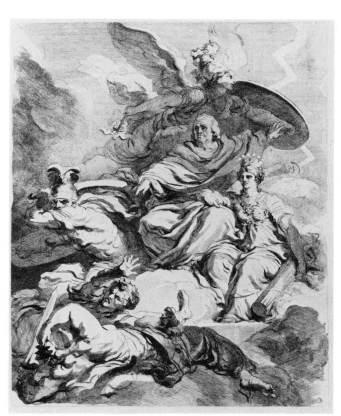

Jean Honoré Fragonard, "Au Génie de Franklin." Drawn and engraved by Fragonard, late eighteenth century. *Courtesy: The Metropolitan Museum of Art, Gift of William H. Huntington*

G. B. Piranesi, "The Prisons." Etching, late eighteenth century. 16¼" × 21⅞". *Courtesy: The Metropolitan Museum of Art, Harris Brisbane Dick Fund*

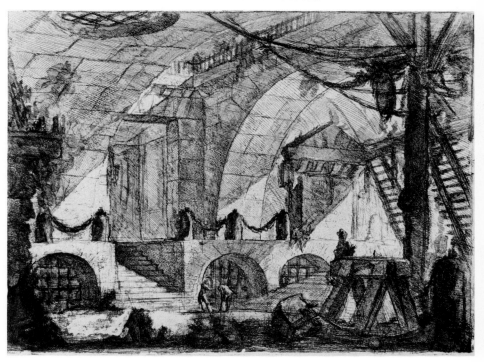

In the early 1600s, in Amsterdam, Jan Van de Velde discovered that if you blew tiny specks of rosin on the etching plate, the acid would etch around it, producing gray tones. Thus the aquatint was born.

At about the same time, and in Amsterdam, Ludwig von Siegen developed the mezzotint by rotating a spiky roulette over areas of the copper plate. This created a roughness that caught the ink with another texture. Prince Rupert of the Palatinate (in 1657) further perfected the mezzotint by roughing the entire copper plate with the roulette and then burnishing in highlights by flattening areas of copper to its original smoothness.

Etching had its own Renaissance in Holland and Germany as a commercial medium with influences extending throughout Europe. Etching and its variations found widespread applications as illustrations in books, catalogs for selling items, exhibit catalogs, pictures of architecture, scenery, interior designs, maps, church announcements, and so on.

Christophe Philippe Oberkampf printed cotton cloth with engravings at his Jouy, France, factory in 1760. Block prints were used on wallpaper in England, and flocking was added to texture line. Wood blocks, etchings, engravings, and mezzotints appeared on china plates. The wood block, or copper plate, was printed in pure oil on thin paper or on a flexible gelatin sheet. The sheet was then offset and pressed or printed onto glazed (china) plates. Then powdered enamel (ground glass) was dusted on. This powder adhered to the oiled areas only. After the plate was fired, the enamel melted and fused to the glaze of the china.

There were other innovations along the way. In the mid-seventeenth century, Giovanni Benedetto Castiglione invented the monotype. He painted a picture in printer's ink on a nonabsorbent surface and then printed it on paper, like an etching. Since only one good copy could be pulled, it was given its name. Many artists have made monotypes over the years, and Degas created more than four hundred of them.

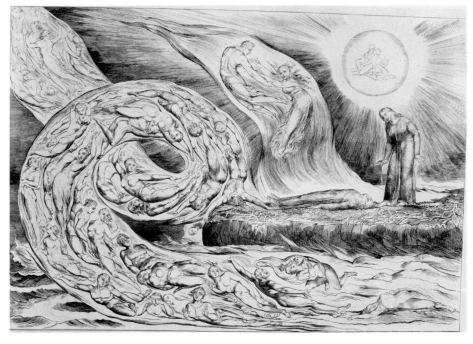

William Blake, "The Whirlwind of Lovers," illustration for Dante's "Inferno," Canto V. Etching, eighteenth century. *Courtesy: The Metropolitan Museum of Art, Rogers Fund*

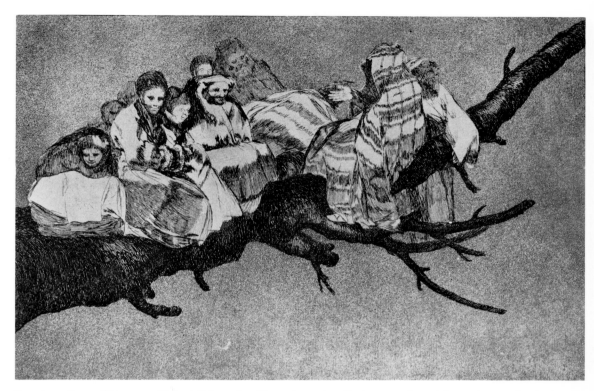

Francisco Goya, "Disparate Ridicule" from *Los Proverbios,* plate 3. Aquatint, late eighteenth or early nineteenth century. *Courtesy: The Metropolitan Museum of Art, Harris Brisbane Dick Fund*

Lithography

In the last decade of the eighteenth century, an Austrian, Aloys Senefelder, who was looking for a technique to reproduce sheet music, invented lithography. He wrote in grease on paper, pressed the greasy line on limestone, soaked the stone with water, applied printer's ink, and then pressed the paper against the stone. Senefelder called this chemical printing and patented the process.

Senefelder thought of lithography as a substitute for etching, describing it thus: "All those lines or parts of the drawing or writing which are to give the impression are engraved into the surface of the stone by means of a sharp needle or bitten into it by the action of an acid."

The process caught on in France and in Germany, probably because lithography lent itself to direct drawing more than any other type of printmaking. And since the image was drawn in black (the grease) on the gray stone surface, one could visualize the finished work.

In England, the establishment, led by John Ruskin, denounced lithography as a cheap imitation of aquatint. In France, however, Theodore Géricault and Eugène Delacroix (1880s) carried the lithograph to a high art. In Spain, Francisco de Goya, who made contributions to printmaking by experimenting with the expressive technique of

Theodore Géricault, "Entrance to the Adelphi Wharf." Lithograph, early nineteenth century. *Courtesy: The Metropolitan Museum of Art, Rogers Fund*

Benjamin West, "He is not Here, He is Risen." Lithograph, plate 12 from *Specimens of Polyautography* London, Vollweiler, 1807. *Courtesy: The Metropolitan Museum of Art, Harris Brisbane Dick Fund*

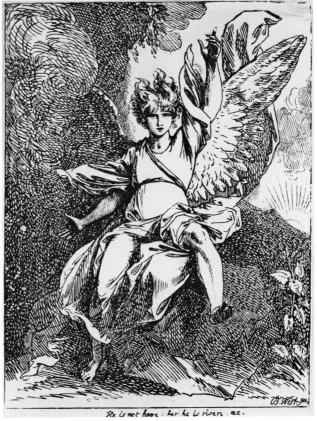

working with aquatint (by varying the qualities of surface—coarse and fine texture), also, at the age of seventy-nine, learned a new medium and created lithographs.

The nineteenth century was a turbulent one, with aesthetic revolutions one after the other. France led the way. Honoré Daumier, printmaker and social satirist, used the lithograph to communicate his messages, most of the time for a newspaper called *Charivari.* In his lifetime, Daumier made four thousand lithographs, some with editions up to thirty-five hundred.

The decade 1890 to 1900 was the golden age of poster making and color lithography. Poster making became quite a fad in France, with production for scrapbooks, collections, and folding screens. Although the fad lasted only ten years, it had great effect on commercial design and the state of lithographic art. The acknowledged master was Jules Chéret.

Chéret innovated in the mechanics of lithograph production by introducing machinery that would print stones three to four inches thick and three feet by five feet. By simplifying the lines and message of the art and by bringing the medium to the commercial community, Chéret revolutionized visual communication.

His contemporary, Toulouse-Lautrec, built upon Chéret's system but abandoned the primary colors and mixed his own inks.

Jules Chéret, "Palais de Glace, Champs-Elysées." Poster, lithograph, 1896. *Courtesy: The Metropolitan Museum of Art*

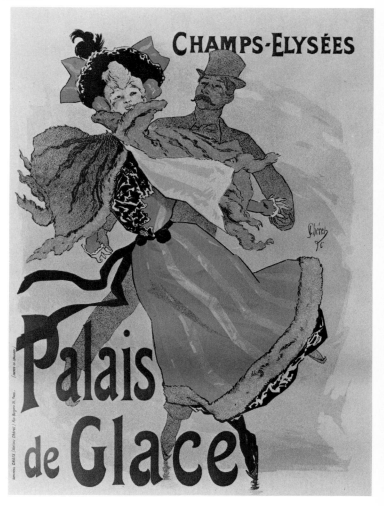

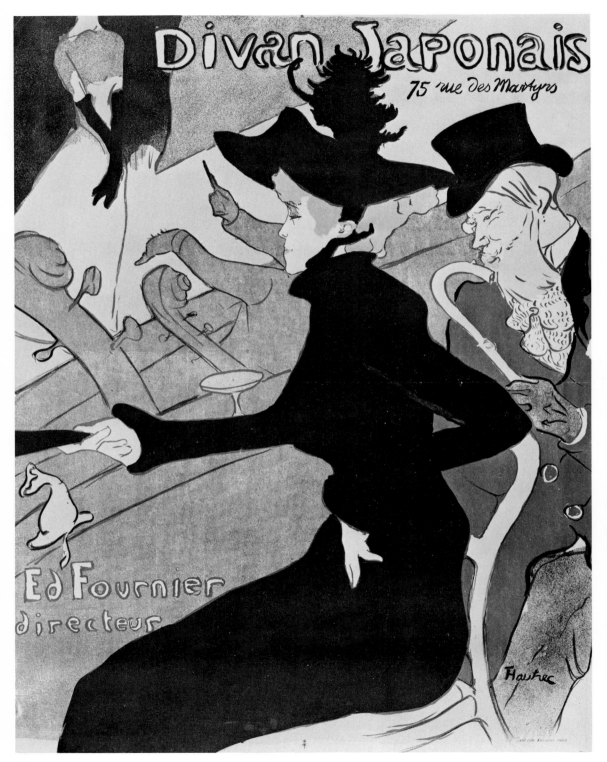

Henri de Toulouse-Lautrec, "Divan Japonais." Lithograph, second half of nineteenth century. *Courtesy: The Metropolitan Museum of Art, Harris Brisbane Dick Fund*

Photography

The invention of photography, perhaps more than any other force, stimulated monumental changes in art form, with printmaking more greatly influenced by indirection because photographic reproduction processes threatened hand printmaking methods. By 1850 photography was established, and printmaking branched into two directions—commercial reproduction, utilizing the new potential of photography, and hand process, which remained the creative artist's medium.

Yet there were many dimensions of photography that had great potential for the artist. Louis-Jacques-Mandé Daguerre published a detailed account of the daguerreotype process in Paris (1839). He described treating a silver-plated copper plate with iodine vapor to form a light-sensitive coating of silver iodide. After exposure in the camera, the image was developed by mercury vapor at 60° C. (140° F.) and fixed with a sodium thiosulfate solution to remove unexposed silver iodide. The daguerreotype was a laterally reversed picture with white highlights against a plain silver background. It became the first commercial process but proved to be a dead end in photographic technology, possibly because each image was unique.

The negative-positive system invented by William Henry Fox Talbot in 1840 (London) led to more practical solutions. In his calotype process (later talbotype), a silver-iodide-coated paper, exposed in a camera, was then developed in a solution of silver nitrate and gaelic acid and fixed with sodium thiosulphate. These paper negatives were then printed on a silver chloride material to produce a positive.

In 1851 an English sculptor, F. Scott Archer, coated a glass plate with a nitrocellulose (collodion) solution containing potassium iodine that was immersed in the dark in a silver nitrate solution. This was exposed in the camera while still wet, developed immediately, and fixed. It was the first time that instantaneous exposures with fine-grain negatives were possible. The wet-collodion plate method became the major photo process for the next twenty years.

Dry plates followed, along with a host of other photosensitive materials. In 1887 Hannibal Goodwin proposed the use of celluloid film carrying a silver bromide emulsion. Eastman Kodak marketed this film soon afterward (later on acetate) and opened the way for instant cameras that widely popularized photography.

On another front F. E. Ives (of Philadelphia, 1885) perfected halftone screens by using pinhead dots, smooth paper, and accurate presses. Eventually this approach took the place of engraving.

Thomas Bolton (1810—15) photographed images, projected them onto a wood block and then engraved the block; and Jean-Baptiste Corot, in his sixty-five *cliché-verre* prints painted on glass with black asphaltum, scratched lines into the paint, placed the glass onto photographic paper, and exposed the plate and paper to sunlight. Millet, Daubigny, and others used this method from 1853 to 1875.

Experimentation by artists was, nonetheless, the exception. Prejudices lingered. Artists in the main left photographic processes to those who reproduced commercial works. Until very recently, it was a separate realm, disassociated from the fine art of printmaking. Photography was ignored because machines intercepted eye and hand coordination. The camera seemed to violate the hand/craft traditions of painting and sculpture. It was an intruder in well-established territory.

Nevertheless, with photo images on the scene, photo influences were felt. They not only stimulated the artist to refocus the way he saw and how he interpreted and expressed images but may have stimulated the artist to look beyond exact recordation of what was seen to more revolutionary subject matter and ways of expressing it.

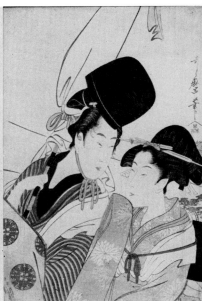

Suzuki Harunobu (1725—77), "Dai'su no Yan."
Wood-block print. Young woman, watching boy fasten
strip of paper to hair of his sister who has fallen asleep.
*Courtesy: The Metropolitan Museum of Art, Frederick
Charles Hewitt Fund*

Kitagawa Utamaro, Triptych, "Ukiyo-e's Analogies of
the Eastern Journey of the Poet Marihira." Eighteenth,
early nineteenth century. *Courtesy: The Metropolitan
Museum of Art, Gift of Samuel Isham*

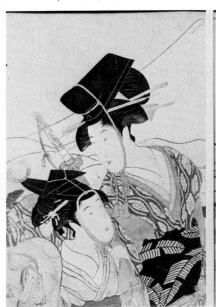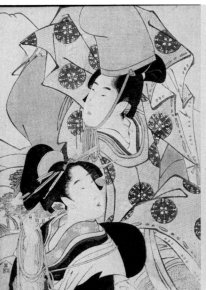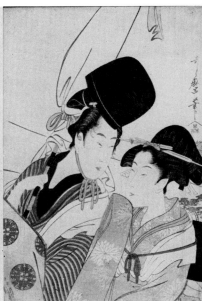

New Styles
and New Directions

A Survey

Many artists found inspiration in "unusual" and "foreign" forms, particularly African sculpture and Japanese prints. Degas, Whistler, and Cassatt were very much affected by the work of the Japanese artists Utamaro, Hokusai, and Hiroshige. Their work shows strong influences on subject matter, and this interest also led to explorations of new techniques as well as new styles. Edvard Munch and Paul Gauguin made block prints, moving away from mechanical concepts back to a very basic material—wood. Gauguin experimented in new ways to cut the end grain of the wood, smudging the register, overprinting, using various textures beneath the paper. Munch printed the grain of wood as Hiroshige did and tried to maintain its essential wood qualities. To print a variety of colors, Munch cut apart his wood blocks, inked parts in various colors, reassembled them, and printed the blocks.

Katsushika Hokusai (1760—1849), "Fuji seen above a thunderstorm with lightning below." *Courtesy: The Metropolitan Museum of Art, Rogers Fund*

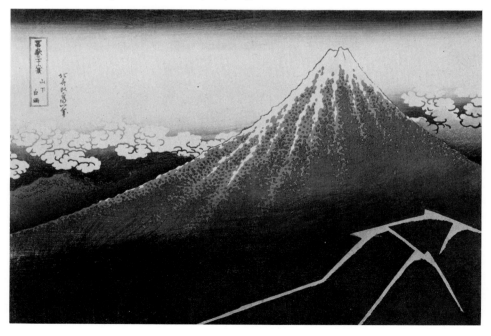

Edgar Degas, "The Black Earring." Monotype, late nineteenth century or early twentieth century. 3⅛" × 2¾". *Courtesy: The Metropolitan Museum of Art*

The Limited Edition

Nonetheless, even at the close of the nineteenth century, most prints were copies of paintings by then-prominent artists (many now forgotten) made by means of steel engravings. These satisfied the Victorian middle class. A break came only when Sir Francis Seymour Haden, an English surgeon who collected etchings, and his brother-in-law, James Abbott McNeill Whistler, established a society of painter-etchers. They wanted to give status to the etching and they did this by printing limited editions and signing and numbering each print in pencil, rather than in the plate. Autographed prints sold for twice as much. By 1925 the signed, limited-edition print was an established form of contemporary art and became standard procedure.

What emerged through Haden's and Whistler's efforts was the *original* print, as distinguished from the *reproduction*. Photographic reproduction processes already were making reproductive printmaking obsolete, but the etching created by contemporary artists as a statement in its own right—rather than an uninspired copy of an oil painting—met with enormous success.

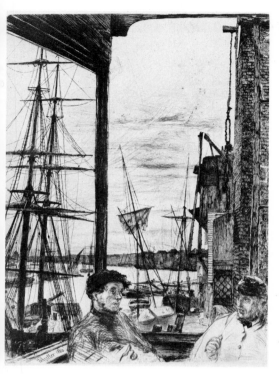

James Abbott McNeill Whistler, "Rotherhith." Intaglio, 1860. 10 ⅞″ × 7 ⅞″. Signed on the plate. *Courtesy: The Metropolitan Museum of Art, Harris Brisbane Dick Fund*

Aubrey Vincent Beardsley's pen-and-ink drawing of Madame Rejane for a line-block reproduction, 1894. In 1839 printers devised a way to mechanically turn line drawings into relief blocks. *Courtesy: The Metropolitan Museum of Art, Rogers Fund*

Etching to Intaglio

Artists began to reinvestigate and reinterpret many of the traditional printmaking processes. Pierre Soulages varied engraving by moving his burin as if it were a pencil, instead of pushing it. He also combined drypoint, etching, and aquatint in single prints to achieve a wider range of gray values.

Rather than wiping the plate clean, Degas pushed ink around the surface of the etched plate to vary grays and give tone and form to the final print.

In the 1930s Stanley William Hayter, an English artist, established Atelier 17 in France, which became the center of experimental printmaking in Paris. (In the forties he worked in New York for a short time.) Many innovative techniques grew out of his work. He printed intaglio and relief simultaneously from a single plate. He also experimented with printing different viscosities and colors of ink on a single print in one run of the press, by selectively depositing inks with different degrees of oiliness (progressively decreasing viscosity), and using hard and soft rollers of different diameters. He stenciled and offset color to contain certain areas. Hayter also made plaster prints from engraved plates.

During the same period, Rolf Nesch (a Norwegian) and Hayter made prints from collages using various kinds of perforated metal. Wire, mesh screening, washers, and

André Masson, "Le Génie de l'Espèce." Drypoint, 1942.

Opposite page, left:
Stanley William Hayter, "Maternité Ailée," 1948. Engraving and soft-ground etching on brass; color applied by offset from a copper plate and two stencils. Printed in four colors in one operation.

Opposite page, right:
Closeup of "Maternité Ailée."

movable metal plates were employed to mold a low relief into flat paper printed under great pressure.

In the forties Hayter brought etching to the United States and revived the term intaglio. His use of the etching graver with a free movement influenced other artists. Jackson Pollock grasped the idea of the automatic line during a few sessions spent at Hayter's New York Atelier 17.

Today Richard Royce, a printer who worked at Hayter's Paris studio is carrying innovation further in Los Angeles.

Along the way, the intaglio became the inkless intaglio, evolving from Rolf Nesch's first experiments. The relief got deeper and deeper. The Hungarian Etienne Hajdu arranged zinc shapes on a printing bed and printed the whole by compressing it into damp paper.

In 1968 Michael Ponce de Leon in "Succubus" carved shapes, cast an aluminum matrix, mounted it on a background of a perforated sewer drain cover, and custom-molded paper in a hydraulic press (with a force of ten thousand pounds) to produce even higher relief prints.

Bong Tae Kim and Vida Hackman at Triad in Los Angeles, California, are implementing these concepts using their unique styles. Vida Hackman is applying color ink to the plate *à la poupée,* selectively inking particular areas and carefully wiping away just as much ink as she would like. She is also embossing areas of the same plate, as well as printing offset from one ink source to another.

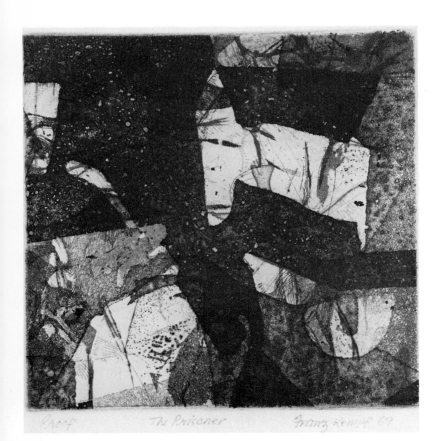

Franz Kempf, "The Prisoner." Etching and Aquatint, 1970s. *Courtesy: Franz Kempf*

Richard Royce, "Ocean Wave." Engraving. 13 ½″ × 10 ¾″. Richard Royce attempted to "peel away" layers of depth in creating fields of line, overlaying layers of images.

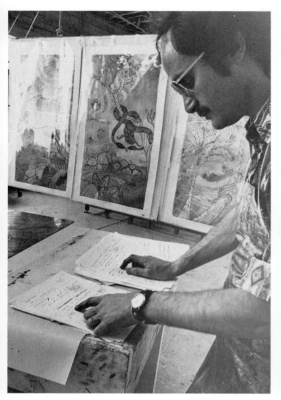

Richard Royce checks over voluminous records with ink samples for the printing of Jessie Allen's "Tryptik," a complicated piece utilizing viscosity printing, blending, spotting, blushing out, rainbow mixing on roller, selective inking, use of metallic powders, crenellating within a line with two colors.

Jacob Samuel (*left*) and Philip Rausch change the roller for rainbow mixing of color.

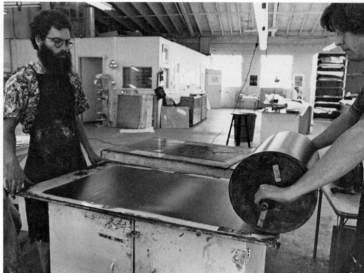

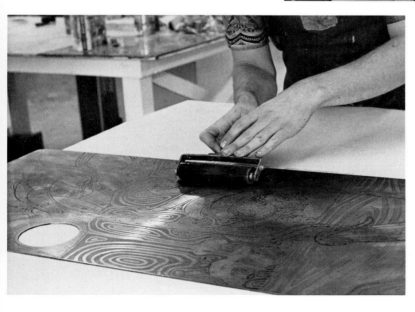

With a brayer, they roll extremely oily extender on the plate in specific patterns.

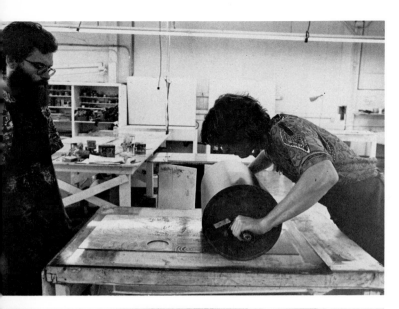

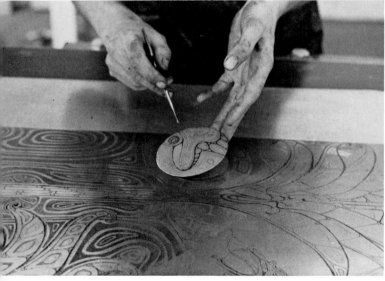

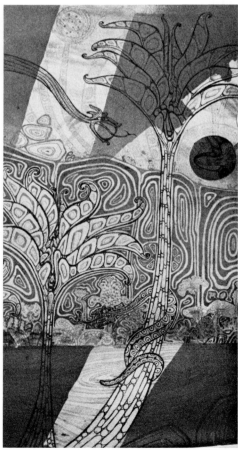

Top: The rainbow-coated roller then is run over the plate with less oily ink. This is viscosity printing.

Above: The removable sun, which is embossed on the first run without ink, is run through on a second run with color.

Right: One panel from Jessie Allen's "Tryptik" very effectively duplicates the original watercolor visualization.

Top, left: Vida Hackman employs etched plates as modular units along with textured pieces of plastic to create intaglios. Here she is applying ink selectively to areas of a series of modular etched and aquatinted units.

Above: Hackman wipes the plate *à la poupée.*

Center: Units are carefully assembled on the bed of the etching press.

Bottom: Blanket and protective paper pulled away reveal the embossing.

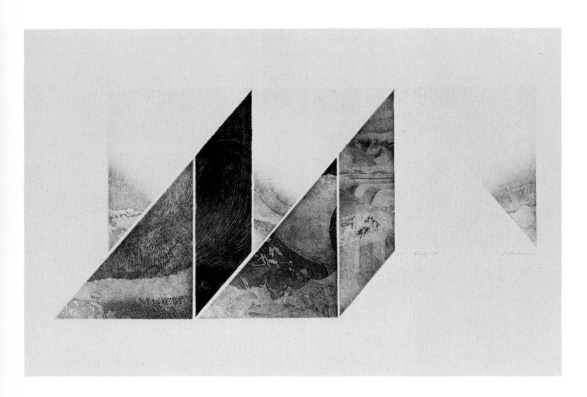

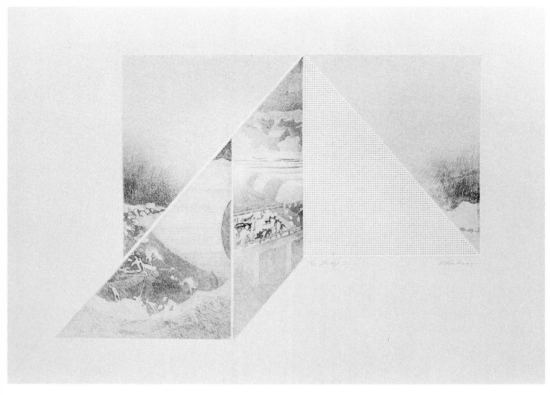

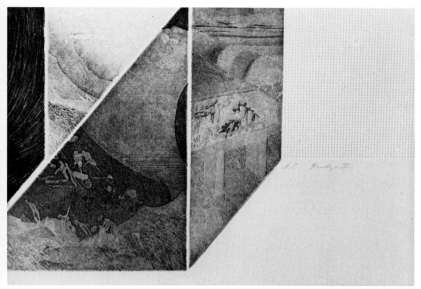

Above: A closeup of "Bridge II" showing the intaglio effects—note embossment made by textured plastic (a piece of lighting diffusion panel).

Right: Bong Tae Kim, "Configuration III B." Color etching and relief. 24″ × 40″. Courtesy: Bong Tae Kim. Photo by Kenneth Peterson.

Opposite page, top: One version of this series by Vida Hackman (who prints at Triad Graphic Workshop), "Bridge II." 1975. A color etching and embossment on German etching paper. Sheet size 22″ × 39″. *Courtesy: Vida Hackman. Photo by Kenneth Peterson*

Opposite page, bottom: Another assemblage of the same units, combined in a different way. Printed at Triad Graphic Workshop by Patricia Nickels. Paper is Murillo. 22″ × 30″. Chase Manhattan Bank and Library of Congress Collection. *Courtesy: Vida Hackman. Photo by Kenneth Peterson*

Lithography—Planographic Variations

Lithography has also changed since Senefelder discovered the process by drawing with waxy materials on grained limestone. Lithographs expanded to utilize metal and plastic plates. The original waxy crayon now includes the liquid (waxy) tusche, which may be applied with brush, pen, or other tools. Varieties of tusche have extended the range of grays and textures available to the lithographer, even further than did Odilon Redon in the nineteenth century. Now tusche-cum-polymer medium is often airbrushed onto the plate or stone. The medium (one part Liquitex medium, one part Liquitex black, and one part distilled water) is mixed, matured overnight, strained before spraying or being applied in a wide variety of ways. Washes composed of various solvents diluted by distilled water, kerosene, turpentine, and so on are known to react in different ways with the various waxes and are used to change the surface and resistance qualities of those materials to produce even greater ranges of grays and textures.

These new stop outs (agents that block or partially block areas from printing ink) result in a medium more resistant to the etches and solvents used to process the litho image.

Instead of grease, we now have polymers—often used not on stone but on roughened (ball-grained) anodized aluminum plates.

Color lithographs, sometimes called chromolithographs or oleographs, were developed in the latter part of the nineteenth century. Toulouse-Lautrec, Paul Gauguin, Pierre Bonnard, and Édouard Vuillard further refined color lithography beyond its crude beginnings to a fine art. Henri Matisse created more than five hundred lithographs (and some outstanding serigraphs made from originals in cut paper). Color lithography was getting closer to painting, particularly through the hands of Wassily Kandinsky and Georges Rouault.

More than one hundred colors have been developed, and many materials besides paper have been used to receive images.

Ruth Weisberg prints lithographs using a tremendous range of grays, not only on traditional paper but also on parchment, chamois, and leather.

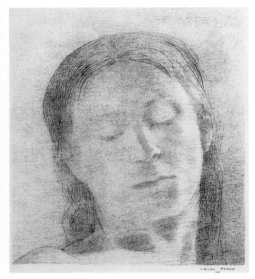

Lithograph by Odilon Redon (1840—1916). "Yeux Clos." Lithograph. *Courtesy: The Metropolitan Museum of Art, Harris Brisbane Dick Fund*

Pierre Auguste Renoir, "Le Chapeau Epinglé." Color lithograph, late nineteenth century. *Courtesy: The Metropolitan Museum of Art, Harris Brisbane Dick Fund*

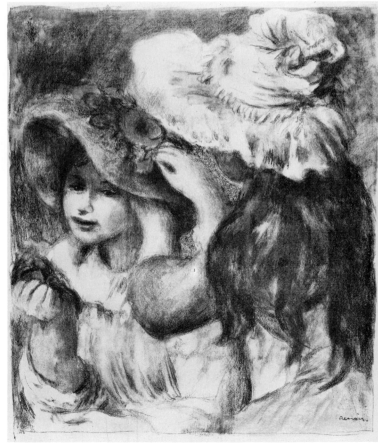

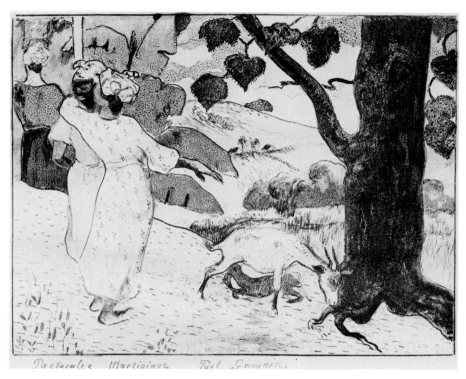

Paul Gauguin, "Pastorales Martinique."
Lithograph on zinc, printed on yellow
paper. 1899. 7 ¼″ × 8 ¾″. *Courtesy: The
Metropolitan Museum of Art, Rogers Fund*

Wassily Kandinsky, "Kleine Welten."
Color lithograph, 1922. *Courtesy: The
Metropolitan Museum of Art, Harris Bris-
bane Dick Fund*

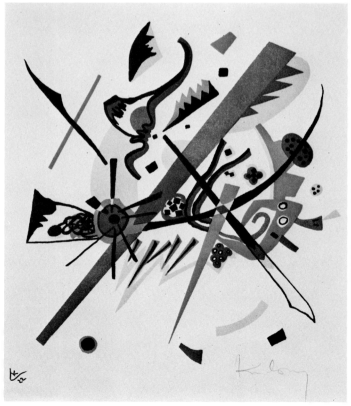

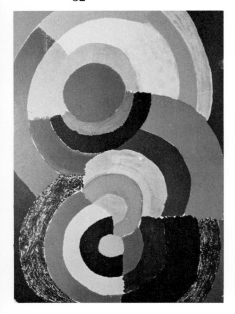

Sonia Delaunay, "H.C." Lithograph.

Robert Rauschenberg, "Tracks." 1970. 44″ × 35″. Lithograph from aluminum plate on special Arjomari paper, *Courtesy: Gemini G.E.L.*

Franz Kempf, "Figuration Suite." Lithograph in three colors. *Courtesy: Franz Kempf*

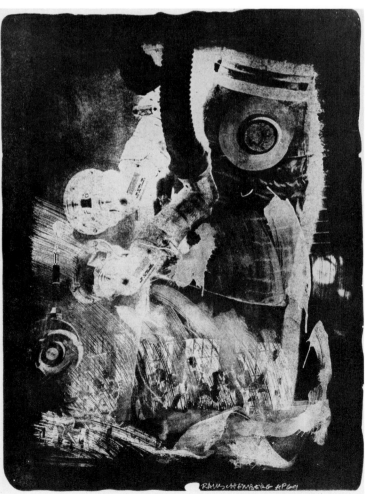

Richard Hamilton, "Sunset (f) Lithograph." One-color *papier collé* lithograph. A thin sheet of paper was printed and mounted simultaneously on a larger and heavier backing. 16½" × 21⅛". *Courtesy: Tyler Graphics Ltd.*

Robert Rauschenberg, "Earth Crust" from *Stoned Moon Series.* Two-color lithograph, 1969. 34" × 25". Printed on stone. Use of chemical reversal of image after first tan color to produce dark-brown printing. On Arches Cover. *Courtesy: Gemini G.E.L.*

33

With tongue in cheek, Les Levine bakes a fish (Arctic char) that was stuffed and seasoned on an aluminum (lithographic) plate.

The fish is eaten.

The plate upon which the fish was baked was printed as a lithograph. Words describing this process are in Inuktituut (Eskimo dialect). From The Cape Dorset Suite. "I Love You Arctic Char" by Les Levine. *Courtesy: Les Levine*

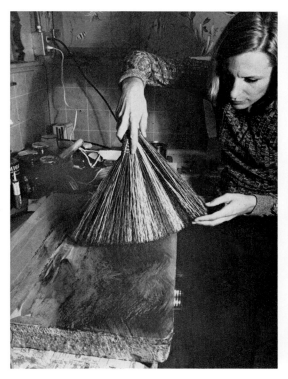

Ruth Weisberg utilizes a wide range of materials to create her textures and lithographic gray values. Here she uses a broom to scratch "lines on her stone. . .

. . . and a hair dryer to blow tusche into patterns."

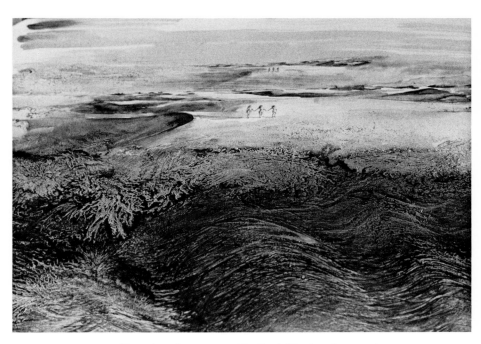

Note the effects created by Ruth Weisberg's special texture treatment.

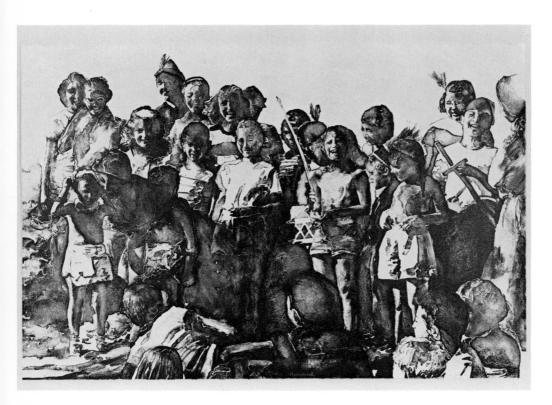

Ruth Weisberg, "Neverland." 1976. 22" × 32¼". A two-stone lithograph on Arches. The first stone was sand color, the second black. The lithograph shows a complex manipulation of tusche and water washes with some accenting with No. 5 pencil. *Courtesy: Ruth Weisberg. Photo by Kenneth Peterson.*

Ruth Weisberg, "Chamois." Two-color lithograph on chamois. 1974. 45" × 52". *Courtesy: Ruth Weisberg. Photo by Ken Hackman.*

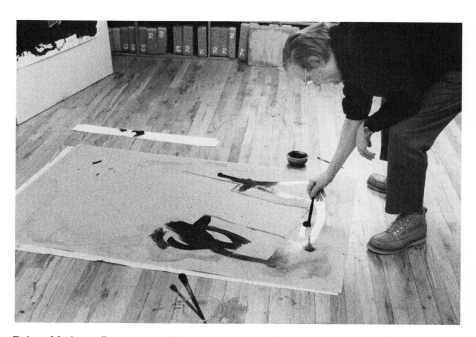

Robert Motherwell paints a tusche mixture on an aluminum plate for one of the six runs required to print "Bastos."

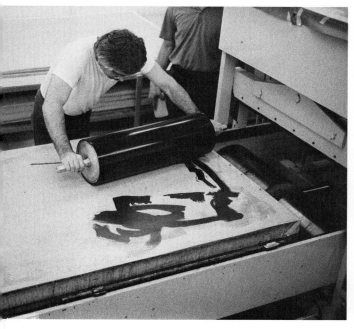

Kenneth Tyler inks plate for one of the printing elements.

A proof is placed in registration for one of the six runs.

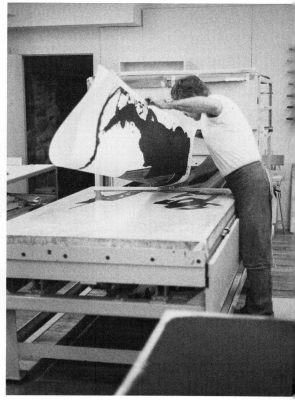

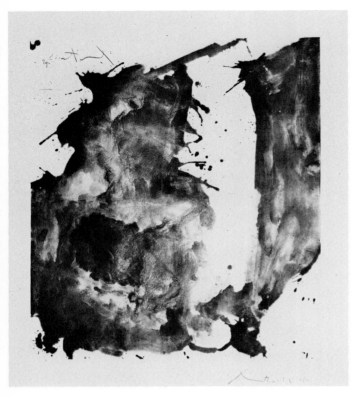

Although not "Bastos," "Poe's Abyss" by Robert Motherwell was executed during the same printing session as described on the previous page. *Series Courtesy: Tyler Graphics Ltd.*

Silkscreen/Serigraphy

Silkscreen printing has also come a long way—with most progress having been made in the twentieth century—since the first stencils were made thirty thousand years ago in the Gargas grottoes of the High Pyrenees. Those ancient artists masked areas with their hands and blew red-colored earth onto the surface of the cave walls through hollow reeds. Stencil printing has since been used all over the world. The Eskimos practiced the process in Baffin Island, making prints from stencils cut in sealskins. (This was before their contact with Western civilization.) The Fiji Islanders also stenciled. Roman children were taught their letters by tracing with stylets through perforations in wooden stencils.

The stencil remained quite primitive, however, until the first silkscreen was invented by Some Ya Yu Zen at the end of the seventeenth century in Japan. He solved the problem, isolating a design or shape inclusion in an open space, which was not possible with the basic stencil since the positive outer edge of the form was necessary to support the open space within. To do this, he sandwiched a lining of hair to fine silk threads between two oil-impregnated sheets of mulberry paper. Within this web of thread, Some Ya Yu Zen suspended shapes, and the fine fibers allowed ink to filter around them and around the forms suspended between them.

Although Japan had sealed herself off from contact with most of the world, some examples of silkscreen found their way to Europe via Dutch trading ships. Yet despite the curiosity evoked by this strange stencil, silkscreen was not practiced widely until the

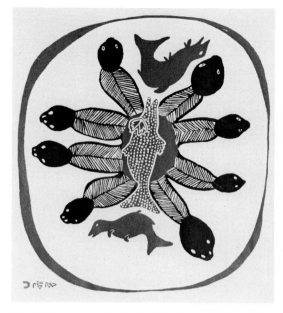

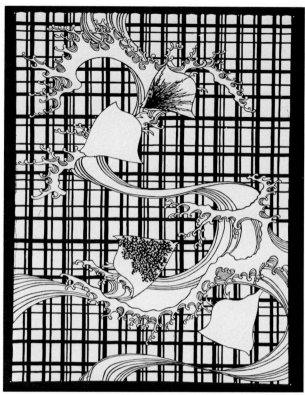

The Eskimos practiced stencil printing before their contact with Western civilization. The practice continues. This is a contemporary Eskimo stencil print.

Japanese, Tokugawa Period (1615—1867). Paper stencil for textile. 21¾″ × 15¾″. *Courtesy: The Metropolitan Museum of Art, Gift of Clarence McK. Lewis*

Stencil print rubbing made from a leather stencil. "T'ai Tsung horse." Chinese, twentieth century. 76¾″ × 50⅜″. *Courtesy: The Metropolitan Museum of Art, Seymour Fund*

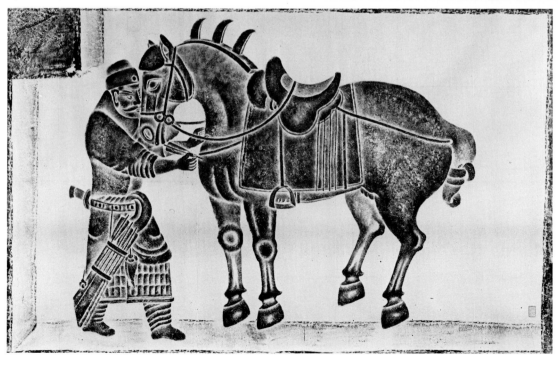

beginning of the twentieth century in England and North America. Even then, it was used essentially as a sign- or poster-making process.

Silkscreen's potential, as a fine art medium, did not emerge until the mid-1930s, when different versions began to pop up in Germany, the United States, England, Holland, and Sweden. Before long, it received a new name, serigraphy.

Serigraphy is a word coined in America by Carl Zigrosser of the Philadelphia Museum of Fine Art to distinguish fine art from commercial silkscreen prints. The National Serigraph Society was founded in 1940, and from that point on, serigraphy was an accepted printmaking medium in the United States—in part as a result of financial stimulation through WPA funding.

It took twenty years more for Europeans to recognize its potential. French artist André Girard tried his hand at silkscreening and helped to disseminate the medium and lend it credibility as a fine art form in Europe. At about that time, Picasso began to use silkscreening—both he and Braque had used stenciled elements earlier in their collages.

Victor Vasarely, one of the early exhibitors of silkscreen prints, participated in the Denise René Gallery Show in France in 1954. Screen printer W. Arcay organized that landmark exhibit and has since been a leading exponent of the medium.

Andy Warhol, Larry Rivers, Robert Indiana, Robert Rauschenberg, and Jasper Johns are among those contemporary artists who regularly employ stenciled or silkscreened elements in their work.

The serigraph has undergone enormous improvement, refinement, and variation in the last forty years. The "silk" of the screen, of course, long since replaced Some Ya Yu Zen's web of thread and is probably going to disappear altogether as a host of synthetic materials with divergent and often superior qualities emerge. Replacing the fine silk gauze are screens of nylon and Tergal, wire (phosphor bronze, stainless steel, nickel) or combinations—nylon-copper, nylon-bronze. New glues and masking materials are also available to block out areas on the screen.

Preparation is still carried out by hand. The design defined by the masking is transferred to the screen. A glue is spread over the surface of the screen—blocking unmasked areas and masking the area not to be printed, and ink is drawn over the screen and forced through it onto the printing surface.

In new variations, films may be attached to the screen with heat or solvents to block ink passage. New polymer inks allow greater flexibility and may be drawn over the screen either by hand, with a squeegee, or with automatic or semiautomatic machinery.

Today silkscreen printing can be used on almost any shape or material. The blade is moved over the screen traditionally, to distribute ink through the screen, but at other times the screen itself may be moved while the blade remains stationary. There are shaped screens, cylindrical machines, vitrifiable transfers for ceramics—the innovation never ceases.

Friedensreich Hundertwasser (Austrian) in his serigraph "Good Morning City, Bleeding Town" (1970), used fifty combinations of color placement and a computerlike method of printing. The edition was ten thousand. Jim Dine has combined several media in one print—lithography, wood block, serigraphy, and direct watercolor.

Because the craft is so complex in many works, whether the artist is Johns, Hundertwasser, Rivers, Oldenburg, Indiana, or Warhol, the process is usually carried out by specialists. In the silkscreen, the gesture or action of making the image is not always so direct or evident as in lithography or etching. Hence, serigraphy lends itself to second-person rendering.

STENCIL RESIST PRINTING JAPANESE STYLE
with Carol Hurst and Shigeko Spear

Stencil knife that cuts much like the X-acto knife.

Another kind of stencil knife that cuts small circles in the stencil paper (shibugami).

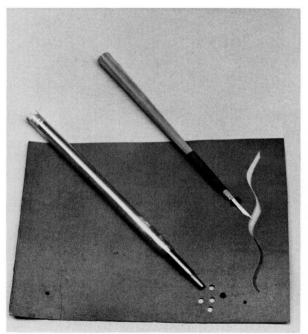

The type of cuts made by each knife.

A Japanese stencil made primarily with small holes.

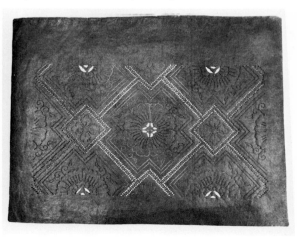

A Japanese stencil cut with a knife and hole cutter.

Japanese paste tubes and spatulas for applying the resist paste.

Japanese brushes for applying the dye.

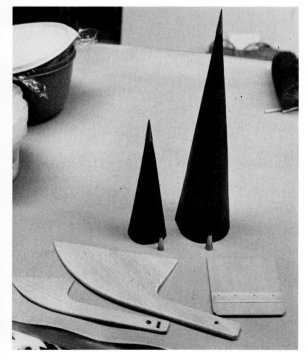

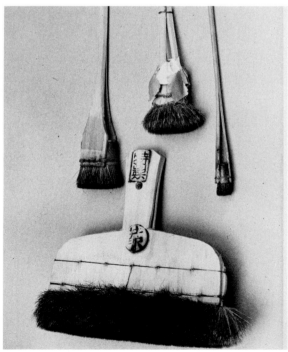

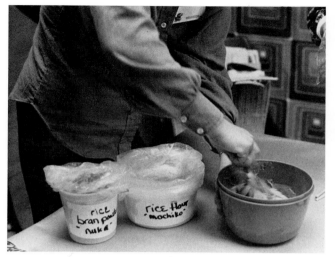

The resist paste is mixed together. For 2½ cups: sift together one cup glutinous rice flour (mochiko) and 1½ cups rice bran powder (nuka) in the ratio of 4 to 6. Mix well. Add about ¾ cup of water. Knead well and shape into two donuts. Wrap well with damp cheesecloth. Place in a steamer and steam for one hour. Remove from steamer and mash in a bowl while still steaming hot. Gradually add 4 to 7 tablespoons salt (the larger amount in dry weather). Beat until paste becomes smooth and sticky. Add about ½ cup water to 2 to 3 tablespoons slaked lime. Dissolve well and let stand for a few minutes to settle. Then gradually pour only the clear liquid off the top of the settled lime into the paste mixture. Continue beating. When the paste changes from a light brown color to a light yellow, it is ready. More water can be added to bring paste to desired consistency.

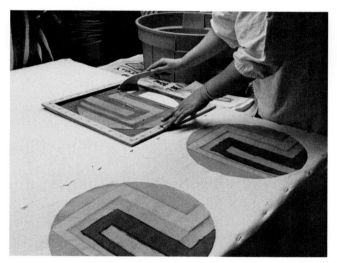

Secure fabric to the table. Soak the shibugami stencil and then remove and blot to remove excess moisture. Apply rice paste to stencil that is framed over stretched nylon gauze in a frame and spread evenly with a spatula.

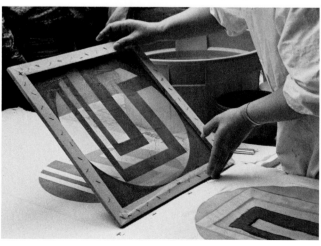

Carefully lift away the stencil. Allow the rice paste to dry and then brush on the dye. Fix the dye. To wash out the paste, soak the fabric for twenty minutes to an hour to loosen glue. The paste should fall away by gently shaking the fabric in water.

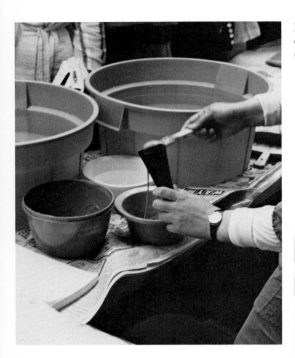

If fine lines are desired for further color/resist application, attach external and internal metal tips securely and half fill the tubes with paste.

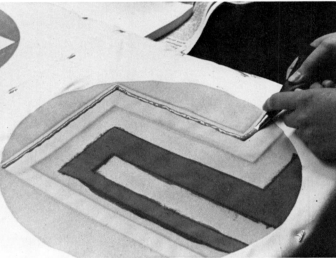

For clean lines, keep the tip clean and moist, touch lightly to the fabric, and squeeze with an even pressure over the fabric. (Resist over the dyed area will maintain that color.)

Two stages of paste application: the first one on the left and the second on the right.

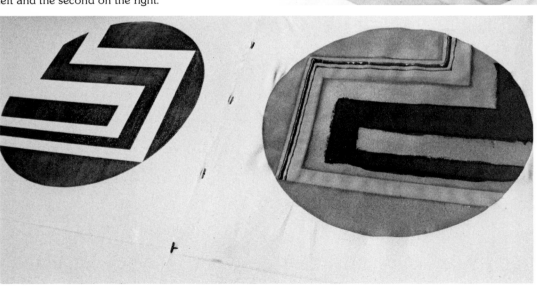

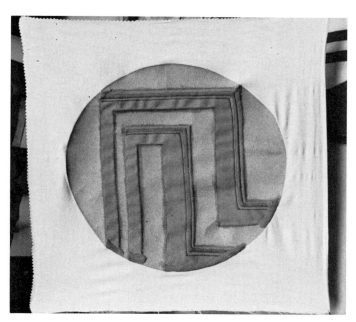

The completed piece.

A contemporary Japanese fabric made with stencil and paste resist (Norizome).

Pablo Picasso, "Pierrot and Harlequin, Seated." Color stencil. 8¼" × 10½". *Courtesy: The Museum of Modern Art, Lillie P. Bliss Collection*

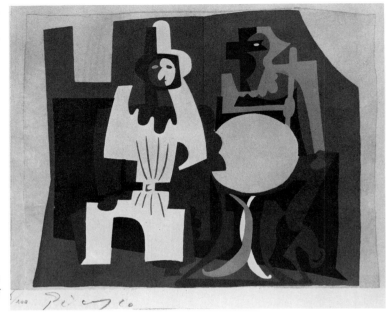

Jackson Pollock, Silkscreen, 1951. 16½" × 22¼". *Courtesy: The Metropolitan Museum of Art, John B. Turner Fund*

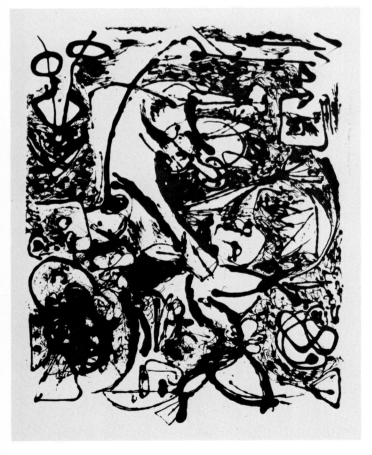

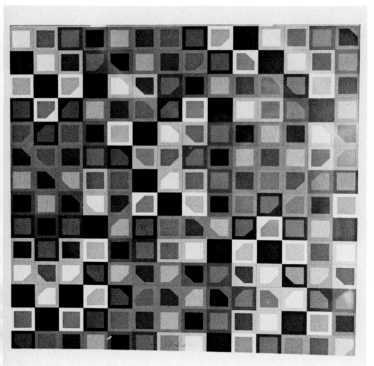

A ten-color silk-screen print by Victor Vasarely.

Josef Albers, "Gray Instrumentation I." Four-color screen print. 19″ × 19″. *Courtesy: Tyler Graphics Ltd.*

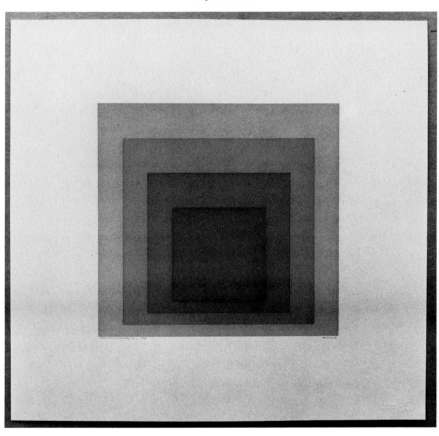

Ben Shahn, "Laissez-faire." Silkscreen print, 1949—50. 16½″ × 8¾″. *Courtesy: The Metropolitan Museum of Art, Gift of Pippin Press*

A paper stencil was used for Marvin Lowe's "Bloomington III." 1970. 72″ × 34″. *Courtesy: Marvin Lowe*

A lacquer stencil was employed for this piece by Marvin Lowe. More than seventy colors were used to achieve "Nautical Number." *Courtesy: Marvin Lowe*

John P. Martineau, "Push-Pull." Screen print. 22″ × 30″. *Courtesy: John P. Martineau*

Richard Hamilton, "Portrait of the Artist by Francis Bacon." Serigraph, 1971. 21⅝″ × 19⅝″. *Courtesy: The Museum of Modern Art, Leo Castelli Funk*

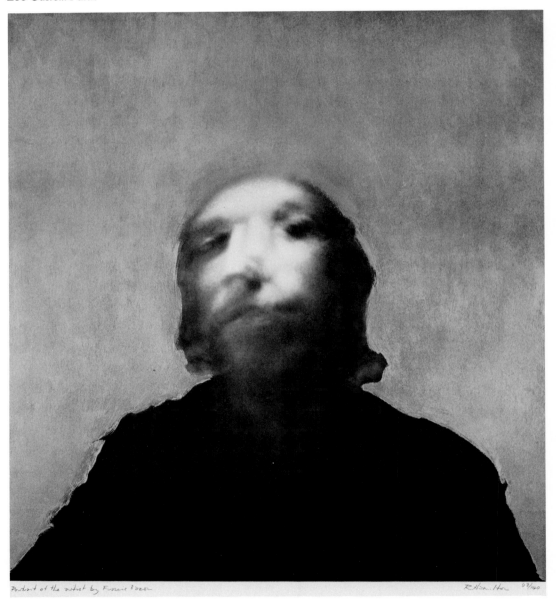

New Views
toward Innovation

Today more prints are being executed in more ways, by more artists, than ever before. Increasingly, artists have turned to printmaking shops following the traditions of Hayter's Atelier 17. They have turned to master printers, skilled and often innovative craftsmen who have achieved no small degree of excellence. Some specialize, as Tatanya Grossman does in lithography. Others practice a wide range of printmaking processes and of necessity invent more.

This is not to say that artists have, in the tradition of stilted nineteenth-century idioms, turned their work over to technicians for aesthetically inferior copies. But as demand has grown and as processes have become more complicated and varied, specialists have naturally stepped in to provide the skill and expertise necessary to tap the rich lode twentieth-century technology has provided.

Typically, artists still participate in the process from creation to exhibition. But the master printer fills an essential function in providing artists with the knowledge and skill to make the transition from concept to form. The relationship has borne unexpected fruits. The demands of artists and the resourcefulness of specialist printmakers have resulted in wide-ranging adaptations of old techniques and invention of entirely new ones. Yet these products, this innovation, have not always met with the warmest recognition from the "official" art world.

One of the more liberal approaches, and creditable, was evidenced by the statement of the Print Council of America in 1961 to the effect that for a print to be an original, the artist must have created the master image. On the other hand, in 1960, the Congress of Plastic Arts of Vienna ruled that an original has to be "signed, serially numbered, and an artist has to make plate, block, or screen." And in 1964 the French National Committee on Engravings ruled out the use of any and all mechanical or photomechanical processes in making an "original."

In any other century those edicts probably would have stultified innovation. Today most artists recognize that the only significant priorities are originality and craftsmanship. There will never be art without absolute dedication to expression and innovation in aesthetics. Just as, assuredly, there is no falseness or betrayal in embracing the range offered that expressive urge by new materials and techniques—and contemporary craftsmen specially skilled in rendering those inspirations concrete. After all, printmaking has never been a static craft. Its media have been evolving constantly.

The touchstone, as ever, must be one's perception of the artist's work in itself because it is only the work and not the mystery or mechanics of a process that should concern us.

According to Ken Tyler, an initiator of Gemini G.E.L. in Los Angeles, California, and of late the principal in Tyler Graphics, Inc., New Bedford, New York, craftsmen "who learn to adopt technology and develop hybrids will succeed, while craftsmen steeped in archaic traditions, with both feet in the past, will 'die.'"

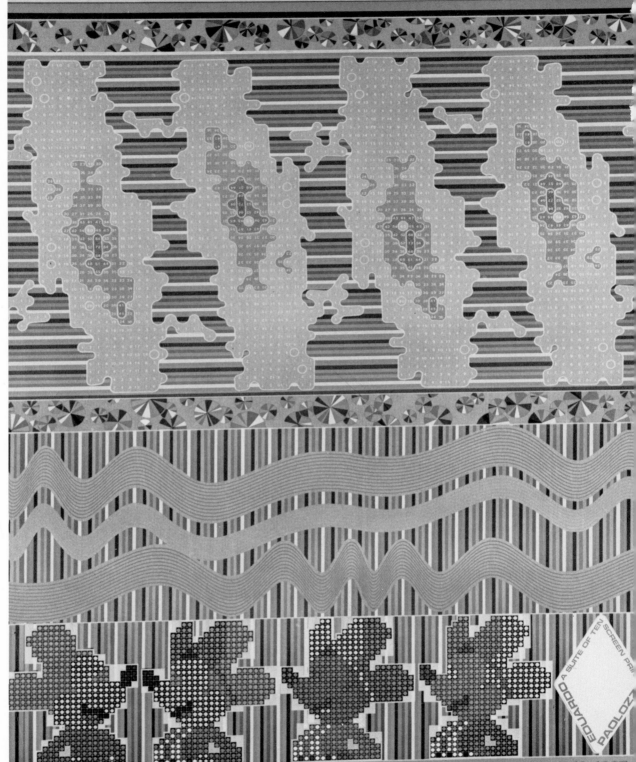

UNIVERSAL ELECTRONIC VACUUM 1967

EDUARDO PAOLOZZI · NEW SCULPTURE AT THE PACE GALLERY · NOV. 18 - DEC. 16, 1967

A SUITE OF TEN SCREEN PRI

EDUARDO PAOLOZZI

A Brief Look at the Techniques and Influence of Commercial Printmaking

The development of high-speed printing techniques and photography caused a schism between fine art and commercial printmaking. Perhaps artists viewed machine-oriented techniques as inferior or threatening, but, whatever the reason, the development of commercial and fine art printmaking followed largely separate courses for most of this century. Only within the last twenty years has there been cross-fertilization and convergence of these two realms.

Photography, for example, has but recently received long-justified recognition as a fine art form, and today photographic techniques are heavily relied on in many areas of printmaking. Photo-silkscreen and photolithography, both originally viewed askance, now occupy central positions in the printmaker's battery of techniques. No less have the commercial printmaker's methods—offset, photo-offset, spirit duplicating, collotype, electrostatic screen printing, letterset, rotogravure, and typesetting—found increasing application in the hands of innovative artists and printmakers.

Offset

One of the processes that suffered most from the pressures of early twentieth-century prejudices was offset. The aspect of an automatic rubber roller or rubber blanket lifting an inked image from a plate and transferring it to paper has inhibited the adoption of the offset process to this day. Though Jim Dine didn't see it that way and is among the contemporary artists who have utilized offset, few others have ventured into this realm. Most aspects remain the province of commercial printmaking (although they are routinely used for registering plates in multicolor printing).

Commercially, offset consists of lithography, duplicator offset, photo-offset, spirit duplicating, and collotype—planographic processes involving printing from a flat or level surface.

A rotary press is used in offset printing. The designs of presses vary considerably. A common denominator among them is that they all contain rotary cylinders—the master cylinder that holds the plate, a rubber blanket cylinder to which the ink image is transferred from the master cylinder, and the impression cylinder that serves as a cushion in conjunction with the blanket cylinder so that the image can be impressed on stock. The paper stock may be sheet fed or fed from a roll called a web. (Speeds on these machines range from twenty-five hundred to ten thousand impressions per hour.)

With each rotation of the plate cylinder, an aqueous solution and greasy ink are transferred to the image. The positive image on the plate repels the aqueous solution and accepts the ink, while the nonimage accepts the water and rejects the ink. The sequence of lithography is from plate to blanket to stock. The ink is not printed directly on the plate but through an intermediary, the rubber blanket cylinder.

53

Offset Duplicator

In the offset duplicator approach, the image may be applied to the plate directly, with grease pencil, graphite, ballpoint pen, rubber stamps, an ink pen, brush, or crayon—or indirectly through photo processes.

Photo-offset

Photo-offset printing is based on the same principle as lithography—that grease (the ink) and water do not mix. The plate may be of either paper or metal—aluminum, magnesium, stainless steel—or another material. It curves around the cylinder of the press. One side is grained to hold moisture. The other side, if photo-offset, is coated with a light-sensitive solution. The coated (sensitized) flexible metal printing plate is exposed to arc lights through a negative (held in place by vacuum), and then the image is developed. The emulsion on the part of the plate that has received the image hardens and resists the action of the developer, thus disclosing an image on the plate. A latent image is formed in areas where light has penetrated.

Spirit Duplicating

Spirit duplicating (sometimes called ditto) is based on the same principles as offset printing. The image is created on the back of a flexible master in aniline dye. This dye transfer is usually accomplished by pressure: typing or drawing. The master is attached to a rotating cylinder, and as the master (with dye image on it) rotates on the drum (by motor or hand power), spirit vapors activate the dye image. With each revolution, the full surface of the master (now wrapped around the rotating drum) meets the surface of a compatible size of printing stock (usually paper), and the aniline dye image is transferred upon contact.

Photogelatin Process—the Collotype

The photogelatin process is similar to lithography inasmuch as they share the principle that grease and water don't mix. The image area on a gelatin plate accepts ink but repels water, and, conversely, the nonimage area accepts water and repels ink.

The basic plate is glass onto which a bichromated gelatin solution is floated. When dry, the coated glass is exposed to light through a continuous tone negative (common negative). Light passing through the negative hardens the gelatin in proportion to the amount of light that hits it. The more light that touches the gelatin, the deeper the tone. In printing, tones reject water and accept ink in a range of values. Areas receiving light lose their hydrophilic properties. Collotype printing is related to lithography and is also similar to rotogravure, inasmuch as the film of ink deposited is not uniform but is in proportion to the tones in the original. This is the only photo-printing reproduction process without a screen that produces faithful copies.

Screen Process Printing

Commercial screen printing is much the same process as fine art serigraphy. A silk, nylon, or metal screen contains the image in the form of masked areas that do not permit ink to pass through and reach the surface to be printed. As a squeegee forces the ink through the screen, the image, defined by masked areas, is transferred onto paper (or other material) positioned below the screen. The screen is first sensitized by coating or covering it with a light-sensitive emulsion or film. Then photographic film positive is placed on the coated screen. Exposure to light hardens the emulsion in proportion to the amount of light that passes through the positive image. The hardened areas become insoluble to water, while the image area of the emulsion remains soluble. The soluble areas are washed away and a negative image is left on the screen. Highly viscous ink may then be drawn over the screen and deposited onto the paper, fabric, or other material being printed.

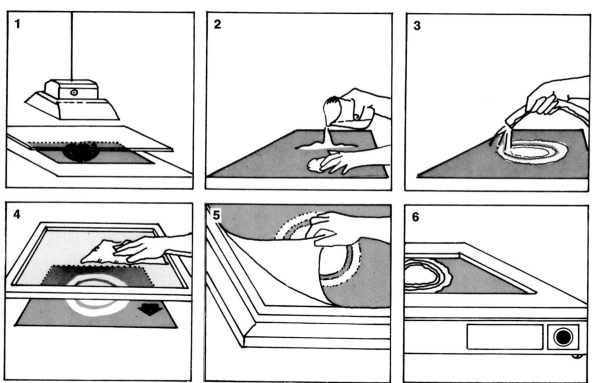

PHOTO-SILKSCREEN PRINTING VIA VACUUM AND ATMOSPHERIC PRESSURE

1. To make a photo stencil, place the stencil film emulsion-side down with original opposite the way it is supposed to look, on top of the film. On top of these, place a ¼-inch-thick glass. Expose with ultraviolet sunlamp.
2. Mix developer per instructions and develop the photo stencil in subdued light for ninety seconds.
3. Wash photo stencil with warm water until image becomes clear and free of emulsion.
4. Bring the underside of the screen in contact with the emulsion and blot into the mesh.
5. After an hour or two, remove the film backing to reveal photo image adhered to the mesh.
6. Use commercial blockout and thoroughly fill in marginal border areas and pinholes. When it is dry, apply colors and print.

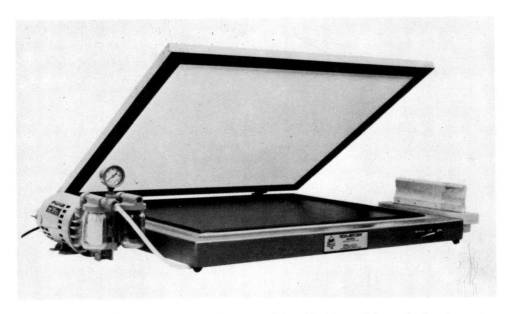

This New-Artform Printer can screen-print a complete subject in a rainbow of colors in one impression.

Thixotropic ink, in a creamy consistency, is placed on the screen. The ink can even be left on the screen for days at a time and still be used.

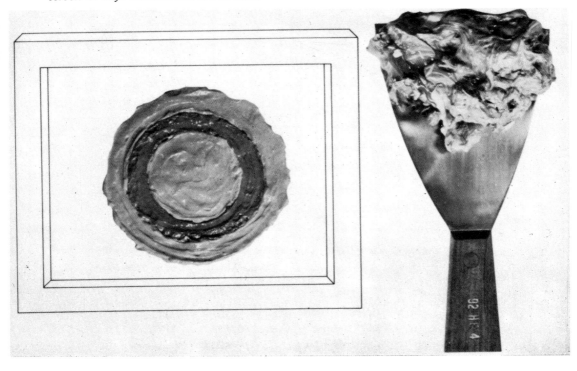

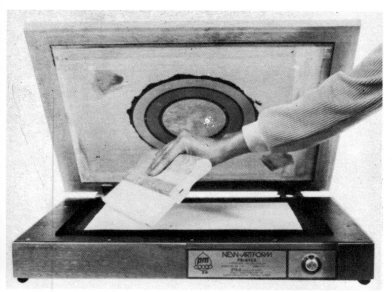

After turning on the vacuum pump, load the felt applicator with moistening solution (T-125) and apply to paper. This is optional; it serves as a release agent for the inks. Then position paper against guides.

Bring down hinged screen to bed of printer, holding it down to achieve good contact and depress button for two to three seconds.

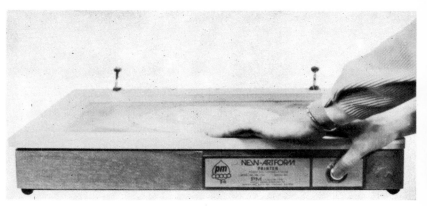

Snap up screen after printing.

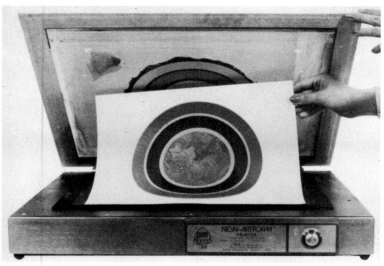

Dean Meeker, "Mardi Gras—To Bestow or Withhold." One screen (New Artform printing) with intaglio. *Series Courtesy: PM Color Inc., wholly owned subsidiary of Poster Products, Inc., Chicago, Ill.*

Electrostatic Screen Printing

Electronography, or pressureless printing, employs a thin, flexible printing element, the stencil, containing fine openings that correspond to the positive image to be printed. Electroscopic, or non-ink,particles —the toner—are metered through the stencil and are attracted to the printing surface by an electric charge. Or the screen can be positively charged and light projected through it onto paper that has been coated with a thin layer of zinc oxide. The particles are held in place by an electrostatic charge until heat fixes them or until the coated paper has been placed in a chemical bath containing pigmented particles where the image is fixed permanently. The plate containing the image does not come in contact with the stock, hence the name pressureless printing. Maps are printed this way, in five colors, at the rate of up to two thousand copies per hour.

Letterset Printing, or Dry Offset

Letterset is like (lithographic) offset printing except that a liquid solution is not used. Like offset, a blanket cylinder transfers the ink image from the plate to the paper. But this is not a planographic process. A typeform (not a flat surface but made up of units in relief and combined) is used as a plate and it appears as a positive transferring to the blanket in reverse and then as a positive onto the stock.

These plates can be of metal or a plastic wraparound type.

INKLESS INTAGLIO COMBINED WITH INKED ELEMENTS
with Roslyn Rose

Outlines of areas to be cut are traced on tracing paper.

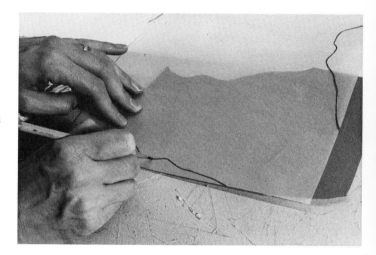

The outline is traced on vinyl printing plate and cut along contours with a utility knife. (This is used as additional elements on an etched plate to improve an area.)

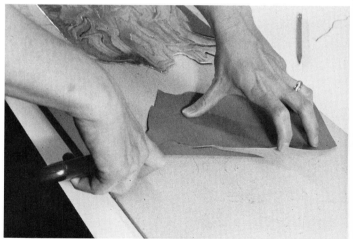

The protective backing of the vinyl plate is peeled away . . .

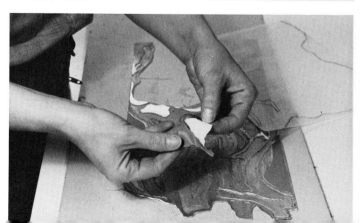

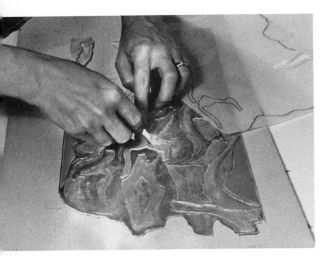

. . . and the piece is pressed down (with its self-sticking backing) into place, combined with the etched zinc plate.

Meanwhile, with a square of hard cardboard, intaglio ink is forced into the crevices of an aquatint plate with a circular motion. (The unit is to be combined with the inkless intaglio.)

Excess ink is removed with tarlatan and finally wiped off with old yellow page telephone directory paper.

The edge is wiped clean with sub-turpentine.

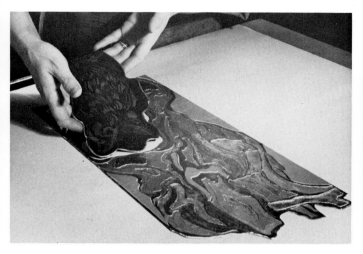

And the unit is combined with the vinyl and zinc plate.

The parts are assembled on the bed of an etching press. Meanwhile, German etching paper has been soaking in tepid water for two to ten minutes and then has been blotted dry between blotters.

The inked and uninked areas are run through the press four times, back and forth. (The press was set to accept the thickness of the plate and padding.) Blankets and blotters are lifted off and the print is placed on a flat surface to dry.

Roslyn Rose, "Three's." Inkless intaglio combined with line etching and aquatint, 1976. 18″ × 24″.

Roslyn Rose, "Butterflies Are . . .". Two plates in inkless intaglio with Speedball flexible printing plate, 1976. 24″ × 11″.

Intaglio Printing, Gravure, Photogravure, Rotogravure

The intaglio is the opposite of a relief plate—the image is formed by incised cuts into a plate as in the etching process rather than in relief. Another word for intaglio is gravure. Photogravure uses photography and rotogravure employs rotary cylinders.

Generally, an engraved plate is employed in conjunction with a screen to break areas to be inked into dots. Ink floods the plate and flows into the incised cavities or depressed areas. The surface of the plate is wiped clean with a doctor blade, leaving ink in the depressed areas. When paper is placed over the plate, the ink is drawn out onto the paper. The surface of the plate is kept free of ink by constant wiping.

Gravure is characterized by the quality of printing—the density of the print depends upon the amount of ink contained in the depressions or cells. If all the cuts are of different depths, then the ink (which is more fluid than in letterpress or silkscreen) will be transferred accordingly.

In rotogravure, the press contains a cylinder bearing the image to be printed and an impression cylinder. The paper moves between them either in sheets or from a roll.

In photogravure, carbon tissue (in sheets or rolls), coated with a layer of gelatin, is sensitized to light by being plunged into a solution of potassium bichromate. The carbon tissue is exposed to light through a glass plate bearing a screen (on an opaque ground) and then exposed another time to the positive image. During each of these exposures, the gelatin is hardened by the light—completely in white or screened areas and partially in halftones corresponding to the images.

The exposed carbon tissue is applied to the copper surface of the plate or cylinder (rotogravure). The tissue part is peeled away, leaving the gelatin attached to the metal. The cylinder (or plate) is plunged into warm water to wash away unhardened gelatin (to the degree that it had hardened when exposed to light).

Then the exposed metal (either solid copper or a plating of copper) is etched with ferric chloride, an acid that attacks the metal in areas not protected by gelatin. The bite of acid depends upon how much gelatin is left on the plate, resulting in various degrees of penetration. After etching, the printing surface is protected by chromium plating.

Many variations of this process exist— different kinds of carbon tissue (or silver emulsions on plastic), photosensitizing by optical means, and electronic engraving— to name a few.

Typesetting

Typesetting has long been a large part of printing. In recent years the process has been revolutionized by the introduction of computerized photo-based systems that can automatically and instantly justify, reduce, enlarge, and change type styles.

The craft has come a long way from the first wooden, hand-carved blocks and the earliest attempt to create movable cast type. The most recent generation of photo typesetters are electronic, computerized marvels, already on the way to widespread use. Camera-ready images can be created faster, cheaper, and sharper than ever before.

Along with this revolution in typesetting has come electronic reproduction of images. These commercial reproduction techniques will soon have no human interface, as automated processes come close to creating an exact facsimile of any image, something that traditional printmaking cannot do.

Helmmo Kindermann, *"Baby Ice Cream Sneakers." 1974. 8″ × 10″*. A series of three images in silver print and acrylic paint. Each image begins with an antique photographic portrait dating to the late 1800s and early 1900s. They are mounted using collage and graphic techniques, such as sensitized canvas and nonphotographic images. Once the photo-collage is complete, the piece is rephotographed and it becomes a photographic print. *Courtesy: Helmmo Kindermann*

A Renaissance

Photography

Photography had a natural affinity for commercial printing processes. And it was quickly wedded to silkscreen, etching, and litographic processes. Photographic images could be produced quickly and didn't necessarily require the deep creative involvement of an artist. Rather than expressing a personal idiom, photographs had the commercial edge of speed and low cost (as prime economic contingencies).

Of course, those very commercial advantages aroused the ire and suspicion of contemporary artists. Many questioned whether any process, any medium, so dependent upon mechanics and chemistry could be viewed as an art form. Such extreme precision and speed belied the notion of art. The infernal machine and complex chemical reactions promised, for the first time, to come between the human eye and hand and the re-creation of the eye-image. Part of that response, no doubt, resulted from an apparent threat: if the new machines could do what artists did, what were artists to do?

Those prejudices lingered,* and photography was shunned for many years as "foe-to-graphic" art. Yet, eventually, photographers proved that as with any medium, perception and not either chemistry or mechanics was the essence of the art.

The road to legitimacy was not an easy one. Because the medium was viewed as mechanical, relatively few creative minds experimented with it. The result was a form that remained stilted for at least a hundred years. Yet the experimenters had an increasing impact. Photography progressed along its experimental route just as printmaking was doing, and parts of it had to rub off.

Eadweard Muybridge set to work to solve a dispute of a group of Californians. "Did a galloping horse ever lift all four feet off the ground at the same time?" Finding out was no simple task for the English photographer. The wet plate process of the day was almost two hundred and fifty times slower than modern camera processes. No one had ever successfully photographed motion, let alone taken a series of photographs in rapid sequence.

Starting in 1872, Eadweard Muybridge spent five years experimenting with various methods but eventually was able to photograph the moment when a running horse was literally suspended in the air. It took more than thirty thousand dollars and twelve cameras triggered by threads stretched across a racetrack for this achievement. But it revolutionized man's concept of motion. (It also inspired Muybridge to invent a revolving disk that allowed people to see photographs "moving" on a screen. This remarkable machine inspired Thomas Edison to invent film and the "motion picture.")

*Even printmaking techniques that utilized photo-processing concepts, such as *cliché-verre,* never got off the ground. A *cliché-verre* is a print made by scratching a drawing into a layer of asphaltum on glass or painting an image on film or glass, then using this as a negative and printing it by standard photo processes. Although no examples are left, the first *cliché-verre* was said to have been made by William Havell in England about 1835, and it was reinvented in 1841 by three French photographers. Some painters of the Barbizon group, particularly Corot, used *cliché-verre.*

Both Muybridge and Thomas Eakins tracked the motion in fireworks, and Taylor and Gilbreth pursued their industrial motion studies. Those explorations influenced the futurists (c. 1912) and restimulated scientific investigations, resulting in stroboscopic photo diagrams developed by Harold Edgerton (M.I.T.) The cubists were influenced as well.

Photomontages, superimposed photographs, and stroboscopic exposures led to new insights and reproduction skills all around. In the work of the photojournalists, a new, unself-conscious, photographic form emerged. Moholy-Nagy and Man Ray spawned a new generation of photo-artists—artists who were willing to apply the technics of photography, even if they did not use "photographs" as they were used commercially.

It gradually became apparent that photography was much more than the exact rendering of events, and that it was a means of exploring perceptions that existed in fact but that may have been impossible for the normal, naked human eye to see. Photographic vision burst forth with an array of expression that went beyond reportage, the exact rendering of events.

There is rapid seeing: fixing of motion, stroboscopic photography, superimposed images; slow seeing: timed exposures; intense seeing: micro- and macro-vision; selective seeing: the use of special filters and film such as infrared, and a variety of lenses; penetrative seeing: X rays and radiography; simultaneous seeing: superimposition of images and multiple exposures; distorted seeing: through prisms and mirrors; manipulated seeing: in the use of chemical and mechanical devices to take and process photos, such as photographing through oil, reticulation, solarization.

There is also the "camera-less" photograph: the photomontage, where photo elements are processed, cut apart, and reassembled; and the photogram, where light is tracked on photosensitive paper or film, often through or around an object that has been placed on the paper. (Fox Talbot, in 1835, made the first photogram by laying lace on paper that had been treated with photosensitive emulsion.) In the 1920s Man Ray and László Moholy-Nagy independently reinvented the photogram.

Just as printmakers took advantage of their mistakes, so did photographers. They learned that light striking an undeveloped negative causes solarization; excessive heat from an enlarging lamp can burn the film too; hot water causes the film emulsion to reticulate or, conversely, freezing will cause the emulsion to shrink. They stumbled upon chemical and mechanical reactions such as crystallization of the hypo and fingerprints—all of which expanded the technical potential of the medium.

The accident—in both printmaking and photography—may result in a unique piece, a monoprint. As Gabor Peterdi expressed it: ". . . even if one image only could be pulled, it is still a print and valid. . . ."

As photography grew away from the self-conscious quest for the photogenic, recording objects, situations, and persons, its subject matter as an art form burgeoned. Modulation of shape, texture, and pattern, tracking light around the opaque and through the transparent, reflecting and mirroring surfaces, penetrating to skeletal structures, and so on expanded photography's expressive potential. Now photography is ready to come back to object, person, and situation with a new insight, a new sense of realism, with less concern for the sensational and the different and with less self-consciousness. Finally established as a bona fide art, photography is bringing new dimensions to printmaking.

Photo-Silkscreen

It wasn't long after William Henry Fox Talbot patented his method (October 29, 1852)* for making a photographic etching on a steel plate that the photo-silkscreen was discovered. Talbot recognized that when a solution of potassium bichromate and gelatin are mixed together, the resulting material becomes sensitive to light, and areas that are exposed to light become insoluble to water, while those which are not exposed remain soluble.

From this concept, the basic processes emerged, and it has evolved, over a century, to a high degree of refinement. The photographic silkscreen has brought the realm of painting closer to printmaking with the precision of silkscreen. Fine line drawing and halftone drawing can be reproduced with greater accuracy using the photo stencil.

Eduardo Paolozzi, who had experience with commercial photo-silkscreen, turned the technology to his advantage as a human and very personal vehicle. Robert Rauschenberg and Andy Warhol utilize the photo stencil—as have Roy Lichtenstein, Tom Wesselmann, R. B. Kitaj, James Rosenquist, Larry Rivers, and many others.

There are two basic methods used to create a photographic stencil—one is the direct method, the other is the transfer method. In the former the "silk" screen itself is coated with a light-sensitive gelatin/bichromate mixture; in the latter, a film of gelatin is sensitized, exposed, and developed away from the screen and then transferred to the mesh at the end of the procedure (before the printing process).

The next to the last of thirteen stencils for Earl D. Klein's "Pisces II." The last run is for dark accents.

*It was in 1852 that the officers of the Royal Society in London intervened because Talbot took out patents on each of his inventions. They felt that these patents unnecessarily restricted the dissemination of his inventions. But Talbot insisted that some of his processes not be used for commercial purposes. The calotype, for one, became an art or amateur form, rather than becoming commercial for another decade.

Earl D. Klein, "Pisces II."

Opposite page: John P. Martineau, "Hands Up." Screen print in twelve colors. 22″ × 30″. Water-soluble hand-cut stencils were used except for the four doll images in which Martineau employed photo stencils. They were halftone conversions of 35-millimeter Tri-X Pan continuous-tone negatives taken by the artist. Rives BFK paper was used. *Courtesy: John P. Martineau*

Earl Klein uses all kinds of textures tacked to the screen, such as cheesecloth, paper towels, and so on, to create textured effects. He also draws on acetate and then makes a photo stencil. This is "Textile Sumi." 12″ × 18″.

The Direct Method

Both methods create strong and durable screens when applied on synthetic fabrics and stainless steel, but silk is no longer used much because of the difficulty of removing the image and reusing the expensive screen.

Once the screen has been cleaned and rinsed, it can be sensitized. A homemade sensitizing solution can be made by dissolving 28 grams of gelatin in 280 grams of boiling distilled water. 2.8 grams of potassium bichromate is dissolved in 170 grams of hot distilled water. The two solutions are combined now and the mixture is stirred and filtered through cotton mesh. (Distilled water can be used to make the mixture thinner.) While hot, the mixture is applied (the glue hardens as it cools) with squeegee or brush or by dipping or spraying. Coats are applied to both sides of the screen until no pinholes of light can be seen through the mesh. (Work is done under a safety light.) The coated screen must be used within the same day.

Other emulsions have a longer shelf life, and if they are used, coated screens can be stored for several weeks. The Azocol products manufactured by Colonial of East Rutherford, New Jersey, is one; Rockland Colloid Corporation of 599 River Road, Piedmont, New York 10968 and Eastman Kodak of Rochester, New York, manufacture others.

Exposure of the sensitized screen is best accomplished through a a vacuum frame, but a sheet of glass on top of the film and film positive may also be employed. There is no set time for exposure because there are many variables—thickness of emulsion and density of film positive, number of photofloods and distance of the lamp from the screen. Tests have to be made. Time can vary from three to eighteen minutes.

The screens should be protected from any light (but darkroom light) until unexposed gelatin has been washed out from both sides with warm water, followed by a quick cold-water rinse. The clean screen is left in a horizontal position until dry. The screen is checked again for pinholes, and any unwanted specks are blocked out.

Janet B. Mackaig, "936 Geraghty Ave." Photo-silkscreen background, brown in color with stuffed photographic inserts, 1975. 15″ × 20″. *Courtesy: Janet B. Mackaig*

Janet B. Mackaig, "3800 E. Hamel St.," Photo-silkscreen background on Arches paper. Direct photo emulsion graffiti on postcard-commercial envelope collaged in place, 1975. 15″ × 22″. *Courtesy: Janet B. Mackaig*

PHOTO PROCESSES IN SILKSCREEN WITH PHOTOMANIPULATION AND IMAGE TRANSFER
by John D. Whitesell

Photomanipulation is use of enlargement and reduction processes with negatives or positives. Image transfer is transferring intricate solid line drawings to Kodaliths, which are then transferred to the screen stencil.

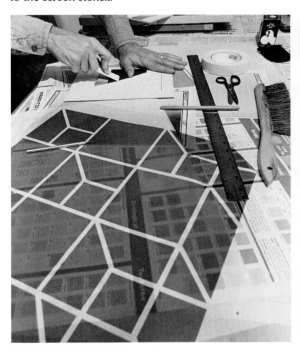

The primary drawings are created in a universal 8″ × 10″ format on four-ply illustration board. The dot patterns and tints are taken from commercial layout materials such as Letraset and Zip-tone. These have transparent acetatelike matrix with a wax back that is made to adhere with a nylon barren.

The 8″ × 10″ layout drawings are photographed in the process camera and transferred to orthographic film negatives and contact-printed film positives. The drawing is placed on the copy board of process or copy camera.

The film is placed in the vacuum back of the camera and the "picture" is taken.

Here the film is removed from the stabilization proc-
essor. Before such a convenience was available,
Whitesell used an ordinary darkroom enlarger. He
simply shot the patterns on 35 millimeter and en-
larged on Kodak Fine Grained Positive film or
Kodalith. Each 8″ × 10″ image was then on film in
negative and positive. The format size is not en-
larged, but remains 8″ × 10″ on the film.

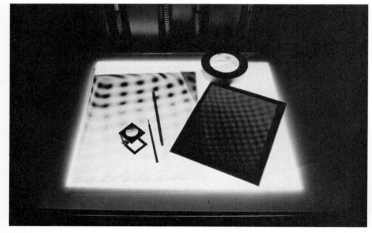

A secondary drawing is finalized on a light table. And a plan for the print-
ing order and the enlargement size is worked out. The films are trimmed
now to ensure correct alignment and to hold the moiré patterns in regis-
tration. At this point, the final images are contact printed onto photo
paper in t e negative. The result is a paper negative. On large-scale im-
ages, the paper negatives are taken to commercial firms that specialize
in copy camerawork or blueprints and have them enlarged on film to
final size. The last films are positives, and since the source originally was
a negative, it requires only one shot to enlarge. This saves money and
helps make for a foolproof procedure. (The enlargement is ordered in
percentage of original copy, i.e., 100 percent is one to one, 200 percent
is double, etc. The cost is usually calculated per square foot of final film
positive.)

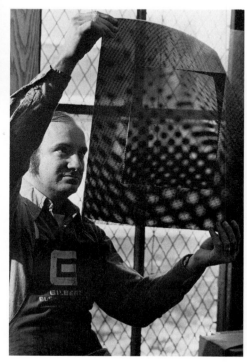

The film positives are checked for registration and quality. If small im-
perfections are found in emulsion, they can be corrected with India ink
or scratched out with a sharp stylus.

For smaller prints, transfer to Ulano's Blue Poly photo film in the platemaker. The Ulano Blue Poly is exposed through the transparent back with the photo film emulsion-side down. The usual exposure is four minutes. This can also be accomplished in a simple contact frame and exposed to sunlight or photofloods. After exposure, the Blue Poly is developed in A and B developer, provided by Ulano, for not less than ninety seconds. This developer is probably Hydrogen Peroxide solution.

The stencil is washed out in lukewarm water in the sink.

The stencil is made to adhere to the silk, gel-side up, while resting on a flat surface.

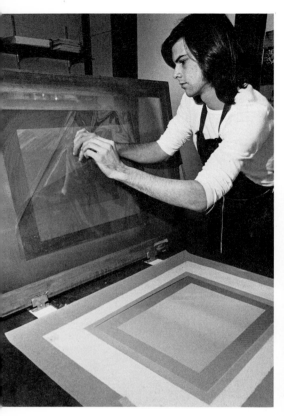

When the gel has dried on the screen, the transparent Mylar backing is pulled away from the Blue Poly and the screen is ready to use. A very large screen requires direct emulsion photo stencils that are made for Whitesell at a local billboard printing company.

The basic image is now in the form of a photo stencil. Paper stencils are used along with the photo stencil to block out edges and to create smaller shapes within the print.
Tracing paper is attached to the screen over the Blue Poly to protect border areas.

Below: Paper is held in register with the use of copyboard pins. Paper is selected maintaining an ample border where ¼-inch reinforced holes are punched. (These borders are trimmed when the print is completed.) The register pins are attached to the tabletop with masking tape. Note the screen guide on the left that aids in screen registration.

The screen had been attached to the table with simple hinge clamps that had been countersunk into the Masonite tabletop. They provide secure screen anchors.

Adjustable screen guides keep the screen from moving.

Normal screen printing procedure follows. Ink is pulled across the screen in a split fountain (two-color blend) approach. Two squeegees are used—one for each direction. (This type of blending takes practice.)

After each run is made, the silk-screened print is hung to dry.

The final large format silkscreen print by John D. Whitesell, called "Lorelei."

John D. Whitesell, "Equinox."

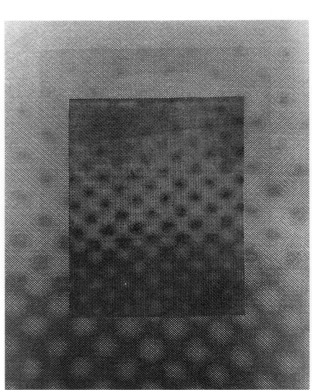

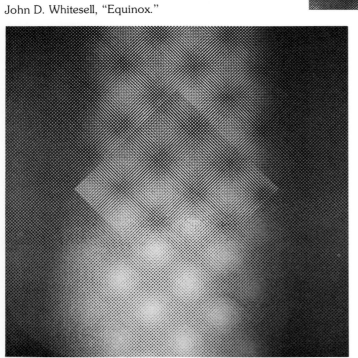

Series Courtesy: John D. Whitesell.
Photos by Carl Maupin

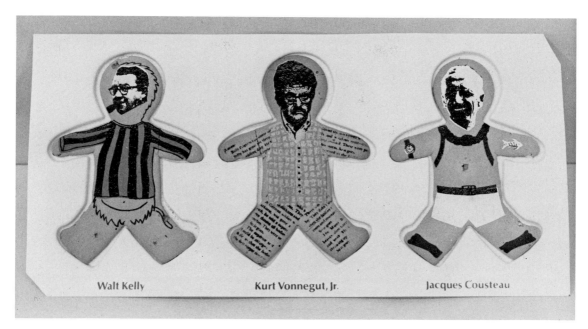

Walt Kelly Kurt Vonnegut, Jr. Jacques Cousteau

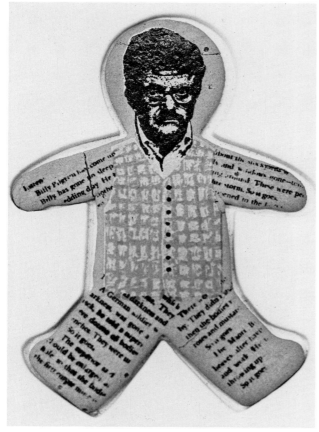

John Risseeuw made edible gingerbread man cookies, "glazed" with a print made by screen-printing photographic faces and other images in seven edible colors. These edible prints were then placed in a vacuum-formed 9" × 13" Plastic tray. The nine different edible people prints in this series were packaged in a handmade box. The edition was twenty. *Courtesy: John Risseeuw*

Detail of "Kurt Vonnegut" in edible form by John Risseeuw. *Courtesy: John Risseeuw*

Pat Tavenner, "Fabricated City." Photo-silkscreen on fabric and sewn together, 1969. 20″ × 31″. *Courtesy and copyright by Pat Tavenner*

John Risseeuw, "Warbride." Photo-silkscreen glaze on ceramic plaque. *Courtesy: John Risseeuw*

John Risseeuw, ceramic plaque with a photo-silkscreen glaze that was later fired. *Courtesy: John Risseeuw*

The Indirect Method

Various very thin photographic gelatins (which are presensitized screen process films) are exposed by contact printing with ultraviolet rays (sunlamp or sun), through high-contrast film positives or drawings made with India ink or other opaque pigments, on acetate, Mylar, or some translucent papers. When ultraviolet light passes through clear areas of the film positive, the emulsion hardens—the other areas do not. Development is done with the manufacturer's specific developer. Then the exposed film is developed under subdued darkroom light.

In the development process, nonexposed areas are softened. At the end of the development time (usually two to three minutes), the film is placed emulsion-side up on a smooth tray or glass and washed out in warm tap water (92° F. to 100° F.) in a gentle spray. Nonhardened areas of film wash away in a few minutes. The washout is completed with a short cold water rinse that sets the emulsion.

While the film is still wet and in a soft state, the screen frame is positioned over the film so that the mesh rests on the film. Excess water is gently blotted away with absorbent paper. And the attached film is allowed to dry near a fan but away from direct heat. It could take an hour or a day. After the film dries, the plastic support sheet or backing is carefully peeled away and discarded. Removing the backing prematurely will separate film from mesh or damage the screen. Any pinholes are blocked out before printing in usual procedures for serigraphy.

Photoetching for Intaglio

As in photo-silkscreen, one can sensitize the plate or buy presensitized copper or zinc plates from a photoengravers' supply house. The latter is probably more uniform in quality. The process is the same in concept and practice as in photo-silkscreen. Soft (unexposed) areas of emulsion are washed away by developer, leaving these areas open for acid etching while hardened emulsion protects the rest of the plate.

PROCEDURES FOR PHOTOETCHING USING KODAK ORTHO RESIST

by Randy Sprout

Gather together the following materials: Resin-safe breathing mask, Kodak Ortho Resist, Kodak Ortho Resist Thinner, Kodak Ortho Resist Developer, Kodak Ortho Resist Dye, copper or zinc plates, a bulb-type sunlamp, plate of heavy glass, nitric acid mixed 1:6 of zinc, ferric chloride, 42 Baume for copper, metal tray for developer, Sears Paint and Varnish Remover, plastic tray for acid, rosin bag (several layers of nylon stocking filled with rosin), Badger airbrush (least expensive), Surall brush, varnish or Universal blockout, halftone positive film image or very grainy positive film image. Good etching paper such as BFK, Murillo, Arches, Copper Plate, and so on and good etching inks, plate oil (burned), Brasso, denatured alcohol, chassis black aerosol paint can, yellow bug light, hair dryer.

Preparing the Plate

Many types of sheet copper come with a protective tape on both sides. This must be peeled off both sides and Brasso used to remove any sticky residue. (Do not coat the plate as is normal with etching.)

If zinc is used, plates should be scraped

and burnished free of any burrs or scratches and then flooded with denatured alcohol to remove all grease. Blow dry with compressed air and keep greasy fingers off the plate—it causes poor adhesion of the resist later on.

Sensitizing the Plate

The resist is sensitive only to ultraviolet light so a yellow bug light (60 watts) is used as a safe light. Fluorescent lights high in ultraviolet will expose the resist, so will daylight.

The resist is mixed half-and-half with the thinner for either airbrush application or direct application. Use only glass or metal containers because both the resist and the thinner will dissolve plastics.

A Badger airbrushing unit is economical and deposits an even layer of resist on the plate. A gradual buildup of fine mist is superior to one thick layer. Never let runs occur because the edge of a run will harden into an unequal thickness of the resist.

To spray, incline the plate about 30° F. and spray or apply the sensitizer with a fine 4-inch bristle brush, brushing the sensitizer smoothly across the plate, working from the top down. This incline will tend to eliminate any brushstrokes. Do not go over the plate again until it is dry; then, only if bare spots exist, apply a full coat of the sensitizer.

The resist and thinner can be mixed half-and-half and stored that way with no appreciable change for over six months. It can be stored in an airtight container.

Drying the resist on the plate is best accomplished with a hair dryer while the plate is kept in a horizontal position.

Caution—a protective breathing mask of commercial quality should be used at all times while spraying or painting the plates, drying, and later during development. The resist is a plastic and care should be taken. Once the resist hardens and dries, it is very difficult to remove, particularly inside one's lungs. Masks that are safe to use are labeled "Safe for Use with Resins."

Once dried, the sensitized plates can be stored indefinitely, as long as they are not exposed to ultraviolet light.

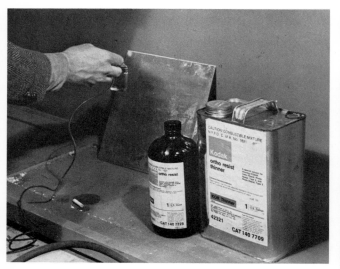

Randy Sprout airbrushes a diluted mixture of photo resist KOR onto a zinc plate.

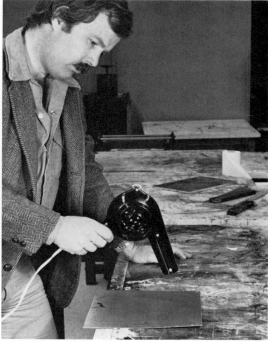

With a hair dryer, he dries the resist.

Film Work

The film positive can be a continuous tone positive or a halftone positive; however, you must remember that the sensitized plate will give only a positive or a negative value with one exposure. That is, either there will be resist left on the plate to keep acid from etching the plate or there will be an opening in the resist where the plate will be exposed to the acid.

Many artists begin by using a halftone positive, either a screened image or a positive printed on Kodak Auto Screen. The dots should be full black with no fog in the film base.

Very nice results can be achieved with small portions of very grainy negatives. This will break up the value scale into irregular dot patterns and provide a less formal and stiff feeling to the image. (This technique works best with Ortho Film and Kodak A & B Developer.)

Grainy negatives can easily be made with Kodak Tri-X in a 35-millimeter camera, with an exposure set at ASA 250 for the smallest grain pattern and ASA 6400 for the largest grain pattern—depending on your subject and the effect that you may want to achieve. Note that the higher the ASA rating the higher the inherent contrast of the negative produced. This means that you must be cautious in photographing subjects of high contrast or you will have nothing but black and white—no gray areas at all.

The following table indicates dilution and time for changing grain patterns. In all cases the film is Kodak Tri-X 35 millimeter and the developer is Afga Rodinal at 68° F. Stop bath and fixer are used as normal. Dilutions are all expressed in parts of Rodinal developer to parts of water. Time is based on agitation for three seconds every minute.

Tri-X, Rodinal Development Table @ 68° F. for Grain Pattern

ASA	Dilution	Time
250	1:85	14 min.
400	1:75	14.5 min.
640	1:75	15.5 min.
800	1:50	16.5 min.
1200	1:65	17.5 min.
1600	1:50	18.5 min.
3200	1:65	20 min.
6400	1:50	22.5 min.

I prefer to work with the 1600 ASA rating when my prints are approximately 20″ × 24″ and a 3200 ASA rating for smaller prints. Of course this is a personal preference, particularly when I want to achieve a coarse grain so that I can more easily draw back into the plate using conventional printmaking tools and techniques. I also use this same film combination to copy some of my existing photographic prints for use in printmaking.

Some of my students have been very successful in projecting through a nylon stocking in order to screen continuous toned negatives.

A series of positives are also nice to work with and are produced with Ortho Film, Kodak A & B Developer, and different exposure times until the exact change of densities desired is achieved.

Care should be taken that you change the exposure time and not the f-stop of the enlarger lens. This can cause change of image size with some lenses. For example, if you want eight values to be superimposed on the same plate, then you must make eight positives; then sensitize, expose, develop, wash out, stain, wash out, aquatint, bite, strip, and begin again for each specific value that you want to establish on the plate. Care must be taken to register the different value positives precisely on the plate

each time. I scratch two x's, one at the top center and one at the bottom center of the negative, along the clear border, using an etching needle. These small x's then print as white x's on the ¼-inch border of the plate. The border is maintained until it has served its purpose of registration.

Color-separated positives can also be used to make three or four different plates, which can then be overlapped and printed on the same paper with the corresponding inks or different colors. The directions contained in Kodak's 4″ × 5″ Super XX film pack is precisely what I use to get very good separations. This film, as the directions indicate, can be used in an easel under the enlarger to separate out a color slide, or it can be loaded directly into a 4″ × 5″ camera.

The resulting 4″ × 5″ color-separated negative can then be contact printed with Kodak Auto Screen and Kodak A & B Developer to produce a color-separated halftone positive 4″ × 5″. Contact printing this positive once again on Ortho Film gives you a 4″ × 5″ negative that is still a halftone and can be used in your enlarger to produce whatever size positive you wish to work with in printing.

Negatives can also be used. For a positive image, the plate needs to be inked by rolling. The surface is printed rather than the normal intaglio method of printing the ink that is left in the bitten holes. Although there is more work in wiping the plate, the intaglio method yields the finest detail and value control.

One can draw directly on the positive using Kodak masking materials or asphaltum to create black lines or spatters.

Exposing the Plate

The easiest method to expose the sensitized plate, after it has been fully dried, is to use a conventional sunlamp (sold at drugstores). My exposure test indicates that the bulb-type sunlamp (ultraviolet light) of all major brands produces very much the same amount of ultraviolet energy. These bulbs have an incandescent filament that lights to heat the chamber of the arc first, followed in about thirty seconds to a full glow. When the arc strikes with a buzz, the color of the light will change to a bluer hue. Begin timing at this point.

I recommend a two-minute base exposure time with the tip of the lamp held 36 inches from the plate. Constantly maintain this distance. Adjust your times according to densities of the film. The sun can be used, but it is not constant enough to achieve precise measurements. After exposure, protect the plate from exposure to more ultraviolet light until after development.

The positive should be held in direct contact with the plate with a sheet of heavy glass.

Dust on film positives, glass, or plates will cause black spots in the prints because they will keep ultraviolet light from hardening the resist. Scratches act the same way.

To determine exposure, make a test on sensitized scrap metal and select the exact exposures for specific details of images.

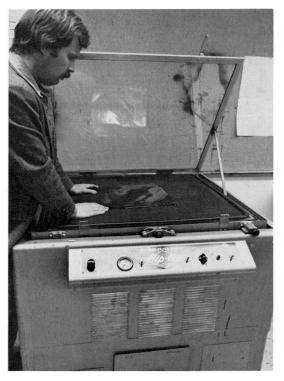

The etching plate and film positive are placed in a plate maker for ultraviolet light exposure.

Plates larger than 20″ × 24″ may require that you move the lamp higher or use two lamps. This means a new batch of test exposures will be necessary.

The longer the exposure, the more plastic resist will adhere to the plate leaving less exposed metal and producing a lighter final print. Some dodging can be done exactly as you would do in printing a negative.

Sunlamps have a long life, and although they are expensive initially, they are less costly in the long run when compared with photofloods that become weaker in ultraviolet intensity as they get older.

Commercial arc lamps work well. Run an exposure test for each type of lamp. (Mine hits right at the two-minute mark.)

Developing the Plate

Use only metal, hard rubber, or glass for the KOR developer. Development time is for three minutes with constant slight agitation. Use only enough developer to cover your plate because it evaporates very quickly. Use developer full strength. Use your mask. The material is toxic.

Don't worry if you don't see anything for three minutes (it is rare if you do). The amber color of the resist at this point is quite transparent and is the same color as the developer.

Try not to pollute your developer with old blockout materials or water from re-etching plates.

After three minutes, stand plate on end in the tray and allow all excess developer to drain off the plate's surface. At this point, you will see ripples indicating where the resist will stick and where it will wash off.

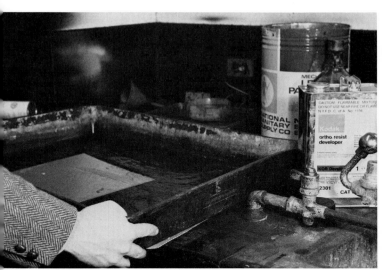

Under darkroom conditions, full-strength developer is used to develop the plate.

Excess developer is drained off the plate.

Washing Out Plate

The first wash is accomplished with 105° F. water (dishwater hot) with a force from the spigot just fast enough to flush away the softened resist and not so forceful to flush away the whole image. The resist, at this point, has the consistency of Vaseline.

Flush the surface of the plate thoroughly for two minutes taking care not to let hands, spigot, or anything else mar the soft resist.

Blow off water droplets after this first wash. Water that remains will dilute the curing resist. At this point, it will be evident where the resist is attached and where there is bare metal.

Hot water is used to wash away soft resist after development.

Staining the Plate

To more easily see the resist, you must stain it using Kodak Ortho Resist Dye. Pour dye directly on the plate, twisting and tilting the plate so that all parts are stained. This dye stains only the resist that adheres, not the bare metal. This is an extremely powerful dye and will enter the protein of your skin and produce a long-lasting stain. Protect your hands with latex rubber (pure rubber) gloves. Most plastic gloves dissolve.

In order to more easily see the resist, Kodak Ortho Resist Dye is carefully (he should be wearing gloves) being poured over the plate.

The dye drained back into the can because it is reusable.

Second Washout

The stained plate is now washed again with 105° F. water. This will clean the dye off only the bare metal.

Inspection and Correction of Plate

The resist should be clearly visible now so that any holes or tears existing in the resist can be corrected with the application of varnish or by universal blockout with a small brush. Any resist appearing over any area that you want to bite can be carefully scraped off to the bare metal. You can make other corrections in composition, such as elimination of some details, at this point by blocking out or covering the bare metal areas that you do not want to bite.

Aquatinting the Plate

If an area that appears bare (has no halftone dots), and if the area should be printed as black, an alternative would be to aquatint. If the artist wants these dark areas to be a true black as in the original or positive, the plate should be aquatinted. This means that small resin particles or paint particles must be made to adhere to these large bare metal areas to act as points for the action of the acid. Points give the plate tooth or texture as holes and bumps to hold the ink later in printing. Otherwise, the acid eats down into the bare metal in a flat smooth manner, producing a surface that will not hold the ink. This is called flat biting and has the effect of producing gray areas rather than a true black. Since these areas are precisely where the darkest darks should be, it gives the print a look of solarization. This may not always be desirable. Areas containing halftone dots will actually print darker than large flat areas because the dots will help to focus the action of the acid. A similar effect will occur with nonscreened images.

To aquatint a plate, there are two alternatives—using rosin or using paint. Paint aquatint is the simplest because it can be accomplished by lightly spraying a fine mist of chassis black paint (using an aerosol can) over the entire surface of the plate. When the paint dries, it is ready for biting.

Rosin aquatint can be applied in either of two ways. The simplest way is to make a sack of nylon stocking—two or three layers thick—and fill it with finely powdered rosin.

Place the plate on the floor, and standing with the bag held at shoulder level, tap the bag gently and evenly, dusting the plate to a hazy yellow. Another method is to construct a box in which the rosin can be circulated in the air inside the box with compressed air that is introduced into the box. This box is built so that there are at least 4 feet of air inside the box above a drawer. After the resin particles are blown into suspension in this space, the blower is turned off and the plate is placed into the drawer. As the rosin gradually settles, it is deposited on the plate in a fine, even pattern.

In either case, finely powdered rosin particles rest over the entire surface of the plate. So that these particles adhere, the plate should be heated to the melting temperature of the rosin about ten minutes and then cooled. Or the plate can be inserted under a box filled with alcohol fumes. These fumes will dissolve the particles into rosin drops, making them adhere to the surface of the plate.

The alcohol rosin curing box may be made out of (plate) packing crates by first lining the inside with plastic bags (to keep fumes from escaping) and then stapling old printing felts to the insides and edges. These felts are charged by sprinkling them with denatured alcohol. When the box is placed upside down over the worktable, it will take three minutes for the fumes to dissolve the rosin. With this approach you don't have to have a hot plate or wait for the plate to cool.

Biting the Plate

Rich blacks are created by biting the aquatinted zinc plate in nitric acid mixed 1:6 with water for ten minutes. After this period, a regular pattern of bubbles will begin to reveal holes where the acid has actually eaten down and around the rosin particles. From this point in time, further biting will make the dark areas lighter as flat biting smooths these surfaces.

Copper plates are bitten in ferric chloride, 42 Baume (which is a measurement of its specific gravity). This combination bites about half as fast as zinc and nitric acid. A bite deep enough to achieve a rich black is produced in about twenty minutes. (Remember to block out the reverse side of copper plates so that they may be used later.)

Biting times are cumulative on the plate so that a really rich dark aquatint can be created with several applications of rosin and biting. Where there is overlapping (separate resist and etches on the same plate), the artist must be aware that the initial value bitten into the plate will become darker and darker with each overlap.

After the plate has been etched, it looks very much like this.

Stripping the Plate

After biting, the rosin and the Ortho Resist can best be removed from the plate by stripping with Sears Paint and Varnish Remover. This is a jellylike stripper that should be allowed to sit on top of the resist for about two minutes in order to soften the resist before wiping it off. Wear latex gloves to protect your hands. Remove all that you can with paper towels first, then rinse with cold water. Dry the plate with compressed air to wipe it dry.

Inking the Plate

Good quality etching inks should be mixed with a little more plate oil (burned) than normally used to print an intaglio plate. This is about a half-and-half mixture by volume. When using black inks (only), I slightly warm the plate before applying ink and allow the plate to cool before wiping. (When you use color inks, the colors are more apt to oxidize and turn gray if the plate is heated.) Zinc plates oxidize colors much faster than copper plates. (Oxidation or the graying of colors, particularly light colors, can be very effectively used to impart an illusion of depth and dimension to the image.) Oxidation occurs primarily when the wiping tarletan or tissue is allowed to build up with ink, and instead of being wiped with a clean piece of tarletan. the area is simply scrubbed until the pigment has absorbed enough oxygen and the desired grayness has been achieved.

A clean, bright yellow color is particularly hard to pull from a zinc plate because most yellow pigments on zinc oxidize almost immediately. Shiva Permasol Yellow Light probably is the best yellow paint for zinc because it is highly resistant to oxidation. It can be applied directly from the tube.

My choice of inks (oil paints) that print in excellent colors for color separations are Grumbacher's Cadmium Red Medium, Winsor & Newton's Winsor Blue, and Shiva Permasol Yellow Light.

Color litho inks and other color oil paints may be used, as well. For wiping color inks, I use a tissue paper called Nol White tissue wrapping from Zellerbach and/or paper towels or yellow pages from old telephone books. The importance of a clean surface in color printing, as in multiple plates, is that if some inks are left on the surface, they combine to form a dulling gray in what was supposed to be a clean highlight.

Printing the Plate

Printing is done with a regular etching press. Etching papers must be soaked for the following lengths of time before printing in order to obtain a good impression:

BFK	1 hour–3 hours
Arches	1 hour–3 hours
Murillo	2.5 hours–5 hours
Copper Plate	15 minutes
Etch Proof	15–20 minutes

From the time that the photo resist is stripped from the plate, the plate can be used as any ordinary intaglio plate employing all kinds of drawing tools and techniques available to the printmaker. I consider the altering of the initial camera image the most exciting part of working in this medium.

Randy Sprout, "Christmas, 1968." Three plate
color separated photo etching. 23¼″ × 23½″.

Randy Sprout, "Joe's Rug." Two plate photo
etching. 23″ × 15½″.

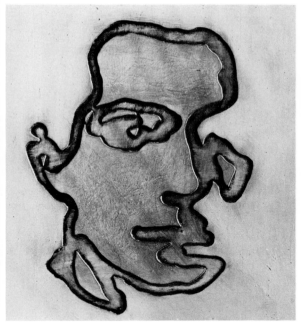

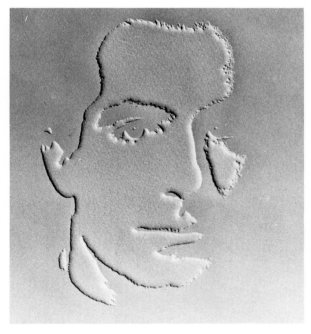

Photoetching (also called photoengraving), "Philip Roth," by Naomi Savage, as plate. A print, out of focus, was reprinted and then photoetched. She sometimes finishes copper plates and mounts them as bas-relief. *Courtesy: Naomi Savage*

The same three-quarter portrait of Philip Roth by Naomi Savage printed as an intaglio or embossment. *Courtesy: Naomi Savage*

Photo etching of a torso by Naomi Savage. *Courtesy: Naomi Savage*

PHOTOETCHING ON METAL PLATE with Merry Moor Winnett

Metal graphics can be produced on various colors of sensitized aluminum in a simple process.

 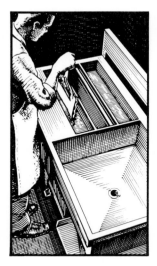

EXPOSE. 2 MINUTES
Remove a sheet of FOTOFOIL from its light-tight package. Place it in a printing frame in tight contact with a film positive or negative that has been made from artwork. The FOTOFOIL sheet is contact printed by exposing through the film, using a photoflood, arclight, or other high UV source.

HARDEN. 1 MINUTE
Place the sheet in a process sheet holder and immerse it in the FOTOFOIL Hardener solution and agitate by raising and lowering in the solution.

WASH. 10 SECONDS
Remove the sheet from the Hardener and wash in a hard spray of tap water to remove the softened portions of the coating. Areas where the coating has been softened and removed (unexposed portions) will be etched.

ETCH. 40 SECONDS Immerse the sheet in the tank of etching solution and agitate. Inspect the sheet occasionally and etch until the copy or design is legible.

WASH. 10 SECONDS Remove the sheet from the etching tank and wash in a hard spray of tap water. Wipe both surfaces with a damp sponge and dry with a cloth or air. You have just produced, in less than five minutes, a full sheet of etched, anodized, colored nameplates.

Courtesy: Miller Dial Company

Merry Moor Winnett, "Pier Group." Photoetching on silver-colored Fotofoil. *Courtesy: Merry Moor Winnett*

Merry Moor Winnett, "Suncloud I." Photoetching on a silver-colored Fotofoil plate, 1975. *Courtesy: Merry Moor Winnett*

Richard Hamilton, "Swinging London 1967 II." Photoetching, etching and aquatint, printed in black relief and silver with collage of white, deep bluegreen, and glossy brown black acetate, 1968. 13⅜″ × 21¹⁵/₁₆″. *Courtesy: The Museum of Modern Art, Joseph M. and Dorothy B. Edinburg Charitable Trust Fund*

Photolithography

Although metal plate lithography was used continuously from as early as 1818 (mentioned by Senefelder), its use was not given impetus until the invention of a steam-driven rotary offset press in 1895. This press and its metal lithographic plate revolutionized commercial printing and very quickly relegated the flatbed press with its heavy stone to the artist-printmaker's studio.

Although artists in France and Great Britain used metal plates for lithography, the process never was very popular in the United States except for a short period in the early 1930s. In fact, Americans did not perfect the process of using metal plates for lithography until the 1960s.

However, with good stones for lithography growing scarce and expensive, studios such as the Tamarind group adopted the metal plate, and processes were perfected for hand printing.

Although the concepts for metal plate lithography are essentially the same as in stone lithography, procedures are different. And the product is slightly different as well because of the dissimilarity in the surfaces of the various plate materials.

Many types of plates and plate surfaces are now manufactured—coated, uncoated, in zinc or aluminum, ball-grained aluminum subbase plate, and photosensitized surfaces for the incorporation of photographic images.

Photographic images can be applied to the lithographic plate in three ways—by transferring images from ready-made halftone plates, by transferring inked images from a printed surface by reactivating the ink for transfer, and by exposing a photographic image that has been processed (with dots) to a sensitized plate.

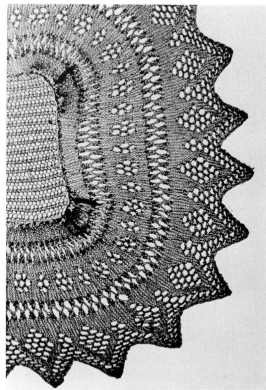

Photolithograph by Ann Sutton.

Knitted texture detail of Ann Sutton's photolithograph.

Photolithography by Ann Sutton.

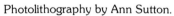

The continuous tones of a photograph have to be divided into dots through use of fine wire mesh halftone screens (150 wires per inch for fine gradations and 65 wires per inch for coarse effects). Very fine dot images tend to fill in.

Stone or metal plates can be sensitized using the usual water-soluble colloids such as casein, albumin, and a bichromate discussed above. The same principles are involved here as in photo-silkscreen. The insoluble parts of the coated plate form the ink-receptive areas of the image. Tonal formation is determined by the halftone dot formation.

As in photoetching, you expose the negative against the stone or metal plate under a carbon arc lamp, by using a vacuum frame (for contact printing in the exact size) or by projecting the negative onto a printing element with an enlarger. (The latter is an excellent technique when very large images are to be made.) Here, too, the duration of exposure is determined by the same variables, and tests are necessary to determine correct exposure.

Development of the image is accomplished by covering the surface with a developing ink, drying by fanning it, and then flushing the ink away with water. Water dissolves the unexposed or nonimage areas, but care must be taken to completely remove the unexposed areas and excess developing ink along with it.

After the image is developed, it is chemically treated to achieve the characteristic lithographic surface—ink-receptive and ink-rejective areas. If stone, it is dried, dusted with talc, and given a weak etch (6 drops nitric acid to 1 ounce of gum arabic). After the stone has dried, the image is washed with lithotine (a turpentine substitute). An asphaltum printing base is applied and fanned dry. The stone is washed and readied for printing. Black printing ink is rolled on and dried so that the work can be studied. Areas requiring retouching are now touched up with tusche. The work is dusted with rosin and talc, again given a mild etch to desensitize it, and the stone is now ready for proofing.

If a metal plate is used, after exposure developing ink is rubbed on image areas and wiped dry. Then the entire plate is washed with desensitizer, allowed to penetrate, and mopped up. Desensitizer is applied a second time and the plate is gently rubbed dry. A mixture of desensitizer and a cup of plate conditioner is flushed over the plate and it is rubbed to completely free any remaining residue or ink. The plate is cleaned and desensitizer is applied a third time over the clean plate and fanned dry quickly to achieve a thick coating.

In two stages, a gum asphaltum etch is poured on the desensitized plate and rubbed into the image areas to dislodge the existing coating. When the coating has completely dissolved, fresh developing ink is applied to the image areas, and the plate is flushed with clean water and then rolled up with black ink. The plate is dried, dusted with talc, coated with cellulose gum, dried, and is ready for proofing.

For proofing, the plate is washed according to the usual procedure, and liquid asphaltum and Triple ink are rubbed into exposed areas. The gum coating is washed off with water and the plate is rolled up with a rolling-up black ink. Proof impressions are taken on either dry or damp paper.

Roy Lichtenstein's *Entablature* Project at Tyler Graphics. The *Entablature* series employed many graphic processes—embossing, silkscreening, photolithography, and collaged foil elements.

Kenneth Tyler cuts film for "Entablature III" which will be used in the photolithography process.

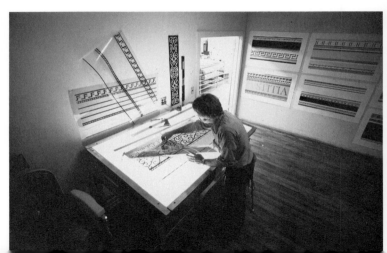

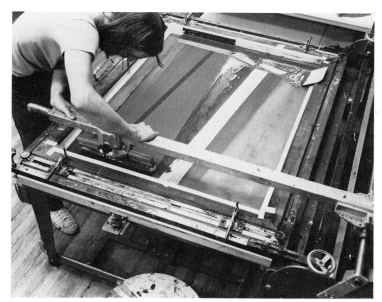

Kim Halliday screens blue color for "Entablature IV."

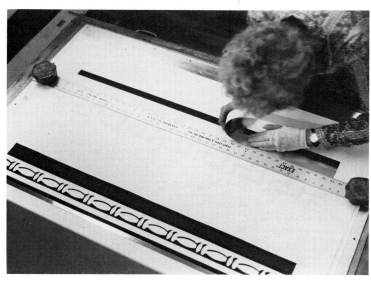

Betty Fiske glues foil onto "Entablature VII."

Roy Lichtenstein and John Hutcheson examining the printed foil color on "Entablature V."

Roy Lichtenstein, "Entablature V." Embossed four-color screen/photolithograph with collaged gloss silver metallic foil. 29¼″ × 45″.

Photo Series Courtesy: Tyler Graphics Ltd.
Photos by Steven Sloman

The Collotype—a Photogelatin Process

The collotype, different from the collagraph, as we shall see later, is a planographic, screenless printing process similar to lithography. The process was patented in France in 1855 under the name of Photocollagraphy, modified in 1865 to be called Phototypy, and in 1868 in Germany called Albertypy. It is still in use in Germany. (The process became quite popular at the end of the nineteenth century and until about World War I.)

Unlike the photolithograph, collotype is a photomechanical process that reproduces an image accurately in a continuous tone, without need of a halftone screen to break the image into dots.

A photosensitive coating is spread on a plate of glass and exposed under a negative. Exposed areas, as in the other photosensitive processes, harden and lose hydrophilic properties in places where light is received. The image is then able to retain both ink and water—the ink repelling the water in inverse proportion to how much light was received.

This mutual repulsion concept is employed in lithography, too, but the collagraph is also like rotogravure, inasmuch as the film of ink is not uniform, as in lithography, but deposited in proportion to the shades of value in the original image.

It is the only printing process that can, with fidelity, reproduce a photographic image without a screen. Commercially, collotypes are printed on a special press that consists of a bed bearing the glass plate (prepared for printing), an impression cylinder to carry the sheet to be printed, and a system of ink rollers. Printing speed is slow—at the most 200 copies an hour, with limited plate life—2,000 to 5,000 copies per plate.

More recently, the glass plate has been replaced by a cellophane film that can then be mounted type height on a wooden or metal block.

COLLOTYPE TRANSFERS
with Jeff Gates

A 35-millimeter negative is enlarged by exposing sheet film in the enlarger and developing the film. This produces a film positive. When this dries, the film positive is placed in the enlarger and the process is repeated, this time producing an enlarged film negative. Jeff Gates uses Kodalith and develops it in Dektol to achieve a continuous-tone high-contrast negative.

Under subdued light (safelight) conditions, a 3 percent solution of potassium bichromate is coated on sheet film (any sheet film but Kodalith). It is hung to dry.

When dry, the plate is ready for exposure under any carbon arc or UV light source. The plate is placed face up and negative emulsion-side down. Depending on distance, negative density and light source, the plate is exposed (for this one, two-and-a-half minutes).

After the plate has been exposed, where light hits it, the gelatin hardens and where light doesn't hit it, the gelatin is soft. The unexposed potassium dichromate is washed off in 60° F. water (water temperature affects the grain of the picture). The sheet is dried and made to adhere to a backing of Masonite or plastic with spray adhesive.

One part glycerine and two parts water is gently sponged over the plate. Areas not hardened are thirsty for water, and those areas that have been exposed to light repel the water (collotype is like the lithographic process). Where water soaks into the plate, ink will not be accepted, and the converse holds true as well.

Collotype ink or a stiff lithography ink is mixed on a glass plate; a spatula is used to blend colors.

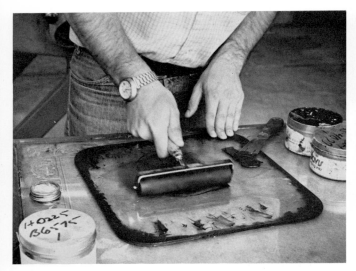

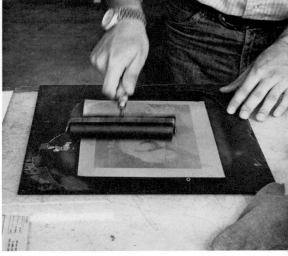

A very soft rubber brayer is charged with ink . . .

. . . . and applied to the wet plate. To control contrast, the plate can be wet with a glycerine-water solution or dried with paint thinner (mineral turpentine). The wetter the plate, the higher the contrast.

Ink is applied with more than one coat. The slower the brayer is rolled on the plate, the more ink will be absorbed. If the entire plate inks up, then too much ink was applied. Excess is wiped away with a soft cotton rag. Jeff Gates uses several coatings of different colors; sometimes more than eight colors are used, building them up from light to dark.

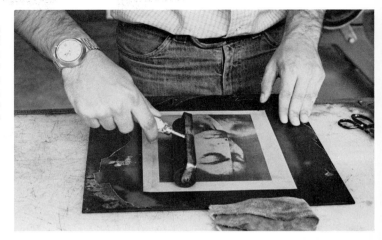

Acetate (.005 gauge) is placed over the plate and under medium pressure is run through the press in order to transfer the inked image to the acetate. (Too much pressure can squeeze the gelatin off the plate and destroy it.)

The acetate (and plate) is removed from the press and pulled from the plate.

Immediately and with care, the freshly printed acetate is placed on Strathmore Plate Finish paper.

By rubbing the acetate with the back of a pen, Gates transfers or offsets the image from acetate to paper. He controls the transfer effect by rubbing some areas more than other parts.

Here he is looking at the quality of transfer.

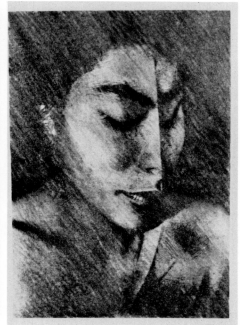

Jeff Gates, "Carla." Collotype transfer, 1976.

Jeff Gates, Untitled. Collotype transfer, 1975.

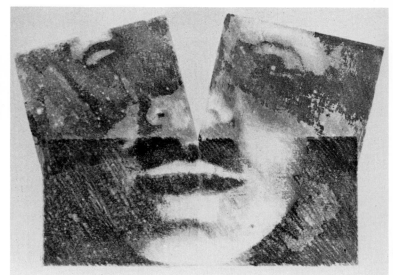

Jeff Gates, Untitled. Collotype transfer, 1976.

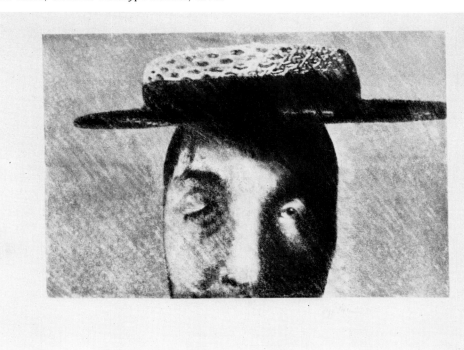

The Photogram Collage and Collage Print

The continuous tone photograph and photogram have been used in other ways. Naomi Savage (niece of Man Ray) has expanded the concept of the photogram and collage into a composite of both. Photogram elements, or sometimes photographed images are cut apart, combined and rephotographed and reproduced. Or the elements of the collage can be printed, by design, and assembled collage-fashion into "three-dimensional" prints, as Robert Rauschenberg did in his *Cardbird* series or as Helmmo Kindermann did in the photograph collage.

Naomi Savage photographs images in high contrast and contact printed or makes photograms of a range of objects. She cuts the high-contrast linear elements apart and reassembles them into a new statement. Sometimes paper negatives are made; this creates reverse values on photographic paper (as a film negative would appear). Elements are also manipulated in other ways such as by solarization. The piece is then photographed and printed as conventional enlargements.

Sometimes these same images are brought to an engraver for translation onto ⅜-inch-thick magnesium plates, which are then copperplated. After they have been used to make inkless intaglios, these metal plates are framed as bas-reliefs.

PHOTOGRAM COLLAGE with Naomi Savage

Photograph or photogram images are processed normally. Naomi Savage then cuts apart elements of these photographs.

They are pasted on a background, ready for a picture to be taken of the photomontage or a photogram made from negatives. Different effects can be created through darkroom manipulation, such as solarization, reticulation.

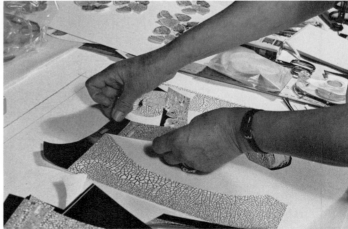

Below: At this point, a photoetching can be made, or gum-bichromate sensitized paper can be used. A completed photogram collage by Naomi Savage.

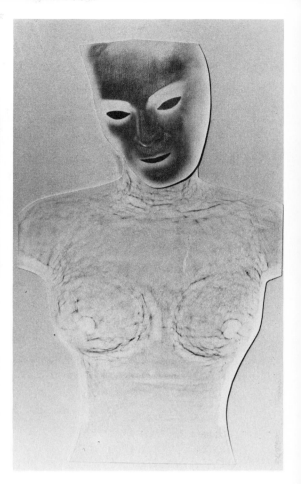

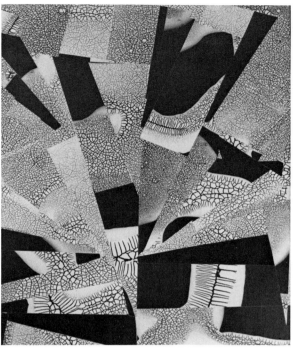

Right: Naomi Savage, "Upper Torso—See Thru." Photogram collage. *Courtesy: Naomi Savage*

Naomi Savage, Untitled. Photogram collage. *Courtesy: Naomi Savage*

Naomi Savage, "I Am a Mushroom." Photogram collage. *Courtesy: Naomi Savage*

Robert Rauschenberg working on the *Cardbird* project in the Gemini studio. He wanted to create a work in a "...material of waste and softness. Something yielding with its only message a collection of lines imprinted like a friendly joke."

Below, left: Robert Rauschenberg, "Cardbird II." Corrugated cardboard, photo-offset, hand-screened, hand-cut, and hand-assembled, 1971. 54″ × 30½″.

Below, right: Robert Rauschenberg, "Cardbird Door." Three-dimensional object of corrugated cardboard, Kraft paper, tape, wood, metal, photo-offset, and screen printing, 1971. 80″ × 30″ × 11″. *Series Courtesy: Gemini G.E.L.*

Non-Silver Photosensitive Printmaking

The silver print, our standard photographic print, was the principal survivor of the nineteenth-century experiments. Although prints can be made electrically, thermally, and through dye-destruction processes, these proved to be commercially obsolete. Processes that took too long, were too complicated, or produced only a limited number of prints were abandoned. But some of these methods are being revived. We have, for example, seen gum bichromates used to sensitize plates and screens for etching, lithography, silkscreen, and the collotype.

Most of these processes require a contact negative or positive—gum and platinum processes need negatives, gravure requires a continuous tone positive. Silkscreen needs a halftone or grainy positive, lithography and photoetching a halftone negative. Gum process prints are based upon the change of solubility of chromated gum arabic when it is exposed to light.

Iron salts, which are moderately photosensitive are called ferrocyanotypes. The process is slow and requires a long exposure to bright light such as a mercury vapor lamp or a bank of ultraviolet fluorescent tubes.

Many of the products that do not employ negatives but use only light, as does the photogram (as a silver print) are employed to produce a single, unique product. Unless, as Naomi Savage does, the result is photographed and reproduced.

The Gum Print

Both potassium bichromate and ammonium dichromate are used to make gum prints. Ammonium dichromate is faster. (Both dichromate and bichromate are synonymous terms.)

The traditional approach to the gum print is to size a good quality paper, such as Rives BFK, with two or three coats of gelatin, which is hardened later with Formalin. Three packages of Knox or A & P unflavored gelatin are soaked in a half quart of cold water for a few minutes, and then a half quart of hot water (to bring mixture to 100° F.) is added. After the gelatin has completely dissolved, two or three more quarts of warm water are added. (A good alternative is to size the paper with a coat of acrylic gesso, which eliminates the use of formaldehyde to harden the gelatin.)

The paper may be floated into the size and manipulated with glass rods until completely covered with a smooth coating, or it may be applied with a Japanese sumi brush. When covered with gelatin, the paper is lifted out and hung to dry. The process is repeated one or two more times.

The gelatin-coated paper is then hardened by immersion in a Formalin solution of 27 milliliters of 37 percent formaldehyde per liter of water. The paper is removed and allowed to dry.

All these materials should be used in a well-ventilated room and should be handled with rubber gloves.

The gum solution consists of 300 to 350 grams of powdered gum arabic per liter of distilled water; the mixture should be stirred and allowed to stand until completely dissolved. This may take two or three days and because a mold tends to form on the gum arabic, 2.5 grams of mercuric chloride (a deadly poison) is added to the gum solution. Care should always be taken not to get any on the skin.

When the gum is ready, the paper coated with hardened gelatin or acrylic medium, a gum sensitizer is applied. This solution consists of 29 grams of potassium or ammonium dichromate dissolved in 50 milliliters of distilled hot water, to which 50 milliliters of distilled cold water is added, making 100 milliliters. (Potassium and ammonium bi-

Jean Locey, "I'm Their Aunt Jean." Gum bichromate on linen, stitched and stuffed. 24″ × 24″. *Courtesy: Jean Locey*

Betty Hahn, "Procesed by Kodak." Gum bichromate on Rives paper, 1968. 22″ × 14″. *Courtesy: Betty Hahn*

chromate and dichromate may be used interchangeably.)

The sensitizer is used at room temperature (about 70° F.) soon after mixing. It does not last for more than a day.

Equal quantities of gum and sensitizer are mixed and applied to the paper quickly, with a brush, either in the dark or under very dim amber light.

If color is desired, as it is by Randy Sprout and Naomi Savage, it should be applied prior to the gum solution in the manner indicated below. Use fine watercolors or gouache pigments. Randy Sprout suggests the following colors for effective staining: titanium, ivory black, Vandyke brown, burnt umber, phthalocyanine blue, alizarin crimson, ferrite lemon, cadmium red, Hansa yellow, chocolate brown oxide, and thiandigo violet.

One way to apply the color is to reserve some water from the sensitizer, add the color to it, and then it to the sensitizer. Color sensitizer can be applied with a thin feather brush, a broad soft brush. The paper is usually hung vertically and the solution stroked on crossways. Three applications are made (under amber light), with one minute between coats, and the paper is dried each time with a hair dryer. When the paper has been sized with acrylic gesso, coat both sides and apply one layer for every two intended applications of sensitized gum.

Large pieces of photosensitized paper are folded and then exposed to light much as is done in making a photogram. By Sheila Pinkel.

Below, left: In some cases, Sheila Pinkel crumples the photosensitized paper.

Below, right: Here Sheila Pinkel suspends threads before exposing the paper to light.

Once the paper has been sized, colored (if desired), sensitized, and the bichromate gum hardened by blue or ultraviolet light (a mercury lamp works best), it is ready to be exposed.

In this form of contact printing, a full-sized negative is held tightly against the paper on a vacuum table. Exposure may be achieved by use of an arc lamp for up to five minutes or with a sunlamp at 20 inches distance for three to six minutes. To compensate for overexposure, development time can be extended.

Develop the print by floating the exposed print butter-side down in a tray of regular tap water. The water must be changed continuously until it runs clean—up to thirty minutes. Even after the light source has been removed, hardening continues for a minute after the paper has been wetted.

Development is complete when the yellow chromate stain disappears.

Blueprinting (Ferroprussiate)

Blueprinting is the familiar process used by architects and engineers to copy drawings and plans. The process results in facsimile copies the same size as the original. The process was discovered in 1842 by Sir John Herschel, an English astronomer.

Blueprints begin with a drawing on translucent paper, tissue, or tracing cloth. This is placed (with its back to the emulsion) in contact with paper that has been sensitized with a mixture of ferric ammonium citrate and ferricyanide, and exposed to light. In parts of the drawing not obscured by line or shape, light reduces the ferric salt to the ferrous state, in which it reacts with the potassium ferricyanide to form an insoluble Prussian blue—the characteristic color of the blueprint. When the exposed paper is washed (developed) in water, the lines of the drawing appear white against the blue ground. The water dissolves and washes away the unused ferric salt and fixes the image.

Sensitizing for the Blueprinting, or Ferroprussiate, Process

This is a light-sensitive process. Sunlight or a strong ultraviolet light source slowly turns the treated paper bronze, until washed in three or four changes of water until the paper turns blue.

Ferroprussiate paper can be purchased. One can also sensitize paper and cotton or linen fabric. The sensitizer solution may be painted on the paper in subdued light or the paper or fabric immersed in the solution. The material is then stretched and dried quickly in a darkroom.

The sensitizer solution has a short life and should be mixed and filtered immediately before use. Two solutions are necessary:

Solution A: 250 g of ferric ammonium citrate (clear red crystals) and 1000 cc of distilled water

Solution B: 200 g of potassium ferricyanide and 1000 cc of distilled water

Mix both in equal quantities. Immerse or coat the paper or cloth with this mixture, and dry the material quickly—perhaps using a hair dryer.

The paper or cloth should then be exposed to sunlight or mercury vapor light until the ground becomes a bronzelike green.

To achieve a more light-stable and contrasting image, a 0.2 percent solution of potassium ferricyanide is added to the first wash water. The print should be washed in that bath for four or five minutes. Toward the end of the washing time, the water is changed three or four times.

BLUEPRINTING with Mary Van Stelle

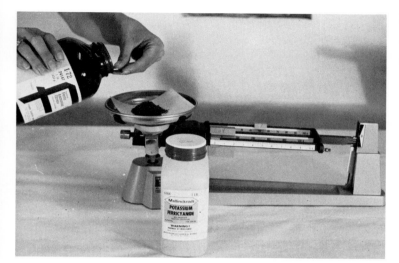

The chemicals—ferric ammonium citrate and potassium ferricyanide—are weighed.

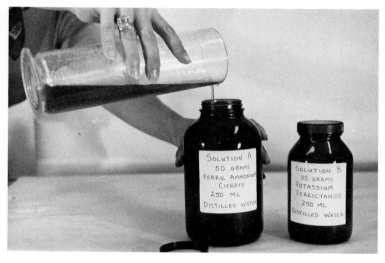

Each chemical is mixed with distilled water.

Both chemical solutions are mixed together.

Under darkroom conditions, the fabric is immersed in the solution. Excess solution is drained off before wringing out and drying the fabric (in a darkroom).

A sunlamp is set up 14 to 16 inches above the table. The dry material is covered with a Kodalith positive (in this case) and plate glass—in that order, and the photo image is exposed. The exposed fabric (or paper) is then washed (developed) in water.

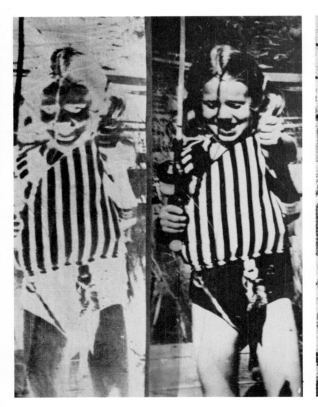

On the right is the Kodalith positive and on the left is the blueprint (as a negative image). By Mary Van Stelle.

In this case, lace was used instead of Kodalith film. *Series Courtesy: Mary Van Stelle and Pat Mansfield. Photos by Mary Van Stelle*

June M. Bonner, "Bailey's Landing." Soft wall piece in blueprint on cotton, using photographic methods followed by patchwork and quilting processes, 1976. 19″ × 29″ × 1″ deep. *Courtesy: June M. Bonner*

June M. Bonner, "Cactus in the Dooryard." Soft wall piece. Blueprints on cotton using photographic methods followed by patchwork and quilting processes. 16½″ × 17½″ × 1″ deep. *Courtesy: June M. Bonner*

Lyn Mandelbaum, "October 18—November 15, 1971." *Page
from Diary Series.* Xerox, blueprint, pencil, 1971. 5¼" × 11".
Courtesy: Lyn Mandelbaum

Cyanotype, or Gum-Iron, Process

Cyanotype is a blue image on a white background—the reverse of a blueprint, although the two are often thought to be the same. Gustav LeSecq and Clarence White were early experimenters with the process.

The method has been adapted by printmakers to express images that can be conceived and planned but not readily executed by drawing. Sheila Pinkel, for example, utilizes the blueprint to describe light and the subtleties of surface itself. She controls the distribution and intensity with which light glances over the textured sensitized paper surface—much as in the photogram process, except that the paper itself is the subject matter. And instead of a silver sensitized paper, the cyanotype process is used. In other instances, Sheila Pinkel creates embossed blueprints by crumpling and folding the paper or by employing pressure against the wet paper with three-dimensional materials such as rope, and using light to dramatize and define the shallow relief, as in her other blueprints.

Lyn Mandelbaum employs the cyanotype with Xerox. And Sylvia Seventy prints via cyanotype on the warp of a loom. Pat Mansfield and Mary Van Stelle blueprint on fabric.

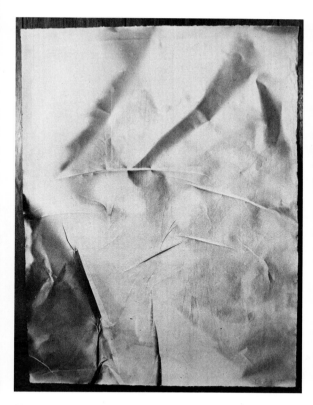

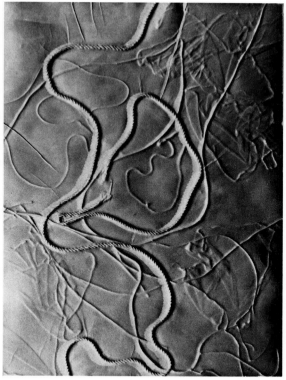

Sheila Pinkel sensitizes Arches paper, crumples the paper, and exposes it to sunlight. She actually tracks light and shadow, much as one would in making a photogram. Since this is a blueprint, the scale can be larger.

In this case Sheila Pinkel runs the damp Arches paper over rope, fabric, and string, through a press with a rubber and two felt blankets to emboss the paper before sensitizing it and exposing it to sunlight, or a carbon arc lamp (a high-intensity light source).

Lyn Mandelbaum, "Drawing Series, 2." Altered cyanotype, pencil, 1971. 22″ × 30″. *Courtesy: Lyn Mandelbaum*

The Cyanotype Process

Pat Mansfield and Mary Van Stelle employ the following basic cyanotype solutions:

Solution A: 50 g of ferric ammonium citrate (green) are mixed with 250 ml of distilled water. (Store in umber or green bottles.)

Solution B: 35 g of potassium ferricyanide (poisonous) are added to 250 ml of distilled water.

Solutions A and B are mixed and kept separately. Mixing vessels and stirring rods are thoroughly washed between solutions. (These solutions stay active for about four months. Once mixed together though, they will remain potent for only six hours.)

Under dim light or safelight, i.e., any darkroom safelight (not fluorescent), equal amounts of Solutions A and B are mixed together and placed in a flat tray (glass or plastic). The paper or fabric (free of additives) is sensitized by soaking for three minutes, until the material is completely saturated. It is possible to spray larger areas rather than immerse them. Excess solution is carefully squeezed out or drained off and the material is allowed to dry. During drying, the ends are reversed so that the fabric dries evenly. Drying time depends on fabric thickness and size (ten to fifteen minutes for cotton about 12″ × 12″).

The sensitized fabric, which will be bright green before exposure to light, is exposed by contact printing. High-contrast negative or positive (Gevalith, Kodalith) or actual object is placed on the cloth or paper. The latter method produces a photogram. In both instances, actual-size negatives are used and no enlargement is possible. A test strip is made to determine time; longer exposure results in darker blues. A good light source is a sunlamp placed about 14 inches from the fabric. Larger areas will require that the light source be kept a further distance and for a longer exposure time. An older bulb will also require a longer exposure.

To expose, the fabric is placed flat under light, the negative, positive, or object is positioned over the fabric, and nonglare glass or acrylic is placed over this. Then the lamp is turned on for approximately twenty minutes or until the exposed areas turn a deep blue (the longer the exposure, the darker the blue). Next, the image is "fixed" by washing the fabric in warm running water until unexposed areas have turned white and the yellow ferricyanide stain disappears. A blue stain remaining in white areas may be a sign of overexposure. The finished fabric or paper is hung to dry, and a hair dryer may be used to hasten the process. The fabric may be washed and laundered if it becomes soiled, but bleach will destroy the image.

One effective variant is to employ several negatives in a single exposure or a sheet of transparent acetate or Mylar that has been drawn upon or printed in a pattern design or texture. June Bonner sometimes uses several generations of black-and-white negatives, printing one from the other until images become linear in quality. From these negatives she prints in varying values of blueprint color. Sometimes acetate is block printed from textures such as barn siding and printed as a negative along with the linear negatives of her images.

Lyn Mandelbaum employs the cyanotype process with Kodalith Ortho film and ink on acetate or Mylar. Value gradations are achieved by varying either the density of the materials or the length of exposure to light. She also alters the color of the cyanotype from blue to brown by immersing the blueprint in a solution of 3.887 grams (.135 ounces) to 115 grams (4 ounces) of water. For localized coloration, the solution is painted onto specific areas.

After application of the tannin, the paper is rinsed again in clear water. Following rinsing, it is immersed in a solution of 3.887 grams of carbonate of soda to 115 grams of water. The paper is kept in this solution for about one minute, or the tannic solution is applied locally and then rinsed in clear water. If the color change is not correct, the entire process can be repeated again —tannin, water, carbonate of soda, water —until the desired color effect has been achieved. Lyn Mandelbaum calls this *altered cyanotype.*

In some instances, Mandelbaum combines photoemulsion, cyanotype, Xerox, and pencil in a single piece, in just that sequence. The pages of her "Diary" are an example—the print is "constructed" through sequential combination of these processes until the final image has been created. First the photographic emulsion is applied in the desired areas, exposed, and developed. The paper is washed well to eliminate any remaining residue and allowed to dry. Next the blueprint solution is applied locally. The second image is exposed and developed. The cyanotype then, if intended to be altered, is color-toned at this point. Next the Xerox images are applied by using a Xerox camera, and finally color or drawing may be added by hand.

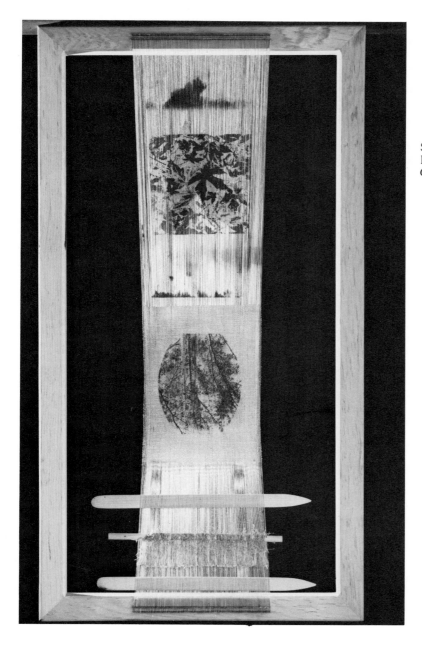

Sylvia Seventy, "Loom Series II." Image on loom in cyanotype. *Courtesy: Sylvia Seventy*

The Kallitype, or Brownprinting

Lyn Mandelbaum's altered cyanotype results in brown images. This can also be achieved by a process developed in England about the same time (1856) as the cyanotype.

Susan Haller, in her life-sized prints, prefers blueprinting and brownprinting because they produce softer images than do either the standard black-and-white printing or the hard-edged silkscreen.

While the speed of this emulsion is very slow compared with other modern light-sensitive coatings and the Kallitype process more complex than general brownprinting processes, it provides for much better control of contrast and tone of the print image.

The Kallitype Process

A rag content paper that can withstand soaking in solutions or a nonsized fabric can be used. It is recommended that the paper be sized with a starch sizing or acrylic gesso.

The Kallitype sensitizer consists of:

Ferric oxalate 5.0 g
Oxalic acid (poison) 0.3 g
Silver nitrate (burns) 2.5 g
Distilled water 30 ml

The mixture should be allowed to mature in a brown bottle for a few days before being used and should then be applied, under darkroom conditions, at 100° F. after the solutions' container is warmed in a water bath.

After application, the paper is dried with a hair dryer in the darkroom. Exposure is achieved by contact printing with a full-sized negative under strong daylight, mercury vapor, or arc light. To create the sepia tone, the following developer is used after exposure.

Borax 28 g
Rochelle salts 52 g
Distilled water 591 ml

For a darker brown, the borax is omitted. And for more contrast, a 10 percent solution of potassium dichromate is added, a drop or two at a time, up to about 6 to 10 drops.

Darkness is also controlled by varying the length of time the print is allowed to remain in the developer. Five minutes is an average; the print should then be washed for two minutes under running water and fixed for ten minutes in a solution of:

Sodium thiosulfate (Hypo) 28 g
Water 591 ml
After fixing, the print is washed thoroughly
 and dried.

Salt Printing for Brown Tone Images

Catherine De Lattre has worked out this variation on the Kallitype theme. It is a modification of the printing-out or physical development process invented by William Henry Fox Talbot in 1839. The process uses silver salts that change color on exposure to light. The light itself acts as the developer, the print needing only to be fixed (and toned if desired). This kind of development was later replaced by chemical reduction, which is the process we now refer to as simply development.

The salt printing process is simple, fairly inexpensive, and yields an image with fine detail, subtle tone, and a range of middle values between the lightest and the darkest areas of the print.

Salt printing is another contact printing process. Paper is sensitized to light by being bathed in a weak solution of common table salt and then, after drying, in a strong solution of silver nitrate. These chemicals react to form silver chloride, a light-sensitive salt, insoluble in water, within the paper. After

Susan Haller, "Palm Tree." Blueprint, brownprint, dye, and sewn on muslin. 116″ × 75″. *Courtesy: Susan Haller*

Catherine DeLattre, brownprint with photographic image on fabric, soft frame, embroidered. *Courtesy: Catherine De Lattre*

Catherine DeLattre, brownprint with photographic images on fabric fan. *Courtesy: Catherine De Lattre*

Susan Haller, "Decaying Leaves," series of six (installation view). Brownprint, dye, string, and sewn on muslin. Series varies in length and width from 69″ × 19″ to 73½″ × 20″. *Courtesy: Susan Haller*

the paper dries a second time, a negative is placed in direct contact with the sensitized paper and exposed to a bright light, preferably sunlight. The printed-out image is further developed in water, then fixed, washed, and dried. The salt bath consists of one teaspoon of kitchen salt (noniodized is best, but others will do) in 32 ounces of water, preferably distilled; the bath, silver nitrate, consists of 25 grams of it dissolved in 250 cubic centimeters of distilled water (the use of other than distilled water in this solution contaminates the silver nitrate); for fixing, a 5 percent solution of a Kodak fixer or other rapid fix product may be used. Any paper that can be soaked repeatedly in water without falling apart will serve as a base; and acetate or rayon fabric will serve as well. The enlarged negative should be either Kodalith or another continuous tone negative, and the more contrast, the better.

The paper or fabric is first soaked in the solution of salt and water until completely saturated (a warm solution facilitates the process of absorption). Since the reaction between salt and silver nitrate forms the silver chloride, it is essential that the salt solution be evenly and fully absorbed by the paper. After soaking, the paper is hung to dry.

The silver nitrate and distilled water should be mixed under safelight conditions. If all the solution is not going to be used at once, the remainder may be stored in a light-tight, well-stoppered bottle.

After the salted paper has dried completely, the silver nitrate solution is applied in any of several ways. The paper may be floated on the solution, but care must be taken not to get any of the fluid on the back of the sheet. (The side that is not coated should be marked for later identification.) The solution may be brushed onto the paper, or it may be sprayed on with an airbrush. The last two ways require more than one coating and exposure. After coating, the paper or fabric is hung to dry in complete darkness or dried flat on screen drying racks.

When dry, the paper or fabric is placed in contact with the negative in a contact frame. Exposures may be made with a sunlamp, photofloods, or sunlight. When photofloods are used, the source must be no more than 6 inches away from the contact print frame and exposures take about forty minutes. Because negatives can be damaged by the intense heat accompanying the long exposures, use of photofloods is risky. Sunlight exposures last from three to twenty minutes, depending on the intensity of the sun, the thickness of the solution, and the density of the negative. (As with any of these methods, a test strip is necessary to judge exposure time.)

After exposure, the print is developed in plain tap water at 68° F. The water becomes milky as it precipitates out the unexposed silver and should be changed often until it runs clear. If another exposure is needed,

the paper is prepared by drying under safelight conditions or in complete darkness and repeating the process, but beginning with the silver nitrate coating and omitting the salt bath.

After development, the print is fixed in a 5 percent solution of fixer. Since the fixer will bleach the image somewhat, it is better to slightly overexpose the print. After fixing for ten minutes, the print is washed completely for about twenty minutes and hung to dry without use of external heat.

Take note that silver nitrate will burn. It also causes brown stains which are impossible to remove from clothes and take weeks to wear off skin. Take care when handling it—wear rubber gloves.

Catherine De Lattre experimented with several kinds of papers and fabrics and charted her results:

Paper	Original Color	Light Source	Exposure Time	Image Tone	Tonal Separation
Arches 100% rag	white	photofloods	40 min.	brown	good
Twin Rocker straw	yellow	photofloods	40 min.	brown	fair
Twin Rocker 100% rag	beige	photofloods	40 min.	brown	good
Fabric					
Viscose rayon	off-white	sun	8—12 min.	brown	good
Bridal satin 100% acetate (dry clean only)	white	sun	8—12 min.	golden brown	fair
100% acetate (washable)	white	sun	8—12 min.	rust	fair

GAF and Rockland Surface Sensitizing

Canvas, fabric, paper, ceramics, glass, leather, wood, plastics—almost any surface can be sensitized with a liquid photographic emulsion—Rockland Print-E-Mulsion, GAF Template Emulsion, or the Kodak products.

Rockland Surface Sensitizing

Helmmo Kindermann stretches cotton duck canvas in the conventional manner. (Porous surfaces need no preparation. Hard surfaces require the application of a varnish, such as polyurethane.) Once stretched, the canvas is sensitized with a liquid photographic emulsion (Rockland Print-E-Mulsion) in the darkroom under standard safelight conditions, with a brush or by dipping, spraying, or rolling on the emulsion. When dry, the canvas is light-sensitive, similar to a standard bromide number 2 photographic printing paper. The image is then printed on the canvas from a photographic negative in an enlarger. The canvas is developed and fixed in standard photographic chemicals, washed, and dried.

At this point, Helmmo Kindermann applies paint and, in some cases, resensitizes the painted canvas surface and prints additional images.

Helmmo Kindermann, "Metamor-
phosis." Collage, sensitized canvas,
handpainted, 1974. 5½" × 4". *Cour-
tesy: Helmmo Kindermann*

GAF Template Emulsion

Janet B. Mackaig combines sensitized
papers, cloth, primed and unprimed can-
vas, with silkscreen. She often stuffs the
photographed form to achieve three-di-
mensional effects.

In a hot water bath (under 115° F.) under
a red safelight, the GAF emulsion is melted
in a glass or stainless steel container. The
paper or cloth is sprayed with two to four
coats. (Unused emulsion can be stored in
the refrigerator. Containers can be cleaned
with a bleach such as Clorox.) As in the
Rockland sensitization, the emulsion
should be allowed to dry in total darkness.
When dry, it can be exposed and developed
in standard photographic procedure. Wash-
ing time at the end of the process should be
one hour for paper and two to three hours
for fabric.

Janet B. Mackaig, "Ago-go Car Wash #2."
Silver screen background in black and silver.
Two graffiti insets. Direct photo emulsion
stuffed with polyester on Arches paper, 1975.
15″ × 22″. *Courtesy: Janet B. Mackaig*

Janet B. Mackaig, "L.A." Photo-silkscreen, direct photo emulsion, stuffed cloud and cow.
1974. 22″ × 30″. *Courtesy: Janet B. Mackaig*

Photogravure

Most ink processes are halftone processes. In order for the ink to appear as values of black to white—in tone gradations, gray areas are translated into tiny dots. The closer together the dots, the darker the gray value. When the dots are very small, the eye cannot see the separations unless aided by a magnifying device.

In order to separate gray values into dots, a mechanical grid is superimposed over the image. Different types and textures of screens are used.

Most printing processes use dots of varying sizes, but photogravure employs dots of varying depths (or areas), using either halftone or a high contrast continuous tone positive. As a result, the range of grays is greatly increased from eight, for the average photograph, to thirty-two grays in photogravure. That is probably why Rouault chose the photogravure method. The resulting colors were very rich. Plates were prepared mechanically for him based on his oil and watercolor originals, and then Rouault worked the surface of the plates for final processing by using gravers, burnishers, roulettes, and a small power grinder played over the surface to increase the range of values.

Randy Sprout has evolved the following approach to photogravure.

PHOTOGRAVURE USING MCGRAW COLORGRAPHY CARBON TISSUE
by Randy Sprout

The following materials should be gathered: copper plate, Brasso, denatured alcohol, ammonium dichromate, deionized water, window squeegee, metal tray (slightly larger than plate), plastic tray (slightly larger than metal tray), asphaltum, rosin bag, hot plate or alcohol box, halftone or continuous tone film positive, gravure carbon tissue made by McGraw Colorgraph (GAF Ortho Plasticopy Film).

The Basic Chemistry

The gravure carbon tissue is actually a strong paper with a thin coating of gelatin applied to its surface. This gelatin is light-sensitized, created by saturating it with a solution of ammonium dichromate.

Exposure to ultraviolet light causes the gelatin to harden under the clear areas of the positive, somewhat like a tanning process. When the gelatin is attached to the plate, it has varying degrees of thickness according to how much the ultraviolet light hardens any particular area.

A hot water wash removes the soft gelatin (which was protected by the dark areas of the positive) and leaves the metal bare and ready for etching.

Acid attacks this bare metal first and then gradually seeps through, etching in gradations depending upon the length of time the plate remains in the bath and how thick the gelatin is in a particular area.

The Film Positive

Since the acid etch is controlled by the gradation of the positive, as it affects the gelatin thickness, the film work can be a continuous tone positive, and this allows as many as thirty-two gray scale tones to be produced at a single biting. Most silver-

based photographic papers allow for only eight to ten gray scale tones. Gravure is far more accurate in printing subtle gray scale shifts in value. It will print everything you can put into a film positive.

Many artists prefer to use a special photogravure positive film (such as GAF Ortho Plasticopy Film) because it has been designed to give an extended gamma tail or foot. When you use the film, if the print highlights measure less than 0.50, increase the exposure. If the shadow densities exceed 1.30, decrease the development. I process most of my positives (using GAF Ortho Plasticopy Film) by developing them

in a very weak solution of Kodak H-C110 developer. This film has a very tough base that resists scratching, and when the developer is mixed 1:320, it gives a fair approximation of continuous tones.

Halftone positives also may be used as gravure. Not only will there be a change in the dot size, but also the depth of the dots will vary, resulting in a different range of blackness in the final print. The positive itself can be created by drawing directly on clear acetate with Kodak masking materials or asphaltum to create black lines or spatters.

Preparing the Plate

Copper is the only material that may be used. In biting zinc plates, nitrogen bubbles are formed. These would tear off the delicate layer of gelatin. Copper bitten in ferric chloride creates no bubbles.

Most copper plates are covered with a protective tape on both sides. This must be peeled off and the sticky residue removed by polishing the surface with Brasso. Any scratches should also be scraped and bur-

nished from the plate, and any remaining grease should be removed by flooding the plate with denatured alcohol. Blow it dry with compressed air. (Any grease left from fingerprints, and so on, will keep the resist from adhering to the plate.)

At this point a rosin aquatint is applied, much as is described in the photoetching process.

The copper plate is cleaned with Brasso.　　Alcohol removes any remaining grease from the copper plate.

Sensitizing the Carbon Tissue Paper

The paper that is coated with a thin layer of animal gelatin is red in color owing to the addition of iron oxide. This color has been added to make it easier to see how far development has progressed at the washing-out stage. Care should be taken in handling the dry paper because this thin layer of gelatin tends to crack, scratch, and tear easily.

The sensitizing solution is made by mixing 35 grams of potassium bichromate or ammonium dichromate (which is slightly faster) with 100 millimeters (1 liter) of deionized water. This solution should be cooled to 55° F. before use.

When the paper is dry, it has an inward curl (toward the gelatin side). The curl reverses as the paper is soaked in the sensitizer at 55° F. for three minutes. As the gelatin absorbs the sensitizer, it expands, causing the curl to reverse. At this point, the gelatin has been fully saturated or sen-

The ammonium dichromate is measured.

Note the inward curl of the carbon tissue paper as it is being cut to plate size.

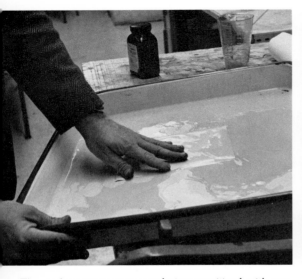

The carbon tissue paper is being sensitized with ammonium dichromate.

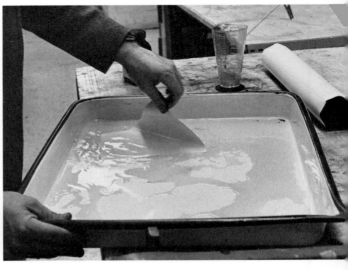

After the curl in the carbon tissue reverses, it is fully saturated and is pulled from the ammonium dichromate.

sitized.

The paper is now removed from the sensitizer and hung to dry. The best drying method is to pin the four corners with thumbtacks and use an electric hair dryer, maintaining low heat (too much heat will cause the water in the gelatin to get hot and melt the gelatin right off the paper).

Some artists recommend squeezing the wet paper on glass and drying it from the back. This works, but it also has the tendency to cause eggshell cracks if the resist does not dry evenly. It also takes longer.

Once the paper is dry, it should be cut to size, $1/4$ inch larger than the film work.

From the time the gelatin is sensitized, it becomes light sensitive. All the above procedures should be carried on while using a safelight or a yellow bug light that is mounted at least 6 feet from the resist.

The dried, sensitized paper may be stored for three days before exposure. After that, it tends to harden or become exposed. The older the paper gets, the faster it will react to ultraviolet light. Best results are obtained when the paper is used the same day.

Exposing the Resist

The most efficient light source is a bulb-type sunlamp (available at any drugstore). Exposure time is six minutes, with the tip of the sunlamp held 36 inches from the resist and the film positive held firmly in contact with the resist with a heavy piece of glass.

Any dust on the glass, positive or gelatin, will cause a black dot to form in the print because the dust will block the light.

Most bulb-type sunlamps have a delayed action (see photoetching). Begin timing when the light changes to a bluish tone. As in photoetching, use test strips of copper to determine ideal exposure times. The longer the exposure, the more gelatin is tanned or hardened and remains on the plate. This produces fewer darks in the final print. (Commercial arc lamps work well too. Run exposure tests.)

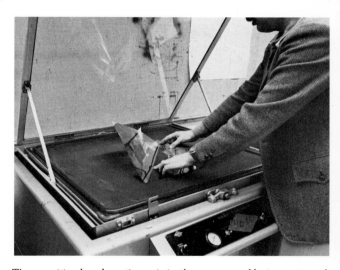

The sensitized carbon tissue is in the process of being exposed.

Making the Resist Adhere to the Plate

Heat the plate in deionized water at 85° F. You can most easily accomplish this by covering the plate with deionized water in a metal tray and floating this metal tray on hot water in a larger plastic tray.

Then cool some deionized water to 55° F. by using ice cubes in film cans or coffee cans that are set into the tray of deionized water. (Be careful not to pollute either tray or deionized water.)

Soak the exposed resist in the 55° F. water for three minutes, watching for the curl to reverse. This is the only point when the gelatin is sticky and will adhere to the warm plate.

Remove the warm plate from the tray and the cold resist from its tray. Place the resist, gelatin side down, on the warm plate starting from the center and squeegeeing it to both ends (using a squeegee). Be careful not to exert too much pressure because the soft resist will distort and record squeegee lines in the final print. Allow it to dry until the paper is dry to the touch (about ten minutes). If adhesion fails, check preceding steps. Look for water pollution as a cause.

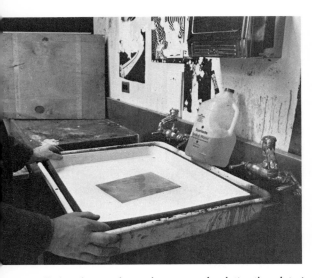

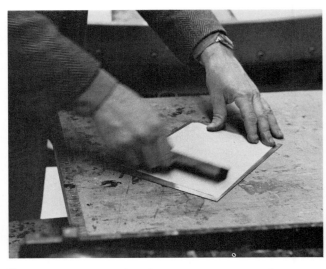

Before laying down the exposed gelatin, the plate is heated and the carbon tissue paper is soaked in cold deionized water.

The gravure resist is placed on a warm aquatinted copper plate after exposure and a three-minute soak in deionized water.

Developing the Resist

Place a tray near a constant 120° F. supply of running tap water. Insert the plate, paper side up, in the warm water and slowly rock the tray. At this point, the gelatin begins to soften under the paper and the paper can be lifted off leaving very soft gelatin on the plate.

Carefully lift the paper away while continuing to rock the tray. The softer gelatin, (unexposed) will wash away leaving varying thicknesses of gelatin on the plate (depend-

ing upon exposure). Development should continue until the red color has disappeared from the water and visual inspection indicates a clear negative resist left on the plate's surface. Dry the resist carefully, using your hair dryer, without heat for about ten minutes. (Heat will cause the resist to pop off and crackle.)

Don't try to block out any errors now. It is easier to correct for rips or tears in the resist later, with normal printmaking tools.

The exposed adhered tissue is developed. Note the hot water is causing the edges of the paper to curl up.

The paper backing is pulled from the carbon tissue, which is adhered to the plate.

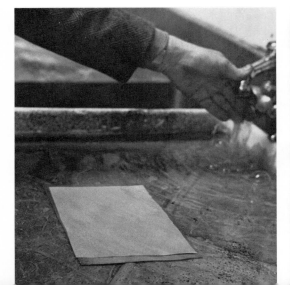

Biting the Plate

Ferric chloride is the best acid to use. It comes in either powdered form or premixed to a specific gravity. The instruction booklet that comes with the McGraw Colorgraphy Carbon Tissue Paper indicates a progression of bites at various specific gravities. After trying them all I found that hand-wiped plates need a deeper etch than the commercial rotogravure plate; therefore, a stronger acid should be used.

Another problem is that the acid may diminish in biting strength in about twenty minutes. Therefore, it is difficult to predetermine how long the plate should remain in the acid. Overall thickness of the gelatin resist and how this particular resist is holding up in adhering to the plate are two factors.

Another determining factor is that the rosin bubbles create a focus point. The effects are the same as in photoetching.

Whenever the gelatin is wet, it is extremely soft and rips at the slightest touch. For this reason many different methods have been devised so that the plate may be inspected while in the acid. Some artists use a sling made out of packing tape and wooden dowels. I tape pencils to the ¼-inch border and use the pencil thickness to support the plate, while the plate is facedown. This permits the residue from the copper to fall out of the holes the acid is creating rather than remain in the holes and hinder further biting. This also permits minimal agitation and helps prevent the soft gelatin from peeling back.

I find that my average biting time with ferric chloride, 42 Baume, is fifteen to twenty minutes. I begin careful visual inspection of the resist surface at twelve minutes, looking for the first sign of etching occurring on the edge of what I want to become a highlight. As the acid gradually seeps through and saturates the gelatin, small black dots gradually build up around the rosin particles. These black dots indicate where the acid has begun to etch. The plate should be bitten as long as possible to achieve a good rich black (in the dark areas) but should be removed before the highlights turn gray.

The gravure plate is being etched, facedown, in ferric chloride. Pencils are used as stilts.

Removing the Resist from the Plate

Once visual inspection has confirmed that the highlights are just beginning to peel back, the plate should be carefully removed from the acid and cold water very gently flooded across the surface. High water pressure will rip the resist. If there still is ferric chloride on the surface, at this point, a haze value will be evidence on the highlights of the final print.

After all the ferric chloride has been washed away, increase the flow and heat of the water to as hot as you can get it. This will melt the resist off the plate. Then blow dry with compressed air.

Ferric chloride is rinsed from the gravure plate after etching has been completed.

After the ferric chloride has been washed away, the plate is dried with compressed air.

Printing the Plate

Rotogravure plates in the industrial print shop are curved to fit the drum of the press and ink is wiped from the surface by a thick steel blade called a doctor. Wiping a hand-built plate with the edge of a razor blade creates wonderful scale and separation;

however, it cannot be controlled to provide an even wipe and there is the very real danger of the slightest piece of dirt getting under the blade and causing a scratch clear across the plate.

Since the etch quality of gravure plates

Randy Sprout, "Music as Light." Photogravure and dye transfer.

has a very fine tooth, the ink used must be looser than the normal intaglio ink mixture. In printing the plate, a 3:1 plate oil (burned) (or 2:1, if preferred), which is a rich loose ink, is first applied to a warmed plate until all holes are full. The plate surface is then wiped entirely clean with the softest tarletan (only). If the tarletan is stiff, its hard edges can pull out all the ink, leaving a white line.

Hand wiping with the heel of the bare hand is another excellent way to bring up the whites, particularly in highlight areas of the plate.

If desired, buffing the final wipe with a tissue such as butcher tissue, with no pressure exerted, will clean the bare metal highlights yet leave enough ink where it is supposed to be.

Many types of oil-based pigments can be used; just adjust their viscosities to correspond to the ink and plate oil (burned) consistency.

The procedures, here on in, are the same as for photoetching.

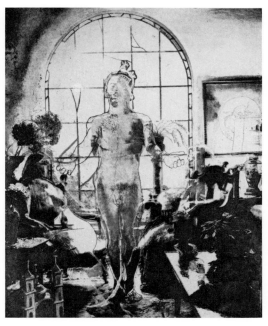

Randy Sprout, "Peggy and Ed." Photogravure and etching, 1976. 25″ × 20″.

The Dye Transfer Process

The dye transfer process is a method of making color prints via the color-separation process. It is an absorption process employing gelatin relief matrices—a sheet on which the image is "cast." The matrix film produces a relief image in the gelatin when exposed through a color-separation negative. If three colors are used in color separation—usually, yellow, magenta, and cyan—then each is soaked in an appropriate dye solution. The yellow is placed in contact with a gelatin-coated paper, which absorbs the dye. The matrix is removed, and the next colors are applied and registered to complete the print.

If you think of a film matrix as a "block" such as is used in block printing, the process is easier to understand. "Ink" or dye is applied to the "block" and printed (actually dye is applied to the matrix and printed). It is very closely related to hand-block printing.

The variables available to the printmaker, as departures from the central concepts, are numerous. The amount of dye in the matrix color mix in the dye bath, length of printing time when matrix is in contact with paper, the order of the color printing (sequence of colors), the order of different matrices that may be printed, registration of the matrices, wetness of the paper—are just a few flexible alternatives. Because of these creative variables, exact duplication is virtually impossible. Each print becomes unique. (For more on this process, see Kodak Pamphlet E-80, "Kodak Dye Transfer Process," available from Eastman Kodak Co., Dept. 454, 343 State Street, Rochester, N.Y. 14650.)

Above: Randy Sprout, "Easter Print." Dye transfer.

Top, right: Randy Sprout, "Abyss." Dye transfer.

Right: Randy Sprout, "Daydream at Jordin's." Dye transfer.

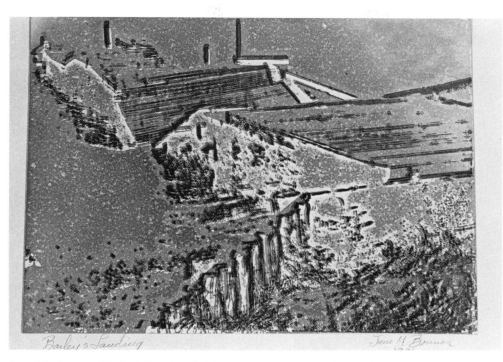

June M. Bonner, "Bailey's Landing." Silver and dye transfer, 1976. 8½″ × 11⅜″ *Courtesy: June M. Bonner*

June M. Bonner, "Urban Scrawl." Free dye transfer, 1974. 7⅜″ × 10½″. *Courtesy: June M. Bonner*

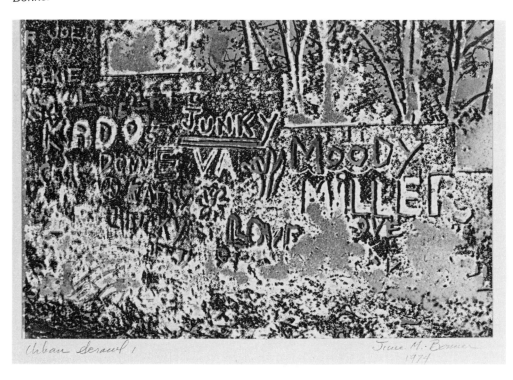

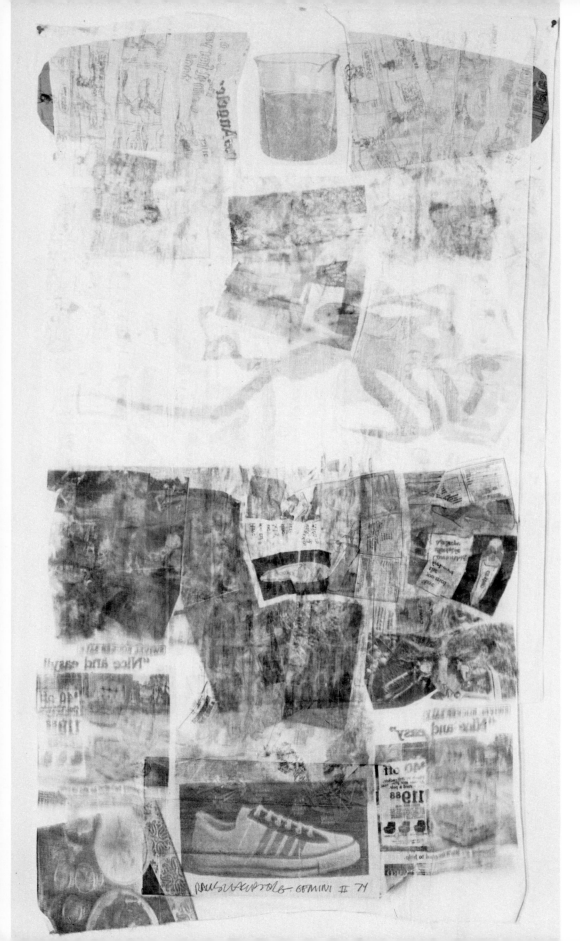

Opposite page: Robert Rauschenberg, "Mule." Transfer and collage. 65″ × 36″. *Courtesy: Gemini G.E.L.*

Robert Rauschenberg, "Pl 's Fours." Transfer and collage on fabric. 67″ × 95″. *Courtesy: Gemini G.E.L.*

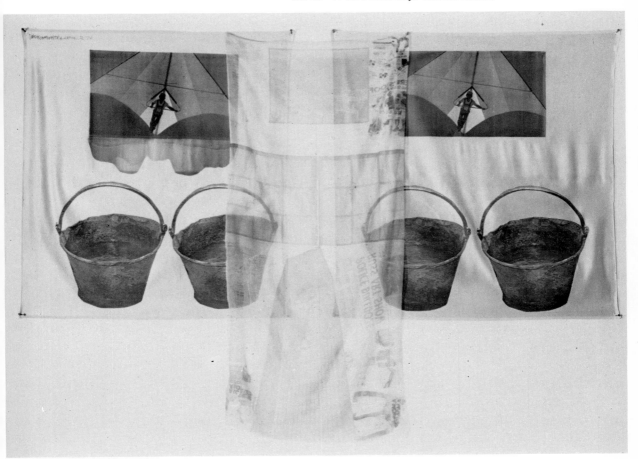

Jean Locey, "Lisa and Jeffrey." Gum bichromate on linen, stitched and stuffed. 24" × 24". *Courtesy: Jean Locey. Photo by Kate Keller*

The Print Gone Soft

A Survey

The printing of textiles is an ancient craft. Indian forms date back to the fourth century B.C., and in Mesopotamia fabrics were printed five thousand years ago. Although it is impossible to pinpoint the beginning of textile printing because fabrics decay easily, it is evident from extant printing tools, such as stamps, blocks, and cylinders, that fabric decoration is one of the earliest applications of printing.

At first, printed fabrics were used essentially for clothing; patterns and colors often defined status, occupation, and region. Other decorative applications followed, and, of course, printed textiles inspired and influenced printmaking on paper. But, at an early point, fabric and paper printing parted company, and both areas have developed primarily in independent directions.

Although there were fine art dimensions to use of textiles, particularly in tapestry and in painting on canvas, neither of these utilized printmaking concepts. Except for an interlude during the American and French revolutions when scenes, mythological designs, and political events were printed on fabric, principally through copper engraving, it wasn't until very recently that fabric became an acceptable base for the fine art print.

When fabric was first rediscovered as a print base, there was no real difference between printmaking on paper or on fabric. Both materials were treated the same way. But because textiles can be manipulated more easily than paper—draped, stuffed, sewn, embroidered—printmaking soon grew into another dimension. We now have the soft print, one that may be two-dimensional or three-dimensional. The print is now stuffed, stitched, and combined with other materials.

Annette Bird and Marion Baker use intaglio printing on fabric, sometimes cutting apart or sewing and stuffing the print. Laura Blacklow makes soft visual books and quilts using brownprinting and blueprinting, silkscreen, and photosensitized fabric. Susan Haller also employs non-silver printing techniques and blows up forms to life-size proportions, sometimes stuffing them (see section on brownprinting). James Sanders III combines many processes, using photosensitized fabric, color Xerox iron-on transfers, touches of color to specific areas, applied by Pentel dye crayons, Procion dye, as well as embroidery.

Jean Locey and Betty Hahn print on fabric, sensitizing it with gum bichromate and then lightly stuffing and stitching their prints.

Robert Rauschenberg in the "Hoarfrost Editions" (Gemini G.E.L.) employed transfer and collage by offsetting printed images to cheesecloth, satin, and China silk. These were then attached collage-fashion to different backings.

Joe Goode in his *Wash and Tear Series* (Gemini G.E.L.) sprayed polyester open-screen water-base ink on rayon satin fabric. Two layers, the top of smooth fabric and

an underlayer of dark blue velvet, were stitched together all around, and the outer layer was slashed by Joe Goode; each in the series was a little different.

Gay Burke has created a soft daguerreotype on photo-linen, processing it like a regular photo, and then cutting, sewing, stuffing, embroidering, and hand-coloring areas. Linda Lindroth also uses photo-linen and sews parts but produces more two-dimensional forms.

Catherine Jansen Larson's pieces utilize photo elements and become large (life-size) soft renditions of the real thing.

ETCHING ON FABRIC
with Marion Baker

Ink is spread on an etched zinc plate.

The plate is wiped with a tarlatan.

A newsprint mask is torn so that the final print will have soft edges and no plate mark. This is important when images are to be repeated.

Above: Damp cloth with natural fibers (cotton, silk, linen) is placed over the plate.

Above, right: The plate is run through the press.

A sandwich is made of the print with a Dacron batting as a filler and a fabric backing.

The piece is pinned and stitched (as for quilting), usually around contours of images.

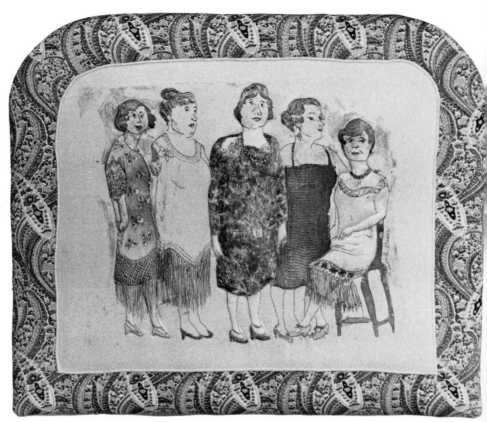

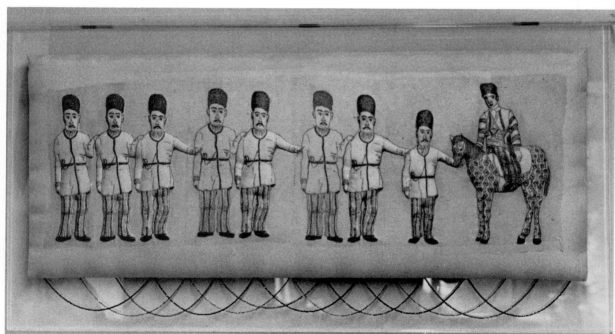

Opposite page:
Top: Marion Baker, "The Girls." Etching on cotton. 20″ × 17″.

Bottom: Marion Baker, "Series of Turks." Etching on silk, quilted, bead loops on bottom. 32″ × 13″.

Right: Annette Bird, "Pattern for a Soft Waterfall." Etching on zinc plate, intaglio wiped with blue black ink and then overlaid with six different color stencils (on the plate) before printing on fabric in one run. 18″ × 24″.
This print is a two-dimensional print and also is designed to be cut out, quilted, and stuffed in the three-dimensional version.

Below: Annette Bird, "Soft Waterfall." The three-dimensional version is a unique print— cut out, quilted with polyester batting, sewn together, and then stuffed. *Courtesy: Annette Bird. Photos by Kenneth Peterson*

Below, right: Annette Bird, "Natural Bridge." A three-dimensional etching constructed from six prints on cotton cloth. The six prints were sewn together, stuffed, and shaped into the bridge form. The base is a second, collagraph plate. *Courtesy: Annette Bird. Photos by Kenneth Peterson*

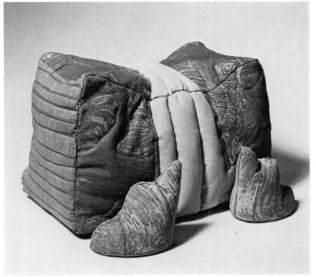

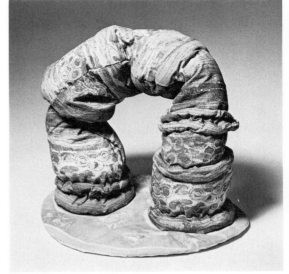

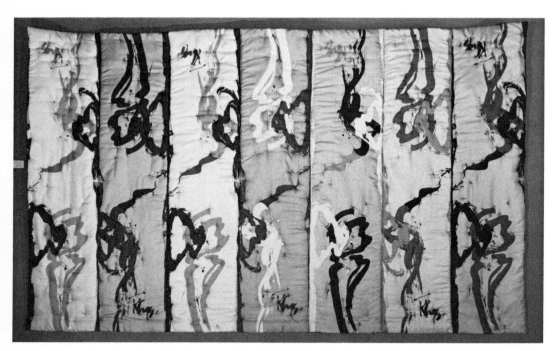

Gordon Kluge, "Flexing Rainbow." Screen print printed with dyes from several photo-screens made from the artist's acetate drawings. Pieced and quilted by hand. 90″ × 70″. *Courtesy: Pratt Graphics Art Center*

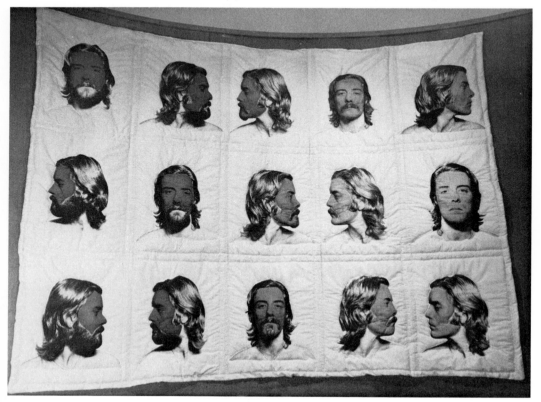

Brooke Larson, "Self-Portrait Action Quilt." 60″ × 80″. Hand-colored screen print, pieced and quilted by the artist. Individual photo-screen stencils were made from the artist's photographs, converted to halftone through the use of auto-screen film enlarged onto Kodalith film. The artist hand-colored the printed pieces before assembling and quilting. *Courtesy: Pratt Graphics Art Center*

Kathleen Caraccio, "Diamond in a Square." 76″ × 76″. Etching and engraving pieced and machine quilted with additional stuffing and trapunto quilting.
Rainbow and fade-out inking techniques were used. The cube illusion within the diamond shape is achieved by fading blue corners interacting with hue changes across the border bands. The embossed effect was achieved by trapunto quilting. After being quilted with a machine stitch, the backing was slit open and additional polyester was stuffed into the specific areas and then the slit was sewn. *Courtesy: Pratt Graphics Art Center*

Laura Blacklow, stuffed book, seven pages, photo-emulsion on canvas. Hand-colored with oil and watercolor paints. *Courtesy: Laura Blacklow*

James H. Sanders III, "May Dance Document: Rhas." Machine embroidery on synthetic fabric with Kwik Proof photosensitive dye, piped, trapuntoed, and quilted. 1976. 25" × 29". *Bottom left:* Detail.
Courtesy: James H. Sanders III

James H. Sanders III, "Diamonds for Douglas." Kwik Proof photosensitive dye on nylon, dye crayon, quilted. 1976. 48" × 76". *Courtesy: James H. Sanders III*

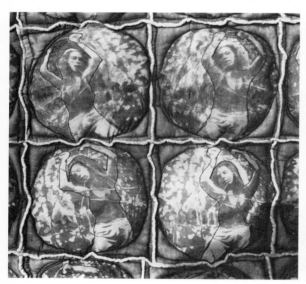

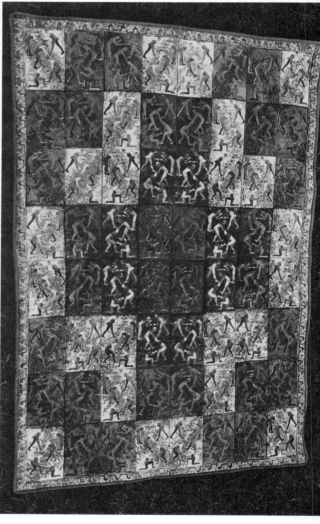

Betty Hahn, Untitled from series *Who Was That Masked Man? I Wanted to Thank Him!* Vandyke print and fabric collage, 1975. 18″ × 22″. *Courtesy: Betty Hahn*

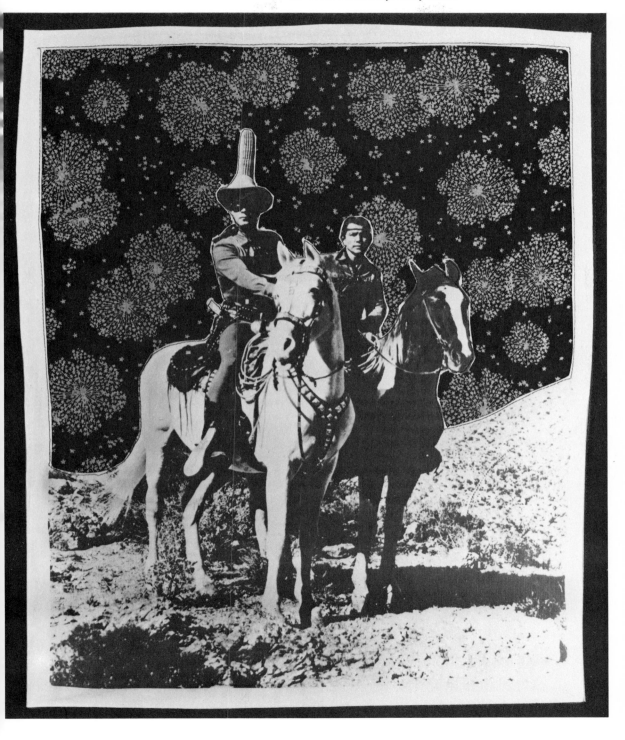

Marion Baker, "Fish to Fry." Linoleum-block-printed-fabric stuffed fish attached to enamel frying pans. Series of three.

Betty Hahn, "Bracketed Exposure." Gum bichromate on muslin with quilting, 1972. 45″ × 14″. *Courtesy: Betty Hahn*

The Processes

Textiles traditionally have been decorated principally by the application of pigments, dyes, or related materials (such as photosensitizing solutions) delivered by hand or machine, through blocks, roller, screen, or camera directly, through discharge (applied color is subtracted by reagents or reducing agents contained in a print paste) or resist (areas protected or blocked from receiving color).

A new type of printing called sublistatic printing has developed along with the use of polyester fabrics. The image is printed on paper with specific dyes; paper and fabric are placed one over the other and passed together through a type of hot calender. The pattern is transferred by heat from paper to fabric. Halftone effects can be achieved in this process.

In all processes, the viscosity of the print paste bearing the color or reagents is important, as is the specific kind of dyes and methods of fixing the dye (steaming or aging), and the final washing.

For the most part, however, images can be applied to fabric much as one would print on paper—as long as the idiosyncrasies of a particular textile are taken into account. Photosensitive emulsions formulated specifically for fabric are available for photo-silkscreen and photo-projection (enlarging) applications. Some brands are compounded for contact (speed) printing on cotton, silk, or linen; others for projecting images via an enlarger. Application of emulsion and exposure are the same whether for fabric or paper, with the exceptions that more emulsion is needed to cover the same area of fabric and that it takes longer for solutions to dry on fabric than on paper.

Photosensitive gums can be combined with dyes to impart both color and image, as in gum printing on paper.

Also, Xerox iron-on transfers can be used (see section on Xerography). Xerox images are made and ironed onto the fabric. The Xerox machine can be controlled to vary the intensity and color range of the transfer.

It is also possible to hand-color images using Pentel dye crayons or AD markers, Procion dye thickened with alginate thickener, or acrylic paint.

Besides photo processes and the use of block prints and silkscreen, fabric can also be printed by etching, using zinc or copper plates, as in a standard intaglio process.

Joe Goode spraying watercolor on a layer of fabric.

Joe Goode and Anthony Zepeda hanging the fabric to dry.

Joe Goode, Untitled from *Wash and Tear Series*. Three-color, two-layer screen print, 1975. 28¾" × 38½". Joe Goode explores concept of inside versus outside with a bit of controlled vandalism. *Courtesy: Gemini G.E.L.*

Below: Vivian Kline, "Ancestral Earn," purse. Twenty-four images are photo-silkscreened in enamel on metal and fired. *Courtesy: Vivan Kline*

Janet B. Mackaig, "Zebra." Direct photo emulsion (sprayed) on canvas, and stuffed, 1974. 3' × 4'. *Courtesy: Janet B. Mackaig*

Opposite page: Linda Lindroth, "Self-portrait as Nude Descending Staircase." Photo emulsion on muslin, with crayon and charcoal. Machine sewn. 1973. 36" × 42". Twenty-four individual photographic images are enlarged on sensitized muslin. *Courtesy: Linda Lindroth*

Gay Burke, soft daguerreotype on photo-linen. Hand-colored, embroidered, stuffed, covered with clear plastic, and sewn into a case that is padded with foam and covered with fake fur. *Courtesy: Gay Burke*

Gay Burke, photo-linen, lace, and collage elements sewn and glued. *Courtesy: Gay Burke*

Catherine Jansen Larson, still life with photographic elements, stuffed. *Courtesy: Catherine Jansen Larson*

Catherine Jansen Larson, bathroom scene with photosensitized fabric, sewn and stuffed. Life scale. *Courtesy: Catherine Jansen Larson*

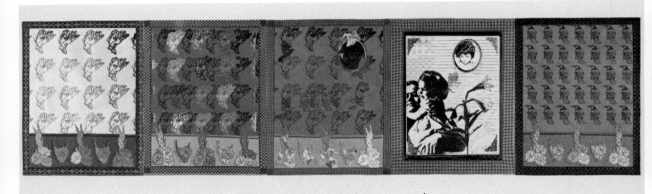

Lyn Mandelbaum, "A Madonna with Child." Photo-silkscreen on fabric, sewn, 1972. 26″ × 100″. *Courtesy: Lyn Mandelbaum*

Detail of "A Madonna with Child." *Courtesy: Lyn Mandelbaum*

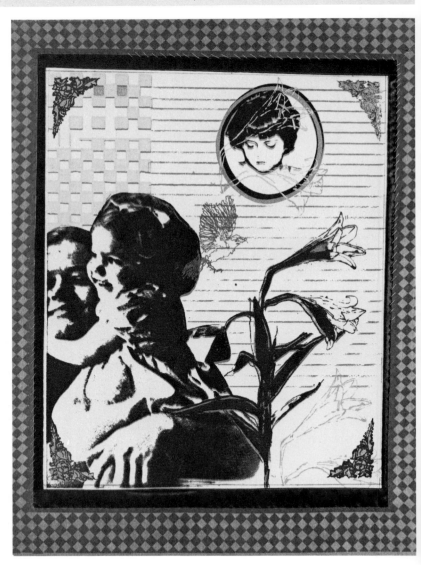

Lyn Mandelbaum, "Rug, 5." Photo-silkscreen, rug hooking, stitching, 1972. 42″ × 44″.

Janet B. Mackaig, "Extinct American Passenger Pigeon." Photo-silkscreen on canvas (grass), direct photo emulsion (stuffed gravestone), sewn on background, 1973. 15½″ × 21″. *Courtesy: Janet B. Mackaig*

Janet B. Mackaig, "Dead American Soldier." Photo-silkscreen on canvas (grass), direct photo emulsion (stuffed gravestone), sewn on background. The sentiment is on a soft gravestone, 1973. 15½″ × 21″. *Courtesy: Janet B. Mackaig*

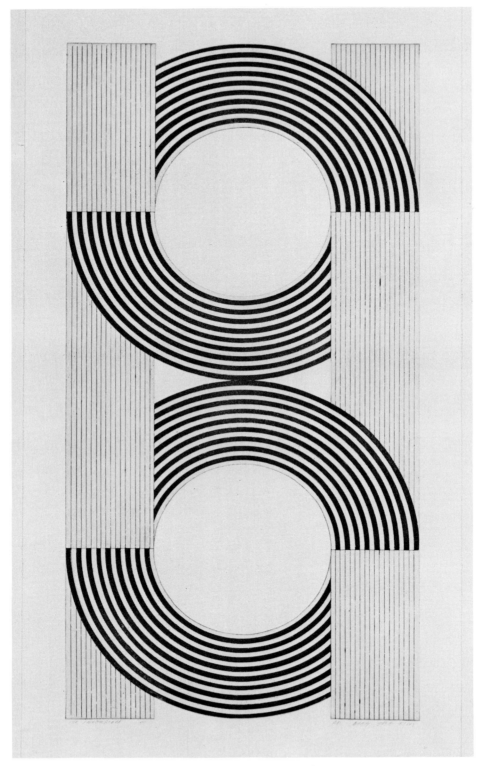

Bong Tae Kim, "ISC Inversion." Color etching and relief. 26″ × 40″. *Courtesy: Bong Tae Kim. Photo by Kenneth Peterson*

The Print in Relief

Embossing

Not only fabric has been used to create forms in bas-relief, but paper has also. Wet paper can be embossed when placed under pressure. (It also can be cast into three-dimensional forms, as we shall see later.) Light then plays a major role in modulating the textured projections from the plane surface of the paper. Artists have taken advantage of this—printing without use of color in the imagery, solely employing embossment, as Josef Albers did in his "Embossed Linear Construction: 1-A" (Gemini G.E.L.).

If an uninked plate containing incised lines and shapes is run through an etching press with damp paper, the paper will be compressed into the incisions forming raised areas. Any intaglio process—whether engraving, etching, drypoint, or aquatint—and a variety of similar techniques will do this. The incised image will "print" as the color of the paper. Color may be superimposed over the embossment.

EMBOSSING JOSEF ALBERS'S LINEAR CONSTRUCTIONS AT GEMINI

Female mold of the engraved aluminum plate for paper embossings. In collaboration with Josef Albers, Ken Tyler and an engineering programmer work out exact profiles for each line and the proper thickness of the paper by computer. The engineering programmer translated the original Albers drawing to a digital Mylar tape. The tape then directed an automatic engraving mill that was equipped with specially designed cutting heads to cut into the printing plates in mirror image of the original drawings. *Series Courtesy: Gemini G.E.L.*

153

Inking the engraved plate in relief.

Placing wet Arches 140-pound (300 grams) watercolor stock over the inked plate.

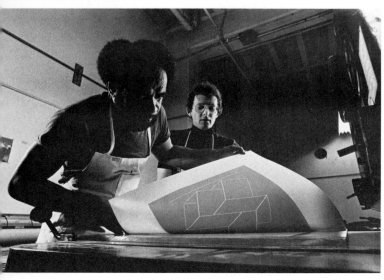

Inspecting Albers's "White Embossings on Gray" at the Hoe Embossing Press. Heat and pressure permanently mold the image into the paper fibers. The result is finely defined raised lines on a flat paper field.

Josef Albers, "Embossed Linear Construction: 1—A." Inkless intaglio embossment. 20¹/₁₆″ × 26³/₃₂″.

Roy Lichtenstein, "Mirror #1." Four-color linecut/photo-silkscreen embossed. 28″ × 28″. *Courtesy: Gemini G.E.L.*

Another hydraulic embossing press (M.A.N.)

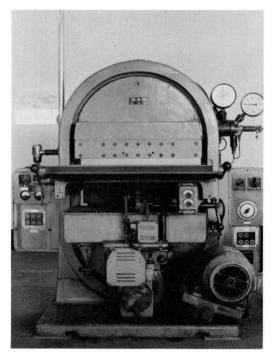

The Collagraph

The collagraph is essentially an intaglio process, too. But unlike engraving and etching, in which parts are scratched or subtracted from the plate, the collagraph plate is an additive form, constructed like a collage. It may employ many elements, even pieces of etching plates. In fact, Glen Alps named this form in the 1950s after the collagelike qualities of the printing vehicle. A great deal of manipulation of the plate is possible. It can be inked or run through a press inkless, as in embossing.

Even though artists have experimented with similar types of plates, the collagraph is a relatively new printmaking medium. Pierre Roche in Paris developed a technique called gypsograph in the late 1800s in which he built up the surface of his image (on the plate) using gypsum and printed two-color gypsograph's (one was "Alques Marines"). But the collages and assemblages of Braque, Picasso, Schwitters, and Gris in the early twentieth century were the real inspiration for this kind of printmaking. The Dadaists and Surrealists also experimented in collage forms rich in texture. So did Paul Klee, in the 1920s, when he utilized burlap, silk, tin, and other "found" materials. And as mentioned earlier, Rolf Nesch created metal plates (in the 1930s) and printed them as deep embossments. Nesch's work predicted innovations that took twenty to thirty more years to take hold. Working with Nesch in the fifties, Michael Ponce de Leon reflected Nesch's influence and created exceedingly complicated and thick metal collage plates—so deep that he had to use a hydraulic press that exerted one hundred pounds of pressure per square inch to print them.

Glen Alps in Washington, Dean Meeker in Wisconsin, James Steg in Louisiana, Edward Stasack in Hawaii, and Clare Romano and John Ross in New York continued to experiment and expand the potential of the collagraph, inspiring students and adding to the technical range, recognition, and popularity of the new medium.

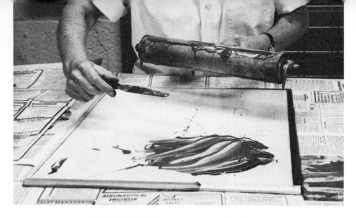

PRINTING A COLLAGRAPH

with Lida Hilton

Ink, which has been extended with Crisco (for better flow), is mixed on a sheet.

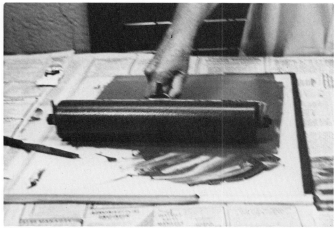

Ink is rolled out so that the brayer can apply color evenly.

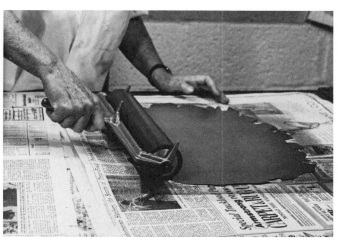

The brayer deposits ink on a piece of mat board that had been textured with acrylic gesso and modeling paste.

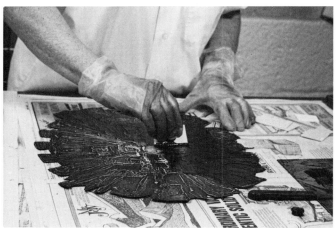

A piece of mat board is used to move the ink into crevices. Then tarlatan is used to wipe off excess ink and further distribute it.

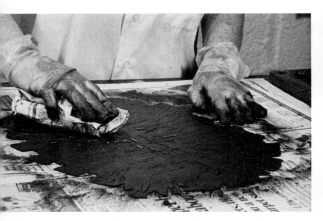

Newspaper "wipes" in highlights. For a second color, the process is repeated.

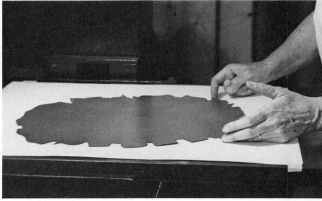

At the press, the first plate is placed on a sheet of oaktag that had previously registered the exact location.

The damp printing paper (taken out from between blotters) is placed over the inked collagraph plate.

A blanket is placed over the whole and the press is rolled.

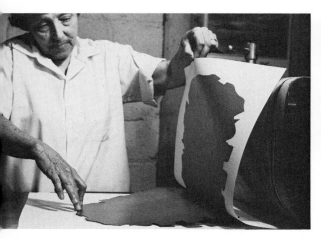

The plate is removed, but the paper is still partially attached under the roller and a second inked collagraph plate is placed at registered points on the paper. The inked paper is lowered onto this plate, and, with blanket in place, the piece is run through the press.

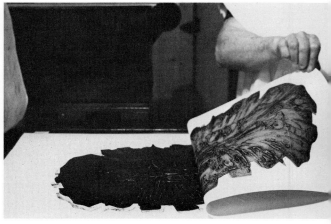

An impasto effect comes through, embossing the paper.

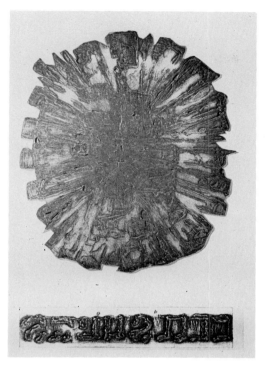

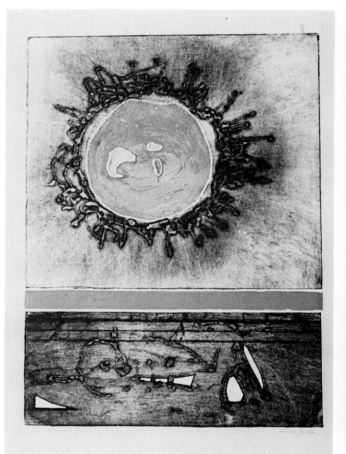

Lida Hilton, "Sunburst." Collagraph in two colors, black and red.

Lida Hilton, "The Sun." Collagraph.

Lida Hilton, "Las Vegas." Collagraph triptych.

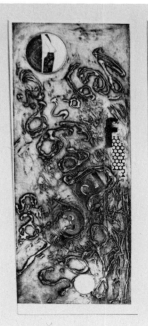
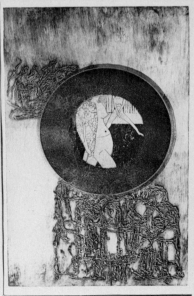
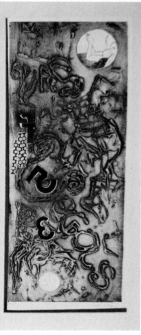

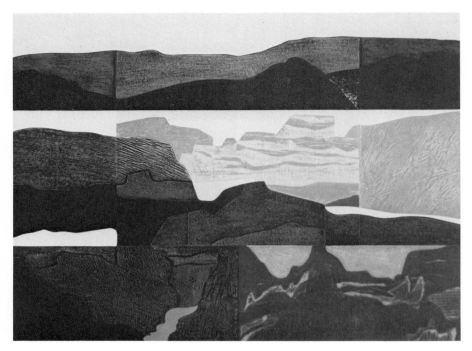

Clare Romano, "Grand Canyon." Ten-color collagraph, full sheet of Arches Buff, seven-piece segmented plate, 1975. 22″ × 30″. *Courtesy: Clare Romano*
The plate is segmented in seven parts, constructed of cardboard, paper, and sand, and adhered with acrylic gesso. The gesso is also used for certain textured areas. When the plate is completed, it is sprayed with acrylic (Krylon) to facilitate wiping and cleaning. The individual parts of the plate are inked separately in intaglio and relief, using ten colors. These are assembled on a Brand Press and printed on a full sheet of Arches in one printing. The use of a segmented plate, plus the combination of etching and relief inks of different viscosities applied with rollers of varying degrees of softness and hardness, enables the artist to use the wide range of brilliant color.

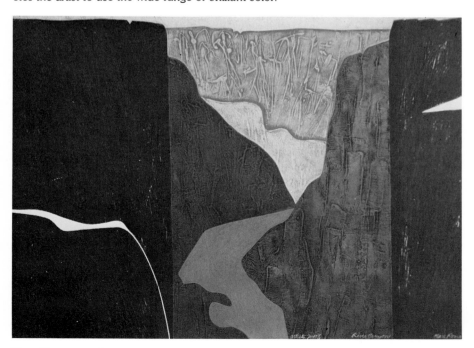

Clare Romano, "River Canyon." Collagraph with six colors, four-piece segmented plate, Arches Buff full sheet, 1975. 22″ × 30″. *Courtesy: Clare Romano*

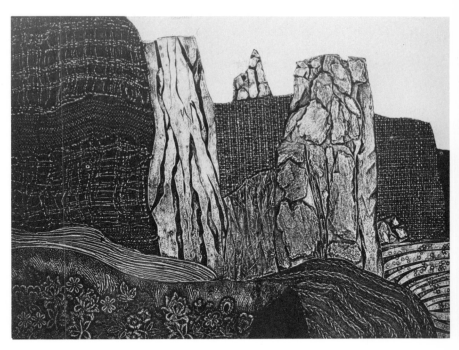

John Ross, "Monolith." Collagraph, black and white, part of a quadriptych. Arches cover. 22½″ × 30¼″. *Courtesy: John Ross*
The plate is made from mat board, which is used as a base. Upholstery fabric, an old sweater, sand, torn paper, cardboard, and burlap are used to texture, and acrylic gesso is applied as glue and as a texturing agent. The surface is further sealed with gesso and clear acrylic spray. The plate is printed on Arches cover on a Brand etching press.

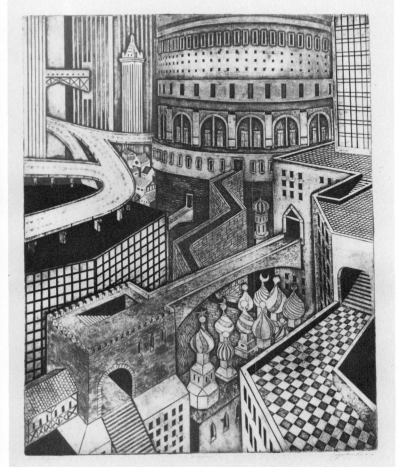

John Ross, "Coliseum." Collagraph in four colors, Arches cover, 1975. 24½″ × 18¾″. *Courtesy: John Ross*
The plate is made from mat board. Shapes are cut from mat board and thin cardboard and glued with acrylic polymer gesso. Detail is cut into the surface with a new single-edged razor blade. Parts are textured with sand, rough paper, and gesso.

The Process

Collagraph plates often begin with two- or three-ply cardboard or ⅛-inch to ¼-inch tempered Masonite, zinc plate, heavy acetate, acrylic sheet—and almost any material that will accept glued elements can be utilized.

There is no limit to the material that can adhere and has adhered to this base: cardboard, paper, fabric, wire, screening, assorted found objects such as container lids, bottle caps, gaskets, sandpaper, sawdust, coffee grounds, crushed shells, and so on. There are few limits. Acrylic modeling paste or gesso can also be applied in shallow relief.

The very abundance of usable materials can create difficulty in achieving effective results. The collagraph plate can easily become an end in itself, rather than a printing vehicle. Faced with this embarrassment of riches, the artist must learn to control depth and texture and to manipulate materials to achieve the effects desired for embossing or for achieving a range of tonal values (for pigmented areas).

Elements should be made to adhere to the plate in relatively even relief, without too many mountains and valleys. A strong bonding agent, such as epoxy, is necessary to attach diverse materials to the base securely. (If the plate is Masonite or metal, edges are beveled so that the hard edge, when under great compression, doesn't cut the paper.)

After all parts are affixed, spraying or coating the surface with acrylic or polyurethane will facilitate the inking/wiping process later.

The plate is inked as is an intaglio plate. A soft ink is used, spreading and wiping with tarletan.

Printing of the plate on dampened paper can be accomplished in an etching press by adjusting the height of the bed to accommodate for the depth of plate relief and by using assorted blankets of wool and/or foam rubber. The number of blankets and amount of pressure must be manipulated until the desired impression is achieved.

The Great Departures: The Print as Cast Paper

Fine quality paper, often handmade, has long been a prerequisite of good prints. Artists who wanted their works to last were concerned about permanence and wanted to use paper that would endure. But although part of a paper's quality is its suitability for different purposes and processes, few artists, until recently, became involved in the production of paper. Smooth finished paper, used for etchings, engravings, and lithographs, served well enough in those applications.

Perhaps inspired by the thick impasto of Vincent Van Gogh's work and the use of found materials in the shallow relief of the collage, artists became more interested in the physical qualities of surface and the textural component of paper. More directly, the collagraph and the use of embossing invited a new look at the dimensional attributes of paper and what the paper surface could do.

Karel Appel's "Il Fait a Forte Tête," and "Faible Femme Sur Eau Rouge" (1975), for example, are heavy embossings on handmade paper. More than that, these pieces are etchings done with a dry paper, made of pure chiffon (it is called Moulin de Puymoyen and is made in Angoulême, France).

Karel Appel, "Il Fait a Forte Tête." Etchings on dry handmade paper (Moulin de Puymoyen) with heavy embossing, 1976. Published by Alexander Kahan and ABCD Gallery. *Courtesy: Kahan/Esikoff Fine Arts Ltd.*

Karel Appel, "Faible Femme sur Eau Rouge." Embossed etching on dry handmade paper. Published by Alexander Kahan and ABCD Gallery. *Courtesy: Kahan/Esikoff*

163

Golda Lewis often casts her own paper and imbeds materials directly in it during the casting process. (Note wool yarn in the clothing of "Torso.") As paper becomes an element of the form, its textures and colors become an integral part of the work. In both Appel's and Lewis's pieces, richly textured paper is combined with traditional processes. In Lewis's case, the inked image is lithographed in "Torso" and hand-painted in "Tree."

Golda Lewis, "Torso." Lithograph on handmade paper (from Upper U.S. Papermill, Oregon, Wisconsin) with collage elements, such as inserted slits of paper and wool yarn, embedded in the paper when the paper was made. Use of lightfast powdered paper pigments (Cities Service, Columbia Carbon Division, Imperial Paper Color). 39″ × 31½″. (Edition: 35). *Courtesy: Golda Lewis*

Golda Lewis, "Tree." Tree is made of cast paper, leaf part has a wire mesh structure to help project the tree area into a bas-relief. Hand colored. 25½″ × 15½″. (Edition: 35.) *Courtesy: Golda Lewis*

As paper has become more a part of the print, artists have become more directly involved in the process of creating it: manipulating and controlling the paper casting and production processes to achieve particular effects (as well as creating inked images). In some cases, the paper is the image.

Artists have discovered that there is nothing extremely difficult about papermaking, and they have found cast paper to be a medium as unique and responsive as any other. Paper casting can yield high-relief impressions when cotton linters are beaten with water into a pulp and cast over three-dimensional objects or collagraphlike plates. Prints become sculptural in quality.

Robert Rauschenberg collaborated with papermakers at Richard de Bas paper mill

in Ambert, France (August 1973) and created a series, in eleven editions, called *Pages and Fuses* (Gemini). (Paper has been made by hand at this plant site since the fourteenth century.) Master papermaker, Marius Peraudeau, completed some of these editions following Rauschenberg's original pieces.

In "Page 1," however, Rauschenberg did the essential forming himself. For each piece, the artist laminated a rag into wet paper pulp as he poured the pulp onto a wire mesh (no mold was used for this piece). The pulp was poured freehand. Each piece was unique. After it was formed, the work was pressed to squeeze out excess water and left to dry naturally. (Even Rauschenberg's signature is embossed.) Since the artist intended that the piece be viewed from both sides, and be held, a special drawer was designed to contain the print.

Other works of this series were cast in molds, often using lightfast pigments in the pulp. In "Link," Japanese tissue paper was screen printed and laminated into the wet paper pulp.

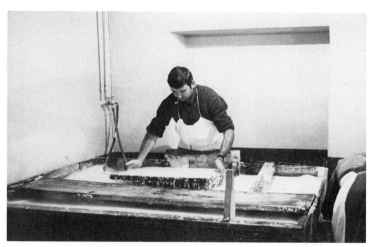

ROBERT RAUSCHENBERG'S CAST PAPER SERIES

Pages and Fuses through Gemini

This series was created at the Moulin à Papier Richard de Bas in Ambert, France.

The papermaker at the Richard de Bas paper mill dipped a mold into a vat containing pulp that was colored with lightfast pigments.

Excess water drains off the mold.

The paper is deposited on felts.

Robert Rauschenberg pours paper pulp to form "Page 1" of *Pages and Fuses* series.

Robert Rauschenberg placing twine on paper.

Some pieces contain laminated bits of rag. Here, Rauschenberg prepares a rag for inclusion. After elements were added, the pieces were pressed and left to dry naturally.

Robert Rauschenberg, "Page 1" from *Pages and Fuses*. Handmade paper and laminated rag, 1973. 23″ × 28″ variable. (Edition: 27.) *Series Courtesy: Gemini G.E.L.*

Robert Rauschenberg, "Link" from *Pages and Fuses*. Elements were screen printed with magazine images on Japanese tissue paper and laminated to wet paper pulp, 1973. 25″ × 20″. (Edition: 29.) *Courtesy: Gemini G.E.L.*

Ronald Davis, working with Ken Tyler, created a series using mixed media—color-aquatint-etching-drypoint on multicolored paper. "Bent Beam," an example in this series, consists of seventeen colors, fifteen applied directly to the paper and two printed from intaglio plates. Ken Tyler and papermaker John Koller collaborated (with Ron Davis) to create an acrylic mold system in order to maintain unique shapes and areas of color.

With this process the artist was able to cast pigmented pulp and blend and register the fifteen colors in the paper with precise printed ink colors from Davis's two hand-drawn copper printing plates. (The plates were created via aquatint, etching, and drypoint.)

RONALD DAVIS "BENT BEAM" PROJECT
1975 AT TYLER WORKSHOP

Above: Acrylic molds that will be used to form areas of dyed pulp (units that were laminated later to a flat sheet). The final print consisted of twelve colors applied in the papermaking and three colors printed from intaglio plates.

Right: Kenneth Tyler mixing dyed paper pulp that will be spooned into the acrylic molds.

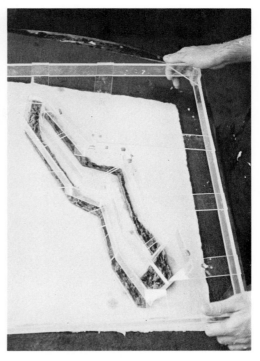

Papermaker John Koller spooning the dyed pulp into the mold and onto a newly formed sheet of handmade paper.

The acrylic mold is being lifted away from the newly molded sheet.

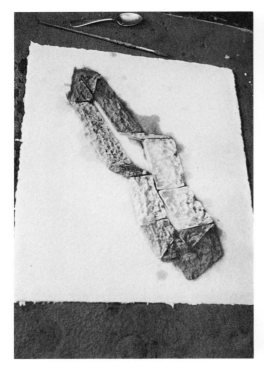

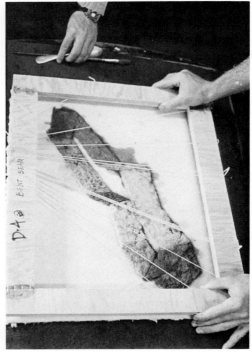

The wet paper pulp just after removal of the acrylic mold (and prior to pressing).

Testing the placement of string lines over the newly laminated pulp.

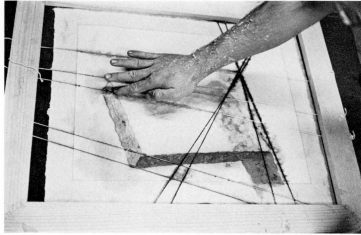

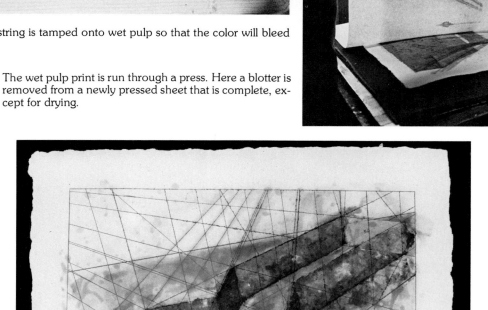

Dye-charged string is tamped onto wet pulp so that the color will bleed into it.

The wet pulp print is run through a press. Here a blotter is removed from a newly pressed sheet that is complete, except for drying.

Ronald Davis, "Bent Beam." Two-color aquatint with etching and drypoint on fifteen-color handmade paper. Through this process, the artist was able to blend and register twelve colors in the paper and coordinate it with the precise printed ink colors from his three hand-drawn copper printing plates. 1975. 20″ × 24″. *Series Courtesy: Tyler Graphics Ltd.*

Frank Stella's *Paper Reliefs* are a series of original hand-colored multiples, also produced at Tyler's Workshop with Ken Tyler and papermakers John and Kathleen Koller. Molds constructed of hand-sewn brass wire strung on mahogany frames were made for each relief. After the initial forming with paper pulp, paper collage and color dyeing were done during the wet stage. Once the paper relief had dried, each piece was individually colored by the artist using casein, watercolors, and dyes.

MOLD MAKING AND PAPERMAKING FOR FRANK STELLA'S PAPER RELIEFS AT TYLER WORKSHOP

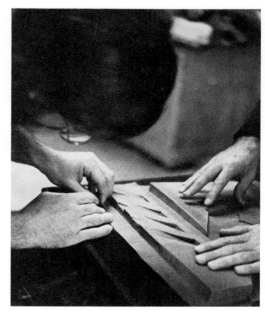

Shaping the wire mesh screen of hand-sewn brass wire to be used to form the paper pulp into shaped paper multiples.

Attaching the shaped wire mesh to a standard laid-line papermaking mold.

Above:

Left: The completed shaped mold.

Center: Papermakers John and Kathleen Koller assisted in this series. Here the shaped mold is dipped into the all-rag paper pulp.

Right: The mold is pulled from the vat leaving a deposit of paper pulp on the screen. Water drains through the mesh.

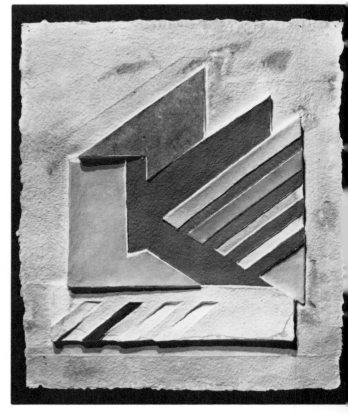

Frank Stella, "Grodno I." 1975. 25½" × 21½" × 1¾". (Edition: 26.) After the first trial proofs were formed in white pulp, Stella designed color patterns for dye and paper collage. The process of coloring and collaging was carried out during the wet stage of forming each relief. Once the paper dried, each piece was individually hand-colored by the artist, using casein, watercolors, and dyes.

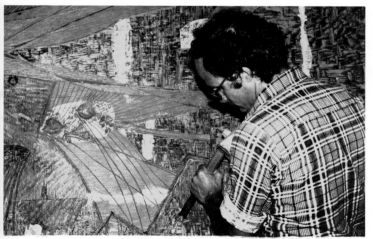

PAPER CASTING IN WOODEN MOLD
with Richard Royce

Richard Royce carves a wooden mold for his 8′ × 8′ cast paper relief "Atlantis."

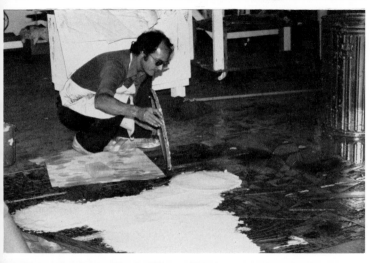

Paper pulp is laid up into the mold.

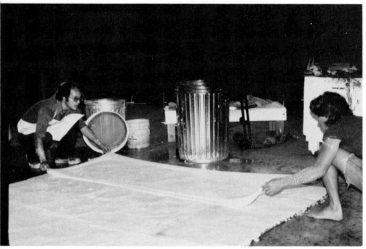

Cheesecloth is laminated to the wet pulp to strengthen the large casting. *Series Courtesy: Richard Royce, Atelier Royce. Photos by Nancy Kane*

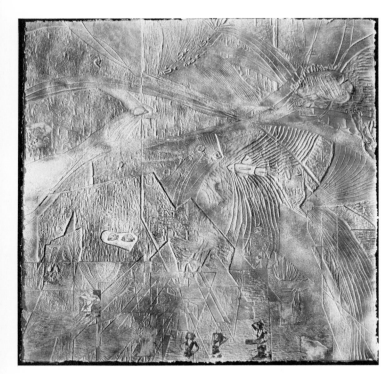

Richard Royce, "Atlantis." Cast paper, 1976. 8' × 8'. *Courtesy: Richard Royce. Photo by Herb Dreivitz*

At the International Institute of Experimental Printmaking, Santa Cruz, California, Garner Tullis specialized in experimental work with paper (among other printmaking processes). Using an eight-hundred-ton M.A.N. hydraulic press, Garner Tullis and his group did embossings. And employing a Hollander paper pulp maker, he used cotton linters or recycled rag content paper to cast the pulp on molds in high relief. Tullis called these pieces technical artifacts. When the pulp castings had dried, he colored them with graphite (dusted over acrylic spray); this produced a leadlike color, particularly when they were burnished. These were papier-mâché-like shells—lightweight sculptural multiples. Besides Tullis's own work, Claire Falkenstein, Louise Nevelson, John Babcock, David Whipple, and Charles Hilger numbered among those who also cast with paper.

Charles Hilger further refined some of the paper casting processes in his own studio using cotton linters (100 percent cellulose). He worked with screens in a traditional sense, creating laid-line screens for specific runs, and also worked with hand-applied pulp. (Note the two step-by-step photo series showing Charles Hilger at work.) Hilger uses no color but relies on the forming qualities of the wet pulp to create his planes and textures. Some of his pieces are huge—8 feet square. He slices into and deforms the wet pulp so that the paper surface projects in subtle relief.

Largeness of paper castings is a *tour de force* permitting printmakers to expand their pieces beyond former size limits of the printing press. Richard Royce has made 8-footers in cast paper as part of his *Atlantis* series. These were formed on carved metal plates (and reinforced with cheesecloth) and are not too unlike enlarged versions of his engravings.

Papermakers such as Twinrocker, John and Kathleen Koller, Upper U.S. Papermill, and Douglas Howell are busier than ever meeting the needs of the printmakers today.

The Process

Regardless of which papermaking process is used (two are covered here), the papermaker always begins with paper pulp. To make a pulp, one can tear up 100 percent cotton, mulberry, or linen paper (good quality printmaking paper) and pulverize it with water in a blender of some kind to achieve a pulp.

Papermakers use a Hollander beater using the proportion of three-quarters of a pound of cotton linters to 5 gallons of water. (Cotton linters are a 100 percent cellulose by-product of cotton processing as the short fibers left on the cottonseed.) The mixture is beaten until it reaches the consistency of loose cottage cheese or milk curds. Usually paper pulp is stored in a large vat. (Hilger's vat is a stainless steel tank with a drain at the bottom.)

Using a Laid-Line Screen

In the traditional approach, using a laid-line method as described by Charles Hilger, one employs a screen consisting of a mahogany, birch, or pear wood frame (probably about 28″ × 30″) and stainless steel or brass wires (.030 thickness) that are horizontally twined around parallel verticals (chain lines) and support vertical ribs of wood. These are strung and tied through fine holes in the rib with thinner, threadlike wire (so the attachment doesn't interrupt the paper).

The entire mold (the frame) is dipped into a vat containing the pulp slurry and lifted out at an angle so that the tilt allows water to strain and drain off, leaving a deposit of pulp on the screen.

Wool felt sheets, dampened to have greater water-attracting properties, are used to transfer paper from screen to felt and then to a board. Sandwiched between boards, the felts and paper are stacked and placed in a press in order to squeeze out excess water.

Upon removal from the press, the paper can be sized with starch—wheat, corn, or rice—made by boiling two tablespoons of flour in a gallon of water, mixing it well, and cooking for five to ten minutes. The starch is applied to the paper while hot.

The stack of felts and paper is removed from the press, the top board and felt lifted off, and the paper is placed on a large board. With a brush, the paper is glued to the board with size. Then it is laid in the sun to dry (tilted at an angle to face the sun). The summertime sun will bleach and dry paper in a couple of hours.

When dry, the paper can be peeled off the board and used. If a smoother sheet is desired, the paper can be calendered by running it through a printing press or by burnishing the surface with an agate (stone).

CASTING A SHEET OF PAPER ON A TRADITIONAL LAID-LINE SCREEN

with Charles Hilger

Charles Hilger makes his own screens from fine brass wire (.030). Here he is laying the supporting chain lines to which . . .

. . . the horizontal wires will be attached.

Hilger measures the number of lines to the inch to maintain consistency.

The sewn screen is strung and tied through fine holes in the ribs of the mahogany (birch and pearwood are alternatives) frame with threadlike wire so that the attachment does not interrupt (mark) the paper.

Hilger mixes and agitates the suspension of cotton linter pulp and water in a vat using a paddle.

He immerses a two-part laid-line screen in the slurry of pulp . . .

. . . quickly withdraws it and removes the outer frame.

A rack that allows for the rocking of the mold for the deposit of the wet paper pulp on dampened felts awaits a new batch.

A dampened felt is placed on the rack. (Damp felt attracts the water from the pulp.)

From one end of the curved rack, the mold is rocked to the other end . . .

. . . and when this is done, the pulp is neatly deposited on the felt.

Another layer of felt is placed over the pulp sheet . . .

. . . . and the sandwich—felt-pulp-felt—is slid to an awaiting board.

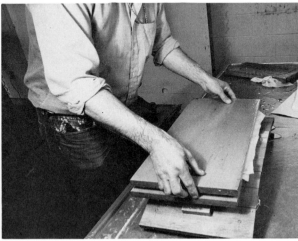

Another sandwich encloses the felt and pulp between two boards.

The sandwich is placed in a press where water is squeezed out and the cotton linters are compressed.

When the stack of felts and paper is removed from the press, the top board and felt are lifted off. The paper is then placed on a large board. The paper is glued to the board with a brush using a starch sizing and then it is laid in the sun to dry.

Charles Hilger, "Box 41." First proof. 8½" × 16". Handmade paper on a laid-line screen. The box image outline is built into the screen with brass wire. The "torn" area is cut while the paper is wet (after it is removed from the press).

Paper Casting with a Screenless Mold

Paper pulp can also be hand-formed on a screen or over a mold. If it is cast on a screen, ¼-inch hardware cloth or nylon window screen edged with duct tape can be used. The paper pulp can be scooped out of the storage tank and poured or hand-deposited on the screen or over the mold. The pulp may be shaped, molded, and compressed by hand until the fibers start to link together. As long as water is still present, the pulp can still be manipulated. If it is desired, a sponge may be used to slightly compress it, while also drawing off some of the water.

Optionally, cotton gauze (cheesecloth) draped over the wet paper pulp (doesn't stick) acts to hold the fibers in place. Terry-cloth towels can also be used. Of course, whatever the material chosen to compress and drain off water, it will leave its mark through its texture.

When most of the water has been extracted, the cheesecloth is pulled away and inclusions can be added. Hilger slices, penetrates, and otherwise manipulates the still viscous pulp at this point.

A fan (no heat) is the best vehicle for final slow drying of the pulp to minimize shrinking and warping (unless both attributes are desired). If warping is preferred, use a hair dryer.

CASTING AN OVERSIZED PAPER WITH A SCREENLESS MOLD
with Charles Hilger

A pot of paper pulp is ladled out of the pulp vat and deposited over a piece of cheese-cloth and nylon screening that is spread on a table. Twenty-four buckets of pulp are needed to form an 8'-square piece.

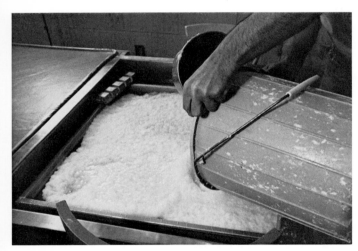

To shorten the operation, a part of the pulp is poured on the form.

The table has a channel all around its sides and a drain for excess water to run off into a pail.

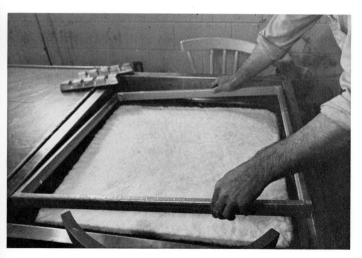

A frame is placed over the pulp.

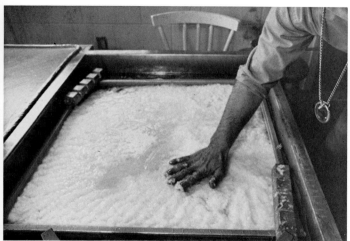

The pulp is distributed and compressed by hand pressure at first.

And more water is sponged off. (Note weights at ends of frame to keep it from warping and moving.)

The frame is tilted to encourage further drainage of water.

When enough water has been sponged, the cheesecloth/screening backed pulp sheet is removed to another table and placed on a piece of hardware cloth.

Another sheet of cheesecloth is placed over the top.

And the pulp is compressed further with a sponge with overlapping pressure, extracting even more water in the process.

A terry-cloth towel is placed over the cheesecloth . . .

. . . to sponge off more water.

The top layers of cheesecloth and toweling are pulled away and a screen is placed over the top. As long as water is still in the paper, patterns can be made at this point.

Here Hilger further compresses the paper.

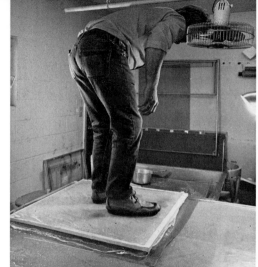

Boards and weights keep the paper from warping in the drying stages. A fan is placed on the paper to aid in the slow-drying of the pulp.

Charles Hilger, "Box 38." Cast paper panel, part of the *Box Series*, 1976. 58″ × 58″.

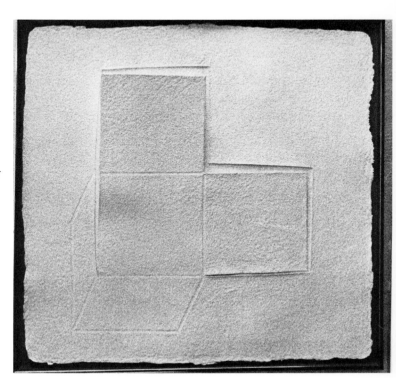

Charles Hilger, "Box 13." Cast paper panel, part of the *Box Series*.

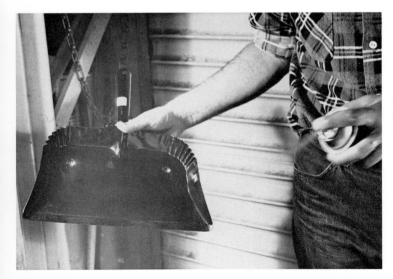

David Whipple casts a dustpan in paper. Silicone is sprayed over the pan. (Silicone acts as a release agent.)

Sheets of wet/compressed paper are molded over the dustpan.

Edges are trimmed and the paper is dried with the aid of a fan that circulates the air.

David Whipple, "Cancelled Dust." Cast paper finished with powdered graphite over shellac. (Edition: 100.)

David Whipple, "Three Dustpans with Deckled Edges."

WILBERT FOO CASTING JOHN BATTENBERG'S "BONDAGE HEAD II"

Paper pulp is hand-placed into a RTV silicone mold that is braced in a plaster jacket.

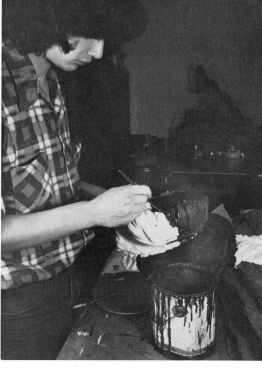

With a small sponge, excess water is extracted while at the same time the paper is compressed. The paper is allowed to dry slowly to minimize shrinkage and warpage. It takes two days before the paper can be pulled from the mold.

A mixture of three parts shellac diluted with three parts alcohol and three parts powdered graphite is brushed with a soft watercolor brush over the cast paper head.

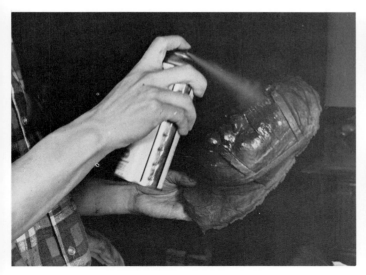 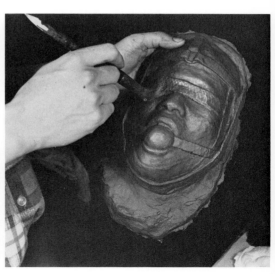

Krylon clear acrylic spray is then sprayed over the mold . . .

. . . and powdered graphite is dusted over the acrylic while it is still wet. The piece is then buffed to a shine.

Garner Tullis, cast paper head, finished with graphite.

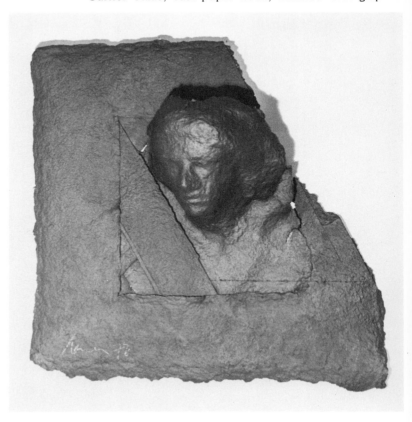

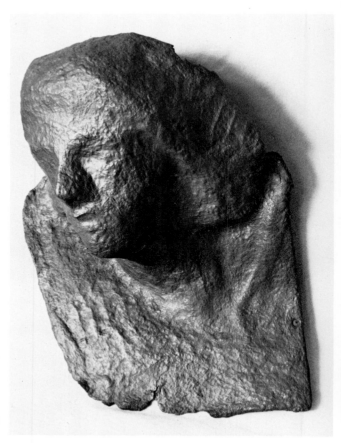

Garner Tullis, a second version of the cast paper head on preceding page.

Garner Tullis, "Veiled Woman." A third version of a paper casting from the same mold.

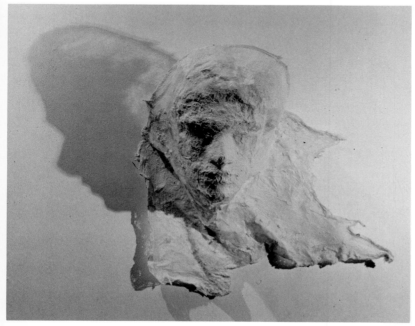

John Babcock forms paper into sheet form and then textures it (while the paper is wet) by using hand manipulation and by dropping water on it from high.

John Babcock, "Luna 38." Cast paper. *Courtesy: John Babcock*

Fritz Hundertwasser (Friedrich Stowasser), "Neruda: Hauteurs
de Machu-Picchu." Ten collages and lithographs. 17½″ ×
18¹/₁₆″ × 10⅜″ (assembled). *Courtesy: Collection, The
Museum of Modern Art, New York, Monroe Wheeler Fund*

The Great Departures: The Print as Three-Dimensional Form

One might ask when does a print cease to be a print and become a sculpture? The purist might reply that a print is still a print when the paper is intrinsically part of the printing operation, such as when paper is cast and printed.

Photoprinting of all types—silkscreen, lithography, and so on—has expanded the potential of what a print will be, inviting grand departures in printing parameters. The print need not be paper only. Plastics such as acrylic, urethane foams, polyesters, metal, lead, can be printed or embossed (as paper would be printed or embossed) and still be classified as a print. These pieces are usually produced in printmaking shops employing an expanded range of printmaking skills and new technology.

The print often has been combined with fragments of different media. Why cannot the print be created with fragments of different technology—using split conventions? Why not translate or transpose a process (or material) utilized in some other field to the creation of prints?

Indeed, Foamcoat, used in printing wallpaper, can be applied as printer's ink would be, but when heat is added, the "ink" swells expanding into a bas-relief that looks very much like a color embossing or flocking that has become an integral part of the print surface—whether paper or fabric. That is one example of using new material.

Edward Kienholz, working at Gemini, used an "old" familiar material in a new way—a car door as the base for his *Sawdy* series. In conjunction with this he used a host of other atypical (to printmaking) materials—mirrored window, polyester resin, fluorescent light—along with silkscreened elements.

Claire Falkenstein in "From Point to the Cone" employed sugar lift etching on German etching paper at Richard Royce's Atelier. After printing, she departed from convention by modeling and manipulating the paper into a three-dimensional form. Parts were sewn together with needle and thread. The piece, by the way, was diagramed so that an edition could be made.

Jo Hanson in "Crab Orchard Cemetery" used photo-silkscreen on Styrofoam® blocks that were carved into gravestone-shaped blanks with hot wire, and then with an etching process created a relief surface on the Styrofoam®. The total effect is very much like a weathered tombstone.

Jo Hanson prepares silkscreen stencils by photographing a rubbing made of a tombstone. The photographs are made into positive and negative transparencies of the image on Kodaline film, which is available in 100-foot lengths and in widths up to 52 inches. She then either contact-prints the transparency on sensitized screen or onto photosensitive stencil. Because of the large size of the negative-positives, sunlight is used for exposure.

After the Styrofoam® (expanded polystyrene) has been cut to size and shaped with a hot wire (a resistance wire used for cutting foam), it is ready for screening. The silkscreen process on Styrofoam® causes an etching action because the solvents in the oil-base ink, when activated by intense sunlight (or the equivalent), bite into the ex-

Two versions of Ed Kienholtz's "Sawdy." It is a car door with mirrored window that rolls down on a scene that is screen printed. The door is textured with lacquer and resin. 39⅓″ × 36″ × 7″. *Courtesy: Gemini G.E.L.*

panded polystyrene, dissolving it with precision. The etching action continues until the solvent has totally evaporated or until the material is removed from sunlight.

Nathan Oliveira at International Institute of Experimental Printmaking, Louise Nevelson at Sergio Tosi (Milan), and Jasper Johns at Gemini have created lead intaglio prints to produce prints in high relief by rolling or pressing sheets of lead into embossing dies using a hydraulic forming machine (or an etching press). The result is a lead relief, much like a paper embossment—except for color and texture.

Jerry McMillan photoetches metal by photo-silkscreening on the brass, copper, or stainless steel with an acid-resistant screen ink. The metal is than submerged or sprayed with nitric acid (or ferric chloride) and the unprinted areas are etched away. The piece stands partially uncurled with the etched elements curled against unetched areas of metal.

Ruth Weisberg lithographs on deerskin and stretches the natural edges tautly in a hoop. These hoops are hung singly or combined into large area environments.

Wendy Calman explores auditory and kinetic aspects when she combines photo processes on plastic with wood, feathers, cloth, and fur into small environments. "The Flying Franklin Lightning Show" incorporates sound and movement. The viewer becomes involved in the viewing process. A sonic burglar alarm that operates on a proximity switch is wired to a tape recorder. When the viewer approaches within a set distance, the alarm is triggered and music issues forth. A small relay is set on a delay to turn the music off. As long as the viewer moves, the sound plays and the Franklin puppet flies.

Using photographic prints that are dry mounted onto ³/₈-inch board, after portions are contour cut on a jigsaw, Stanley Bowman in "Hidden Faces" combines these with other collage elements. The three-dimensional work projects itself out at the viewer rather than inviting one on through a rectangular opening to an illusory place beyond.

A "participation" print, called "Breaktime," General Fix Co., Milan, Italy. The background is stenciled on wool felt. Balls are covered with Velcro.

FORMING CLAIRE FALKENSTEIN'S "FROM POINT TO THE CONE" AT ATELIER ROYCE

Claire Falkenstein painting her patterns for "From the Point to the Cone."

Falkenstein creating the paper sculpture shapes.

A "road map" or illustrated record is drawn of each element so that the edition can be consistent.

Sugar lift etching is used as the technique for creating Claire Falkenstein's patterns. India ink is poured into a can.

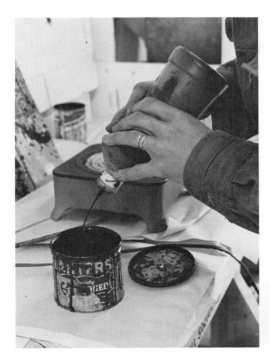

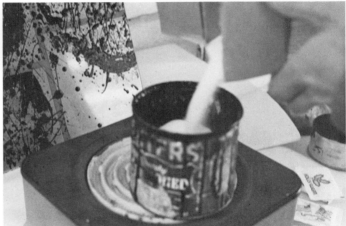

Sugar is added until it forms a cone.

The mixture is heated to boiling until the sugar dissolves completely. (Unused amounts can be saved.)

The sugar/ink is brushed on a zinc plate to duplicate Claire Falkenstein's patterns. It acts as a resist for Universal Etching Ground, which is then flooded over the sugar lift while the plate is held in a vertical position.

After the ground is dry, Richard Royce directs a sharp spray of hot water to dissolve the sugar left, leaving areas not to be etched protected with ground.

When the etching has been completed, the plate is wiped with a weak mixture of lye and water (1 pint water to ⅔ teaspoon lye) and dried and inked, as for intaglio, with white ink.

The white ink is printed on both sides of the black German etching paper; embossing is done with heavy pressure.

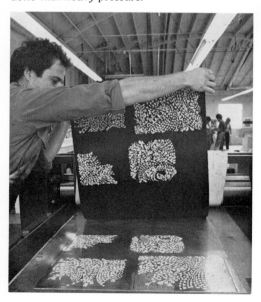

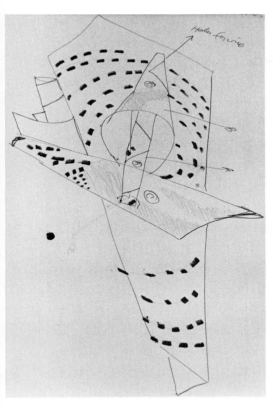

The print is ready to be formed. The appropriate drawing/diagram is brought out . . .

. . . and the unit is shaped. Note model in the case.

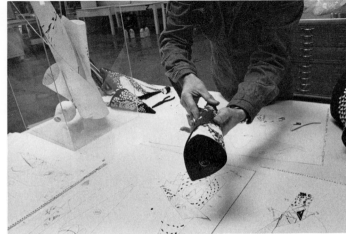

Richard Royce (*left*) and Robert Aull are sewing and wiring parts together.

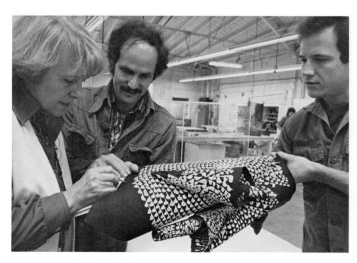

Claire Falkenstein approves with her signature.

All the parts and the final version in an acrylic case.

Claire Falkenstein's "From Point to the Cone." Acrylic box, 1976. 25″ × 14″ × 14″ (Edition: 30.)

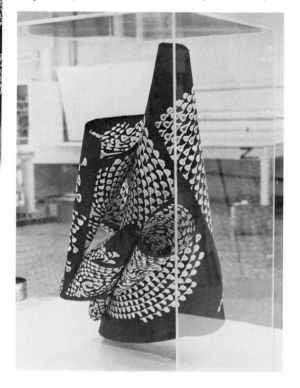

CREATING TEXTURE USING FOAMCOAT
with Debra Seeman

Foamcoat is applied in its liquid state directly (or by screen printing). It is available in basic colors that may be altered through use of pigments or dyes.

Foamcoat expands eight to fifteen times with application of heat (220° F.) while the material is wet. If Foamcoat reaches temperatures over 266° F., it will collapse. Heat lamps, heating elements, or forced hot air are good heat sources.

A sample of a Foamcoat application on fabric.

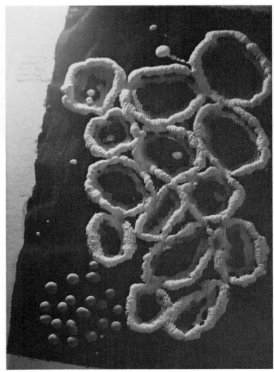

Applied using a screen (photo emulsion stencil) Each print was dried & heated with a heat lamp (watts) directly after screening

Photo-silkscreen and Foamcoat used as the ink.

Ruth Weisberg, "Angel's Gate." Lithograph on deerskin, with oak hoops, chamois sculpture, 1974. 9′ × 9′ × 9′. *Courtesy: Ruth Weisberg. Photo by Ken Hackman*

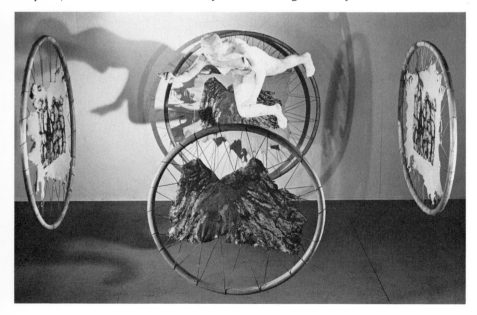

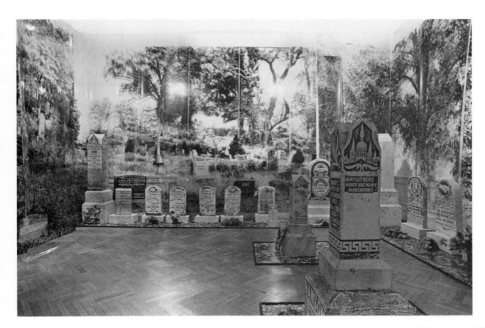

Jo Hanson (gallery installation of), "Crab Orchard Cemetery." Tombstone rubbings were photographed to make photo-silkscreens. These were enlarged on Kodaline film, transferred to the screen, and screened on the Styrofoam®. When they were exposed to sunlight, the action of ultraviolet light etched the inked images. *Courtesy: Jo Hanson. Copyright: Jo Hanson*

Jo Hanson, more cemetery images. *Courtesy: Jo Hanson. Copyright: Jo Hanson*

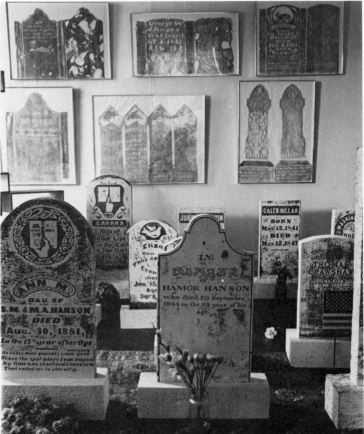

Nathan Oliveira (*right*) and Garner Tullis study lead embossments. *Courtesy: International Institute of Experimental Printmaking*

Nathan Oliveira, "Slate." Lead relief. *Courtesy: International Institute of Experimental Printmaking*

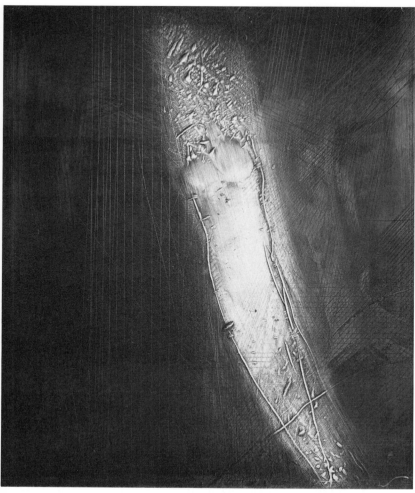

LEAD EMBOSSMENT OF JASPER JOHNS' "HIGH SCHOOL DAYS" AT GEMINI

The original models were created by Jasper Johns in wax and plaster. From these models, cast metal and epoxy forming molds were made. Here the mold is undergoing a last-minute buffing before entering the embossing press.

Very soft cold rolled sheet lead (.015) was placed over the mold . . .

. . . paper and a felt blanket was added.

After forming in the hydraulic emboss-
ing press, the sheet was adhered to
rigid polystyrene with spray rubber
cement and with a wood support.

Touch-up modeling corrects any im-
perfections.

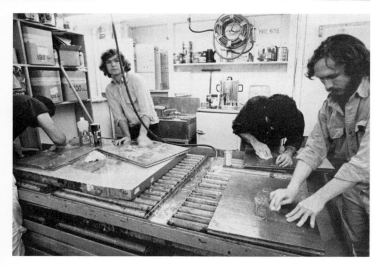

The lead surface was specially cleaned
to permit natural oxidation to take
place over the years.

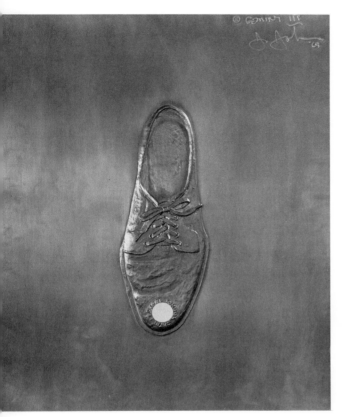

Jasper Johns, "High School Days." Lead relief with glass mirror insert, 1969. 23″ × 17″. (Edition: 60.) *Series Courtesy: Gemini G.E.L.*

Jerry McMillan, Untitled (Palm Coil). Photoetched brass, 1975. 12″ × 300″ × .016″. *Courtesy: Jerry McMillan*

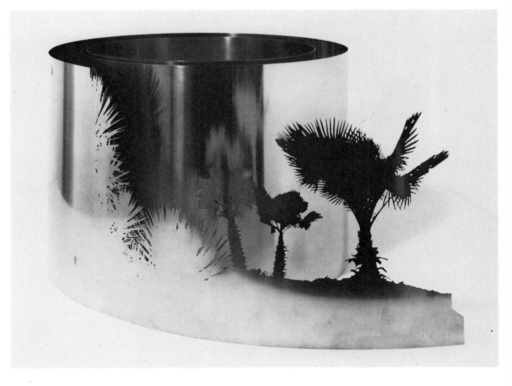

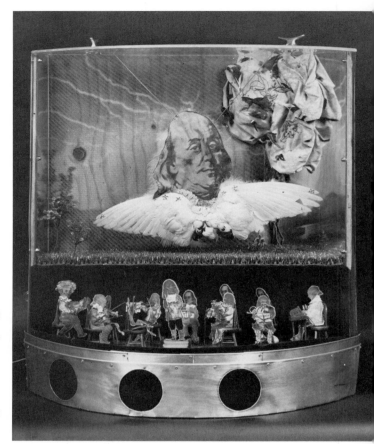

Wendy Calman, "The Flying Franklin Lightning Show—and It Really, Really Works." Wood, feathers, cloth, fur, acrylic, Kodalith. Wired for sound. 1974. 32″ × 23″ × 16″. *Courtesy: Wendy Calman*

Details of "The Flying Franklin . . ." showing the Kodalith figures of the orchestra pit. *Courtesy: Wendy Calman*

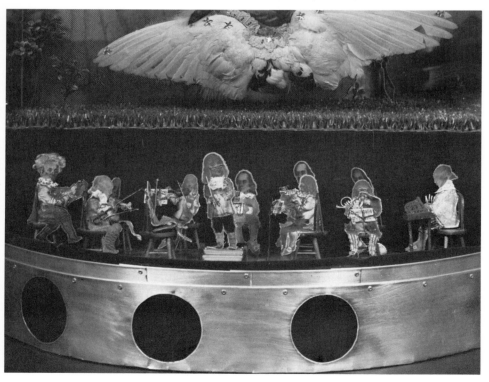

ABOUT LEAD CASTING

Pure lead is the softest of the many metals used in sculpture. Because of its fairly low melting point and ease of forming and finishing, there are records that it has been employed in art as early as the sixth century B.C. when the Spartans used the metal to make their votive figures. It has recently been revised to make multiples.

Lead can be carved, hammered, or beaten into shape or cast into negative molds. These processes can be combined as well, particularly in the finishing processes. Cast forms can also be refined by hammering or carving their surfaces. (Since lead is soft, it can easily break. Care should be exercised to make certain that undue stresses are not induced.)

Lead melts at 621° F. (327° C.). When it cools, it shrinks approximately ⁵/₁₆ inch per foot.

Molten lead should be poured into molds that are water-free, nonporous, and tolerant of high temperatures up to 700° F., such as refractory clay, metals, or some RTV silicones. Plaster of Paris and wood are not good molds for lead.

Lead is melted (in a room with good ventilation) in a heavy iron or steel crucible. Impurities rise to the surface and form a scum that can be skimmed off with a metal ladle. After it is melted, the lead can be poured into the negative, or female, mold.

It is possible to create alloys by melting other metals with the lead. Tin, for example, provides various degrees of hardness and imparts a more silvery quality, depending on how much is used. Usually, the surface of lead is dull because it tarnishes quickly when exposed to air.

Lead sheets can also be rolled through an etching press over a collagraph plate or over a shallow matrix made of wood. Although it can be molded easily, if the lead is stretched too much, it tears.

After the lead intaglio is made, the lead requires some kind of mounting to give support to the relief and keep it from denting.

Stanley Bowman, "Hidden Faces." Construction piece using photo paper on particleboard, 1975. 3½' × 5'. *Courtesy: Stanley Bowman*

John Chamberlain, "Le Molé." Three-dimensional object of
polyester resin, aluminum, and silicon oxide. 1971. 7″ high.
(Edition: 56.) *Courtesy: Gemini G.E.L.*

The Great Departures: The Print as a Multiple

Multiples have existed for a long time. Books are multiples, records are multiples, films and photographs are multiples—all of these depend upon printmaking in some way. Printmaking has always been a multiplier process—its products are multiples.

It is difficult to decide where a print ends and a multiple begins, particularly when the piece is three-dimensional and does not use any *traditional* printmaking processes.

Perhaps that is the difficulty. (We fix too much on traditional processes.) If we could agree that the term multiples encompasses three-dimensional editioned art objects, then some prints could easily fit into the largess of that definition.

The diversity and proliferation of new materials, equipment, and processes have expanded the scope of printmaking. It may be that sculptors have the same difficulties in establishing clear boundaries for their three-dimensional images. It could very well be that an exhibit that in all appearances contains sculpture could actually be made up of multiples, with a high proportion of pieces classified as prints.

Traditional demarcations are becoming very fuzzy. All areas of art expression have been undergoing a transformation resulting in new processing of imagery with non-conforming management of tools, materials, and equipment. Old classifications of art media just don't work. We must loosely define areas, set up new parameters, or forget about it.

Claes Oldenburg's *Ice Bag* series is a case in point. It is a sculpture, a multiple, a monumental kinetic construction, produced in an edition of twenty-five at Gemini, with the help of master printers Ken Tyler and Jeff Sanders. The piece is certainly a product of recent technology. It contains a mechanism providing programmed movements of the whole, including blowers programmed to inflate a complex bag with a "wet-look" nylon outer skin that is sewn in fifteen pleated segments. The bag also zippers open so that the internal workings can be inspected. The cowling and cap are fiberglass. An interior system of acrylic air deflectors was aerodynamically designed so that the bag inflates with the proper proportion of air to volume. A spun steel liner attaches to the drive rod in the mechanism and supports the weight of the bag. And the bag is attached to the cap liner and to the base cowling with Velcro.

John Chamberlain's "Le Molé" is another product of technology. The edition of fifty-six was cast with transparent polyester resin in an RTV rubber mold. The castings were then dry blasted and spray coated with a special premetalized coating that permitted a very thin metalized aluminum coating to be deposited in a vacuum chamber. These aluminum particles were vaporized, electrostatically charged, and deposited on the castings.

Following the aluminizing process, which results in deposition of an irregular, highly reflective coating, a second set of electrodes were energized, one at a time. Filaments connected to these electrodes contained crystals of silicon oxide. When the silicon oxide vaporized and was deposited over the aluminum coating, many colors were produced because of the differences in thickness of the silicon oxide coating and the

Some of the internal hydraulic mechanism for Claes Oldenburg's "Ice Bag."

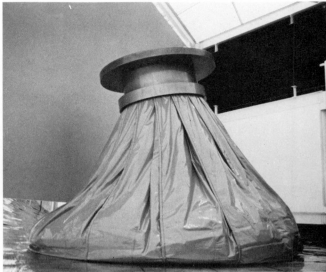

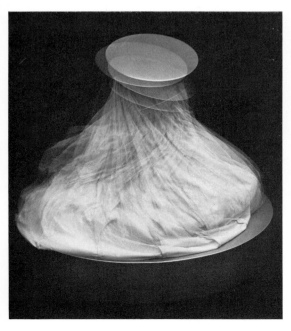

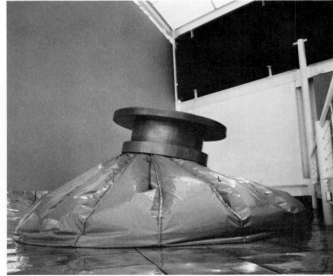

Above: Two views of Claes Oldenburg's "Ice Bag." Red polyvinyl material on nylon, lacquered wood, hydraulic and mechanical movement. 18′ diameter, rising to 16′.

Time exposure for Oldenburg's "Ice Bag." *Series Courtesy: Gemini G.E.L.*

irregular surface of the casting. John Chamberlain controlled the color formations—each piece was unique in color effect. (The entire form then received a coating to protect the thin metalized coating.)

Bronze sand castings were made for Roy Lichtenstein's "Peace Through Chemistry Bronze" at Gemini, and for his "Untitled Head," brass was machine profiled following a cardboard maquette created by Lichtenstein.

Louise Nevelson created a maquette of wood for a bas-relief "Sky Passage" (Pace Editions, Inc.) that was cast in polyester resin and painted black.

Plaster, latex, and rubber molds are used to make castings in pourable resins such as polyester and epoxy.

That leads us to yet another element that has been newly introduced into printmaking through use of plastics (particularly transparent and translucent varieties)—light.

Louise Nevelson, "Sky Passage." Cast filled polyester, painted mat black. 10¼″ × 5¾″. (Edition: 150.)

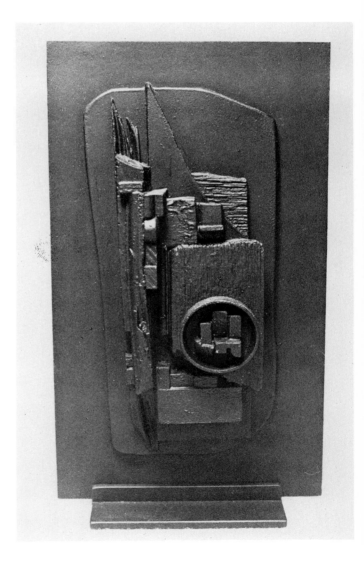

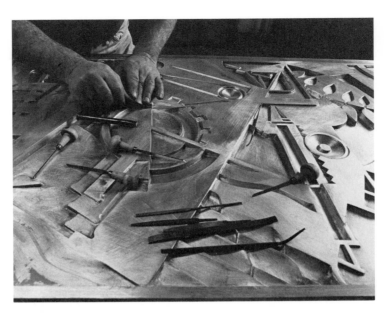

Hand chasing of bronze plaque. Roy Lichtenstein created the original cardboard and clay maquette. From this, a plaster model was made that served as the mold maker's pattern for the bronze sand castings.

Roy Lichtenstein, "Peace Through Chemistry Bronze." Three-dimensional object, sand cast bronze, hand-chased and sandblasted. 1971. 24¼″ × 46¼″. (Edition: 38.) *Courtesy: Gemini G.E.L.*

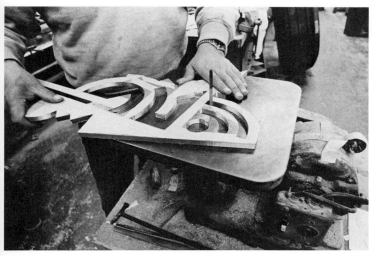

Roy Lichtenstein created the original cardboard maquette and collaborated with Gemini in the making of the solid brass prototype. The brass head was machine profiled.

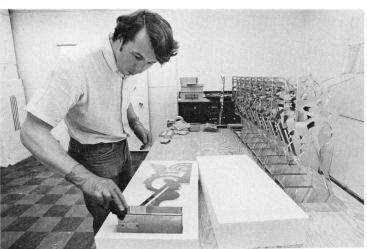

The head is being hand polished.

Roy Lichtenstein, "Untitled Head I." Hand cut and polished brass. 1970. 25⅝" high. (Edition: 75.) *Series Courtesy: Roy Lichtenstein*

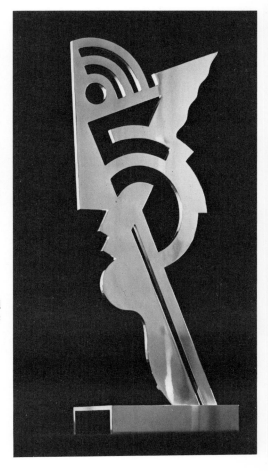

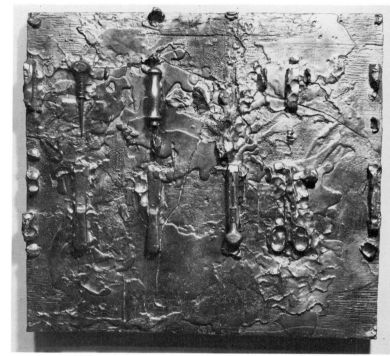

Jim Dine, "Tool Relief #7." Cast aluminum. 1974. 27" × 29" × 4". Series of 5 in an edition of 5. *Courtesy: Petersburg Press Inc.*

Jim Dine, "A Plant Becomes a Fan." Five-piece multiple cast in aluminum and hand finished. 1974. 29" × 19" × 13". (Edition: 24.) *Courtesy: Petersburg Press, Inc.*

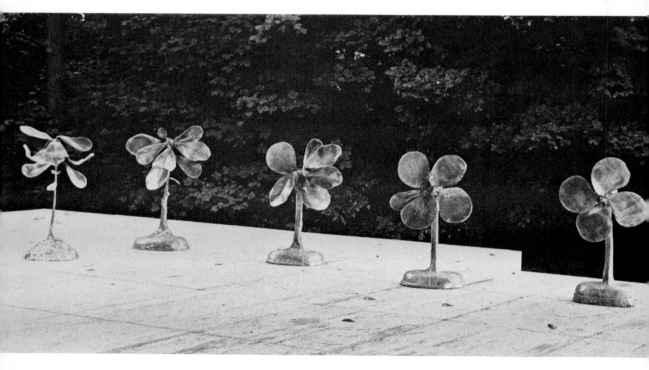

Claes Oldenburg, "Sculpture in the Form of a Bicycle Saddle." Ceramic sculpture fabricated at the Royal College of Art, London, with wood and sand base. 14″ × 8½″ × 8½″. Three color variants, gray, green, brown. (Edition: 36.) *Courtesy: Petersburg Press, Inc.*

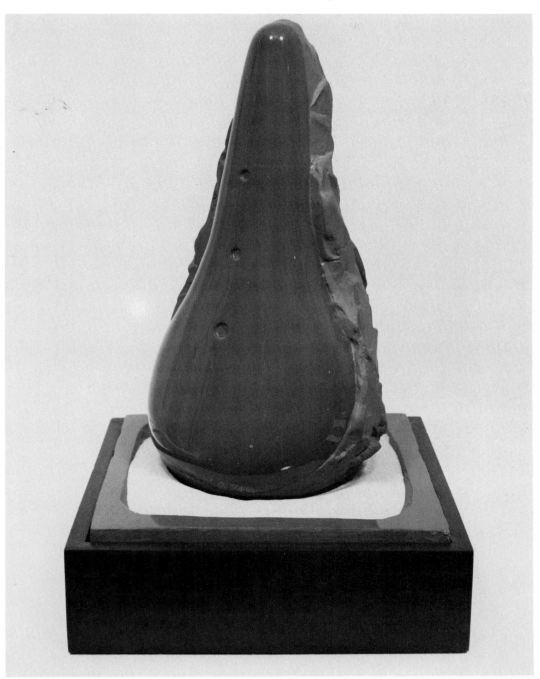

Wendy L. Calman, mixed conventions of photo elements and collage in plastic containers. *Courtesy: Wendy L. Calman*

Perceptual Effects: Optical and Transparent Imagery

About Light

Light is an essence. Without it we cannot see. Yet we take light for granted and notice it only when the bulb burns out, when light flickers, when color changes, when storm clouds darken the daytime sky, when we move from a darkened room into the sunlight—when something atypical occurs. Until recently, our concern with light as art form was in capturing illusions, depicting luminescence, atmosphere, form, and color as light, in painting, in sculpture, and in stained glass windows. Little attention was paid to transmission of light as it passed through transparent objects or escaped through interruptions in its path, by bending, rearranging, diffusing, and modulating, refracting and reflecting light. Transparency in materials such as plastics offers new possibilities. Light can become as important as color and, without color, the defining element.

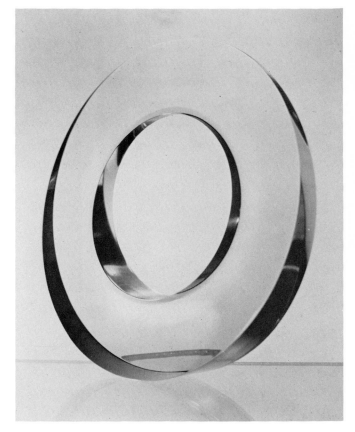

Fred Eversley, "Circular Flight." Cast polyester, of three concentric layers in three colors. 1971. 8″ diameter, bottom edge 1½″. (Edition: 25.) *Courtesy: Multiples, Inc.*

Light can reach beyond the perimeters of a form by filling an entire room with visual echoes in endless variations of the form itself. Light may be blocked and then allowed to pass through etched or textured surfaces, piped through holes and projections. It may be interrupted by opaque solids, refracted by lenslike shapes, or diffracted by gratings.

Light plus time adds other possibilities. If time consists of intervals and an ordering of events, then light interrupted, synchronized, alternating, constant, repeating, accelerating, fast, slow, becomes another dimension—the kinetic aspect. Light for its own sake, then, embodies elements in itself such as rhythm, repetition, temporal form; when it is combined with transparent materials as a defining "container" of its own volumes and edges, we have entirely different aesthetic elements with which to express ourselves.

Black-and-white photography depends on light and traps light in two-dimensional form consisting of white, grays, and black. But when transparent plastics, as an instance, are used as three-dimensional form, light lives in space and time—it can be created and it can die. In Darla Masterson's acrylic cubes containing planes of silkscreened transparent acrylic, transparency is a simultaneous perception of different spatial locations.

PHOTO-SCREENING ON ACRYLIC with Darla Masterson

Darla Masterson cleans the screen prior to printing. Her initial conceptualization was rendered with pen or brush and ink on frosted Mylar (the kind architects use). These drawings result in a positive transparency. The positive is exposed with a carbon arc light on Blue Poly II film (for a negative), which is processed and adhered to the screen.

Right:
Top: Naz-Dar 70 series, Plasti-Vac gloss ink is mixed and placed on the screen and with a squeegee drawn forward . . .

Bottom: . . . to reveal the positive transposed images on ³/₁₆″-thick acrylic sheet.

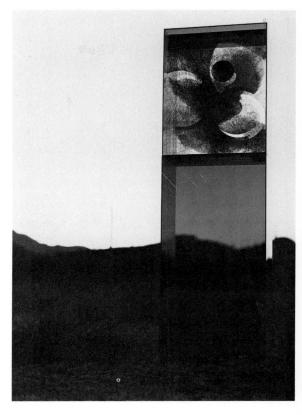

Darla J. Masterson, "Landscape Enclosure XX." Silkscreen on acrylic, 1973—74. 59″ × 18″ × 13″. *Courtesy: Darla Masterson. Photo by David Tang*

Darla J. Masterson, "Gray Space Enclosure I." Silkscreen on acrylic, 1974. 68″ × 18″ × 12″. *Courtesy: Darla Masterson*

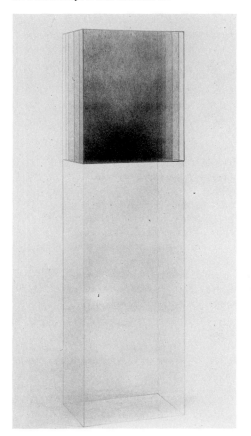

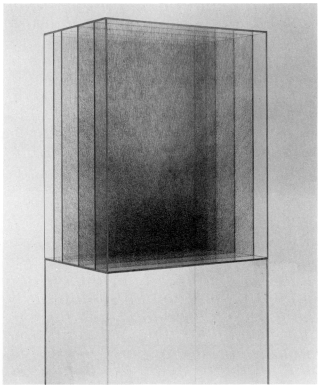

Close-up of "Gray Space Enclosure I." *Courtesy: Darla Masterson*

PRINTING ON PLASTIC

Serigraphy

Water-soluble or lacquer-proof films, photographic screens, tusche, and glue can be used to block out the screen. The screening process is essentially the same as in standard serigraphy procedures, except for the type of ink.

Heat-resistant inks that are specifically designed for plastics should be used if any heat forming is to be performed. Naz-Dar's Plasti-Vac gloss ink of the 7000-000 series; Colonial's Vacuum Forming Inks, series 7200; and Advance Multi-Vac Plastic Forming Inks (PAB), series (Excello Color and Chemical Company), are good choices.

These inks print well on acrylic, cellulose, acetate, cellulose acetate, butyrate, styrene, and rigid vinyl. They are a lacquer type that dry by evaporation, within twenty to forty minutes. These inks can be thinned with a thinner. Use a slow-drying low-odor vinyl thinner such as Advance T-920, which doesn't attack plastic surfaces as some thinners do. These inks can be extended with an extender. Some are transparent, others opaque—they come in a wide range of colors.

Stencil Spray Painting

A stencil-masking tape, regular stencil, or a spray mask can be used in conjunction with a stencil. Grip Flex (Wyandotte Paint Products Company) is a peelable spray mask for acrylic and other plastics.

After applying spray mask to about 10 to 15 mils (wet), allow four hours of drying time. When dry, edges and shapes can be refined by cutting the mask with a sharp knife and stripping away unwanted portions.

Before applying ink by spraying (make certain the mask has dried), rub the exposed plastic with a chamois to remove static. Static can cause patterns to form in the paint film.

To spray, use specifically formulated inks for plastics, diluting them so that they can pass through the nozzle of a spray gun. If you are going to spray onto a transparent plastic, a backlight will help you to see whether the paint is sprayed evenly.

Only spray in a well-ventilated spray booth. This is essential—anything less is a health hazard.

After the ink has been thinned, stirred, and placed into the siphon cup, if you are using professional-type equipment, turn off both valves of the spray gun and pull the trigger, holding it open continuously while you start to turn on the air valve and watch the pressure gauge. Stop opening the air valve when the compressor can no longer maintain adequate pressure, and then crack (open) the paint valve slowly until the paint begins to appear. The final setting should be gauged by how much flow it takes to complete a coating in six or more light passes. Try not to manipulate the gun trigger except in the beginning and at the end. You will have to adjust your procedures for variations in each color and to take into account temperature and humidity.

The Optical Illusion

If we project light and manipulate it on mirrors, distorting lenses, metalized surfaces (flat and curved), into plastics that contain internal interruptions such as cracks and bubbles—light and concomitant shadows define, contrast, and interact to create optical illusions of movement. Movement, instead of being a purely physiological experience, becomes both physiological and psychological. As soon as a discrepancy is introduced between our perceptual judgment and the actual physical character of the original stimulus, we have produced an optical illusion. The slightest changing of optical direction on the part of the observer causes a transformation—a gradual, sequential change, a metamorphosis from one image or pattern to another, sometimes with dizzying effects.

Illusions can be created by using periodic structures in which geometric elements such as lines, circles, and triangles are repeated in the same values at regular intervals, such as concentric circles or spirals. Or these periodic structures can be interrupted at intervals and rearranged. Other types of optical effects that have nothing to do with periodic structures are the phenomena of irradiation and diffusion. A sense of diffusion, blurring, or luminosity is achieved when simple, clearly defined units, such as dots, are repeated with tonal contrast. A sense of movement, called diffusion, is created by these opaque, hard-edged units. Sometimes there is also an illusion of

Marvin Lowe, Untitled, photo-silkscreen supergraphic—over 6'. Use of extremely large screens requires help to achieve registration of the various screens. *Courtesy: Marvin Lowe*

luminosity (referred to as irradiation). Vasarely plays with these effects as he manipulates his rectangular and circular elements. John Whitesell and Marvin Lowe have employed grids of various types to create these effects of diffusion and irradiation.

When similar periodic structures are superimposed over one another and yet another illusion is achieved, the effect is a moiré pattern. This occurs when the repetitive elements in each pattern are nearly equal and when the angle of intersection between these patterns, as they are overlapped, is very small. Apparently the eye is unable to resolve the intersections. Patricia Jean Burg, Gerald Oster, and Alberto Biasi have silkscreened one periodic pattern on a background of wood or paper and another on transparent plastic, which is superimposed. Moiré effects move as the angle of vision is changed. A sense of play or participation occurs between image and observer.

Artificially induced distortions can be created by superimposing a hemisphere over a flat image, as in Henry Pearson's and John Risseeuw's works. A myopic blur is caused by the diffused edges as the curved shape distorts. Overlapping images in a series of panels present a similar problem in selective focus. The repeated information projected through a series of layers causes a dilemma of number and definition. Optically stretched images; anamorphic (distorted) perspective; images seen through water, glass, or plastic, where some distortion in the transparent form is present; and reflection from mirrors and other reflective surfaces can create effects not otherwise achieved when traditional materials on standard grounds are used. Patricia Jean Burg plays with reflective surfaces and transparent grids on overlays to create echoing of images that repeat in so many ways that what is reality and what is reflection is difficult to determine.

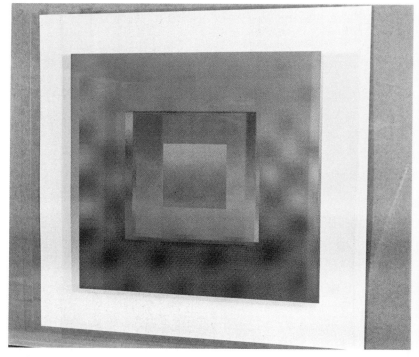

Patricia Jean Burg, "Cyclops II (Blue)." Silkscreen background on board, silkscreen transparent overlay on acetate. *Courtesy: Patricia Jean Burg. Photo by Kenneth Peterson*

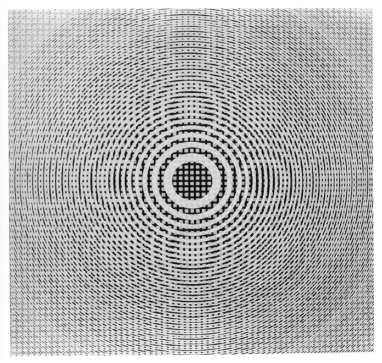

Alberto Biasi, "Visione Dinamica." Serigraph on acrylic and polyvinyl chloride (pvc), 1964. 19¾″ × 19¾″ × 3⅝″. *Courtesy: The Museum of Modern Art*

Gerald Oster, "Triple Radial." Serigraph on plastic, paper, and wood. 41″ × 43″. *Courtesy: Howard Wise Gallery*

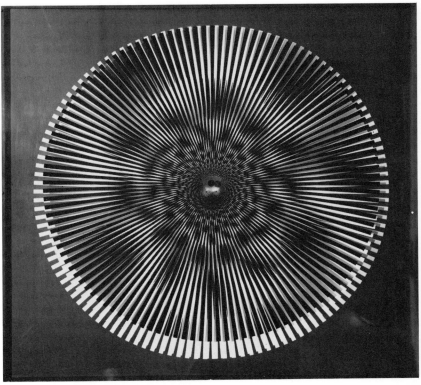

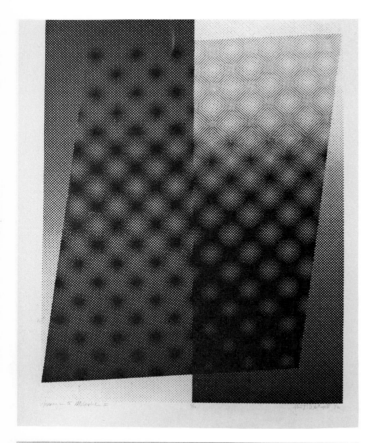

John D. Whitesell, "Homage to Malevich II." Silkscreen supergraphic. *Courtesy: John D. Whitesell*

Marvin Lowe, "Behind the Screen: Dawn." Color intaglio and relief, 1973. 27" × 24". *Courtesy: Marvin Lowe*

Henry Pearson, "Moirasphere." Blow molded acrylic dome, silkscreened with curvilinear lines that are reflected as a moiré pattern in a mirror on the base. *Courtesy: Artmongers Manufactory, Inc.*

Roslyn Rose, "A Thousand Years Are But As Yesterday." Background, etching on German etch paper, and silkscreen on acrylic (before vacuum forming). 1972. 23″ × 23″.

Patricia Jean Burg, "Moma Revisited."
Silkscreen background printed on board
(black on silver), silkscreen overlay on ace-
tate. 24″ × 24″. *Courtesy: Patricia Jean
Burg. Photo by Kenneth Peterson*

Patricia Jean Burg, "Wretched Etching."
Etching with cutaway parts curled in front
of metalized Mylar backing that is printed
with similar shapes. These also reflect the
foreground etching. 10″ × 10″. (Edition:
10.)

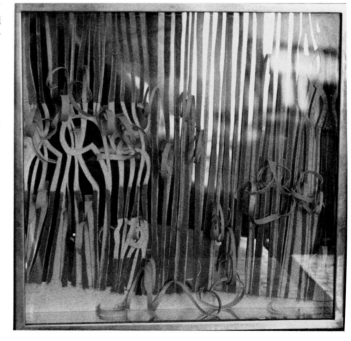

VACUUM FORMING

In vacuum forming, a vacuum is created in a chamber that draws a plastics sheet that has been heated to a softening point, through an opening in the forming plate. The vacuum chamber must be airtight. Masonite is often used as the forming plate. It contains a cutout that will determine the contour and the height (depth of draw). Control is achieved by regulating the vacuum valve between the vacuum chamber and the vacuum storage tank.

Another method is to place a heated plastic sheet (often acrylic) over a mold. The mold contains draw holes so that the compressor can force the plastic to conform tightly to the object underneath as air is drawn out. When the thermoplastic has cooled, the plastic can be released from the mold. If the mold has undercuts, the plastic would become permanently attached.

Any nonmeltable form (without undercuts) could be used—tools, machine parts, blocks, toys, and so on.

There are many small commercial vacuum-forming machines available. Plans for building a vacuum-forming machine appear in the appendix. A. E. Moll, chairman of the art department of the University of Wisconsin, designed and constructed the machine under a four-hundred-dollar grant in 1965. (He had enough money left to buy 100 pounds of sheet styrene.) Prices have more than doubled since then, but it is still an inexpensive way to provide a studio vacuum former of a useful size for the artist.

Sondra Beal built one for her studio and Lee Bontecou used that machine to produce some of her fish and flower pieces. Only the most basic tools and skills are needed to construct the machine and use it. For more information, contact A. E. Moll at the University of Wisconsin— Madison (6241 Humanities Building, 455 North Park Street, Madison, Wis. 53706.

Most thermoplastic sheet plastics are usable for vacuum forming. A thermoplastic can be softened with heat and formed, and then when cooled the sheet hardens to its new shape. Thermoplastics can be reheated, softened, and reshaped, whereas thermosetting plastics cannot be softened with heat once the plastic takes its shape. The process is irreversible, as with ceramics after clay has been fired.

Acrylic, styrene, butyrate, and the acetates are examples of thermoplastics—all are excellent for vacuum forming. (Epoxies and polyesters, on the other hand, are two examples we commonly know that are thermosetting plastics.)

Thicknesses in the range of .010 gauge to .060 are most easy to form. The thicker the sheet, the longer it takes for the sheet to soften and the more power is needed to draw a vacuum. Some plastics such as styrene sheet of .020 gauge can be cut with a paper cutter. Thicker gauges require cutting with a saw (table, band, or hand-held saws).

The plastic sheet should be cut to the size to fit within the frame of the vacuum former so that clamping action of the frame can securely hold the sheet in place.

The heating element of the machine functions as an oven, with its built-in elements heating the plastic to softening point. Each plastic has different softening points: some, such as acetate, need up to 500° F.; acrylic will bubble at 500° F. and should not be softened above 300° F. (for ½ inch thickness) or 315° F. (for ¼ inch thickness).

The objects to be formed are placed on a base (which contains small holes as in a pegboard). The rigid plastic sheet is clamped into the frame and lowered above (but at this point not touching) the elements to be formed.

After the heating element is activated, the plastic sheet will begin to soften and then alternately sag and contract. Temperature is critical. Test pieces should be made with time/temperature aspects recorded. If the sheet is not soft enough, it will not properly be drawn over the forms.

When the plastic has reached the proper forming temperature, the sheet is lowered over the mold, and the vacuum pump is turned on. In seconds, it will draw out the air and suck the softened plastic over the mold positives. If there are no undercuts in the mold, the formed plastic can then be pulled away after a few more seconds; if there are slight undercuts, pry out the mold pieces while the plastic is in a semi-rubbery state. Air will quickly cool the plastic. As it does, the sheet will harden to its new contours.

A SIMPLIFIED VACUUM-FORMING PROCESS

Place acetate or other thin thermoplastic sheet over top of figure between vacuum unit and heating element.

Close lid and turn on heat unit. When plastic gets soft, put on vacuum.

The thermoplastic cools quickly. Unit is ready to incorporate into piece.

PROCEDURES FOR CREATING A VACUUM-FORMED SCREENPRINT

By John L. Risseeuw

Conception of the idea.

Layout of the image with indication of positions of forms.

Construction of the mold.

> Assemble form materials or construct forms using plaster, wood, or metal; casts in plaster, resin, clay. Be careful of plastic materials that may adhere to the hot plastic.
>
> Mount forms on ¼-inch Masonite.
>
> Fill in undercuts with automobile body putty.
>
> Drill holes for suction around forms using ¹/₃₂″ drill.
>
> Enlarge drill holes on back side with ¼-inch drill.
>
> Connect all drill holes on back with sawcuts using a table saw blade turned down to barely cut the surface of the mold back.

Test mold.

> Mount mold on vacuum-forming machine bed, sealing off edges of mold with tape so that air can be sucked only through the mold holes.
>
> Mount plastic holding frame in machine.
>
> Place sheet of plastic in frame that has been previously screened with a 1-inch grid pattern and place under (or over) heater.
>
> Form test sheet on mold and pull off, if possible.

Mold Correction.

> Build up all areas and undercuts that prevent release of formed plastic.
>
> Drill suction holes or add more sawcuts to bring suction to any unaffected areas.

Repeat tests and corrections until satisfactory.

Planning print.

> Use distortion evident in test sheet grid pattern to plan printing areas. Images screenprinted on the flat plastic can be planned to meet the distortion and cover a formed shape or they can be intentionally distorted by stretching normal flat shapes over the forms.

Print.

> Screenprint flat plastic only, using heat-resistant acrylic-based inks that are formulated specifically for vacuum forming. (Advance Co., Multi-Vac ABS series, or Naz-Dar, Plastic-Vac 7000-000 series; etc.) Photo images can also be printed by offset lithography with a flatbed offset proof press. Use offset inks for plastic only. Finer detail may be obtained with this method, and four-color separations can be printed and formed.

Forming.

> Edition is formed over mold, with particular attention paid to registration of plastic over mold. Mark the position of plastic in holding frame and also keep a record of amount of time it is heated. Too little time will heat plastic insufficiently and mold detail will be lost. Too much time will give overstretched plastic that will produce wrinkles, ribs, and nonregistered images. This is critical.

Assembling.

> Print is assembled, generally within a metal section frame to flatten it and hold it tightly.

Plastics and Perceptual Effects

The range, quality, and treatment of surfaces that may be combined is broad. John Risseeuw vacuum forms plastic prints. The plastic is printed with silkscreen or offset lithography and then vacuum formed over molds he makes. Some works are in opaque white plastic, some on silvered plastic, and some on clear plastic. Interestingly, these vacuum-formed pieces grew out of a solution to another printmaking problem Risseeuw devised. He vacuum formed plastic containers for edible screenprint cookies. After the edibles were consumed, the containers remained.

Wendy Calman creates containers of acrylic for real materials such as fur and photographed elements. And Andrew Stasik lithographs and stencil prints on paper inside an acrylic box. Silkscreened printing on the acrylic is cast as shadows on the background. The image is mapped in an illusory manner.

Charles J. Roitz, working with machine acrylic and aluminum that contain photoserigraphed additions, takes advantage of acrylic's optical properties and their relationship to photographic optics. Aluminum is employed because it, too, is similar in appearance to the "silver" photographic image. When he reduces photo images to interphase lines or to tones with little or no gradation, he drops illusion of space and "reality" that is normally associated with the photo image. By combining these forms with reflective surfaces, he, in effect, returns tonal values to the image that are not inherent to it in the first place.

Walter Askin utilizes the light piping qualities of colored acrylic sheets in works he calls polyplanographs. These boxlike structures contain many parallel planes, graphics created by original decalcomania elements applied to the acrylic. What one sees is a juxtaposition of images on layered planes. These planes are enclosed in a plastic box that may be colored in transparent blue, fluorescent orange, or pink, with an opaque acrylic background. The stand encloses showcase lights that are timed to go off and on in 2¼-minute intervals. The images take on very different qualities when lighted. A sense of movement is created at the moment that the light turns on.

It is no surprise that artists would eventually discover the optical properties of acrylic and mirror. These have been made into various types of lenses, telescopes, and optical devices by scientists for a half century, in the case of acrylic, and glass mirrors have been used for centuries.

A more subtle type of reflection occurs when Robin Vaccarino uses pearlescent ink in her *Gemstone Series*. Silkscreened pearlescent color changes as it relates to hard-edged forms and as our angle of vision changes. New images and planes appear. Shapes are activated by the reflective qualities of the ink and flip-flop in space.

Josef Albers in his *Structural Constellation Series* engraved "impossible" figures on plastic. There can be no coherent reading of these linear forms because there is an essential contradiction between our experiences (in seeing forms) and what these elements define—illusions of perspective in two dimensions that cannot be translated into three-dimensional form.

When transparent plastics are molded and vacuum formed, they become three-dimensional. When these transparent three-dimensional forms are superimposed over flat images, light casts ghostlike shadows that appear to move as angles of vision change. Such is the effect created by Claes Oldenburg when his molded polyurethane car form was superimposed over a lithograph in the *Airflow Series* for Gemini G.E.L.

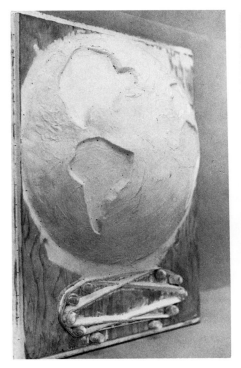

Plaster vacuum-forming mold for John Risseeuw's "All the World's a Cookie."

Wooden back of vacuum-forming mold. Note holes and saw marks created so that the air can be sucked out.

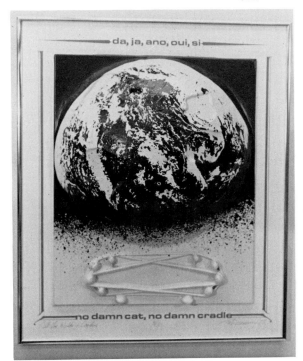

John Risseeuw, "All the World's a Cookie." Vacuum formed with silkscreen.

Side view showing relief. *Series Courtesy: John Risseeuw*

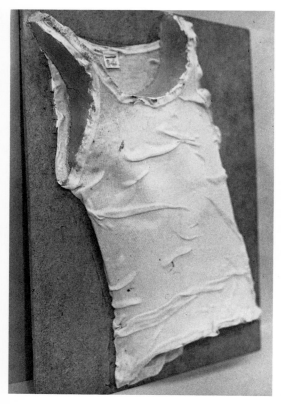

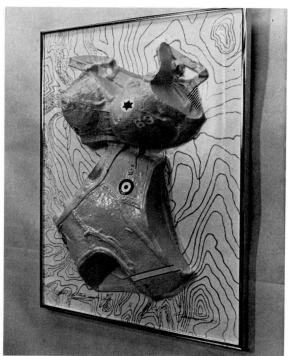

Mold for John Risseeuw's "Time/Space Projection," with plaster reinforcement.

Preliminary test-forming with grid to indicate where distortions are so that printing on the flat sheet can be corrected (beforehand) for distortions.

John Risseeuw, "Time/Space Projection." Vacuum-formed plastic serigraph. *Courtesy: John Risseeuw*

John Risseeuw, "Israeli Bra Attacks Egyptian Shorts." Vacuum-formed plastic and serigraphy. *Courtesy: John Risseeuw*

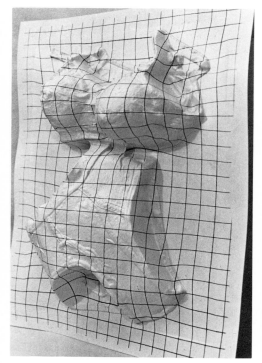

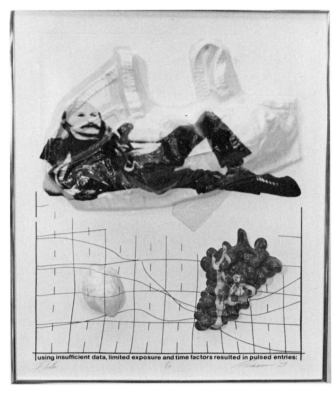

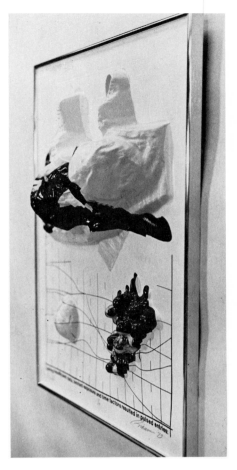

Two views of John Risseeuw's "Data." Vacuum-formed plastic and serigraph. *Courtesy: John Risseeuw*

Andrew Stasik, "The Home Buyer." Assembled print, lithograph, and stencil print on paper inside an acrylic box that contains multicolored plastic screen printing (ink) on the top surface. 16″ × 20″. *Courtesy: Andrew Stasik*

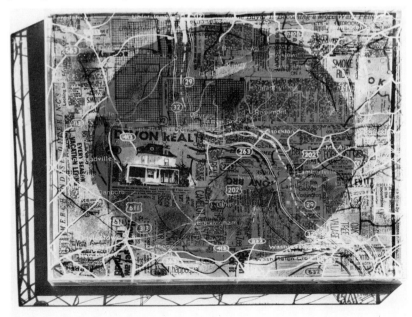

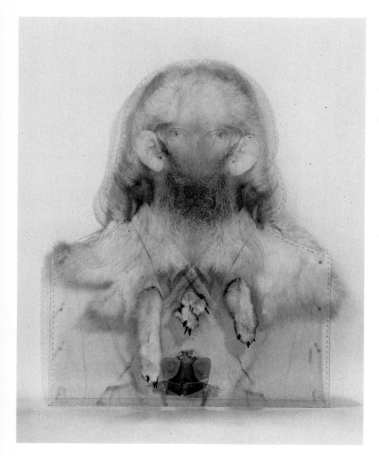

Wendy L. Calman, photo elements, fur, hair, enclosed in acrylic container. *Courtesy: Wendy L. Calman*

Charles J. Roitz, Untitled. Machined acrylic, aluminum (polished base, anodized plate with image enclosed), mineral oil. Image process—tonal reduction using Agfa contour film. Two-color silkscreen prints. Cavity containing mineral oil on top of image. "O" ring seals. Piece can be disassembled and image plate changed. 1974. 6½" high × 11" diameter. *Courtesy: Charles J. Roitz*

Charles J. Roitz's original print before a "reductive" process to drop out tones and leave only interphase lines. *Courtesy: Charles J. Roitz*

Below, left: Kodalith print made from Agfa contour negative. *Courtesy: Charles J. Roitz*

Charles J. Roitz, Untitled. Machined acrylic, high-contrast film and aluminum. Image processing—reduction of image to interphase lines with Agfa contour film. Image is made up of thirty-four Kodalith images that were the same except in size (which was dictated by the circular form). Illusion of volume in figures gained and image changes as viewer moves around the form. 1973. 9¾" × 8½" diameter. *Courtesy: Charles J. Roitz*

WALTER ASKIN'S POLYPLANOGRAPH

(Juxtaposition of graphic images on
many-layered parallel planes.)

Walter Askin starts with a series of drawings that
have basic modular characteristics so that parts can
be recombined to form different images. They be-
come a vocabulary of images. He charcoal-draws
the parts to achieve "gritty" overtones.

Askin transposes these on Bourges sheets (trans-
paque) and scratches away parts he doesn't want
until contours form around the original charcoal
drawings.

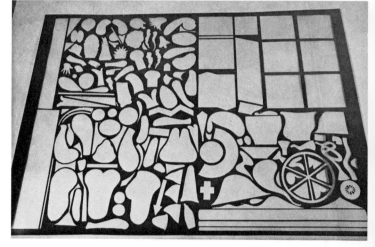

Below: He also uses Zip-a-tone to create textures
and patterns for original overlay. From these over-
lays he makes photographic reductions. There are
three photo plates for these images—one for the
overall contour, one for textured effects, and a
third, the line screen, for darkest colors or outlines.
Plates are then reduced to 75 percent of the origi-
nal by a photographic service. The negatives are
then made into a silkscreen, and images are pro-
duced using opaque polyvinyl ink onto decal-
comania paper. These images are made in six col-
ors in four different color combinations—pink,
blue, white, red, yellow, green.

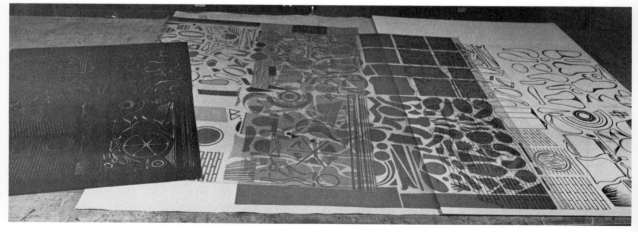

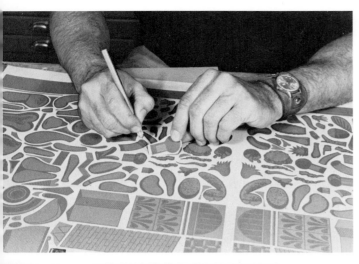

With an X-acto knife, images are roughly cut out of the decal sheet . . .

. . . and more finely trimmed with scissors.

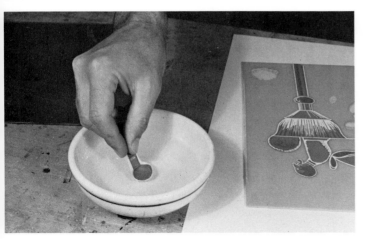

The element is placed in tepid water for one-half to one minute.

Rags are used to absorb excess water from the decal.

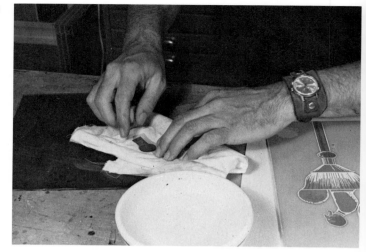

And the piece is applied to clean acrylic.

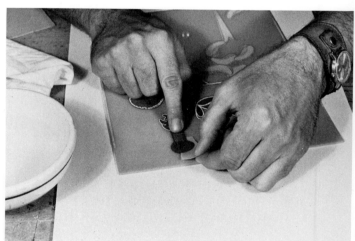

Cardboard is used to squeegee excess water.

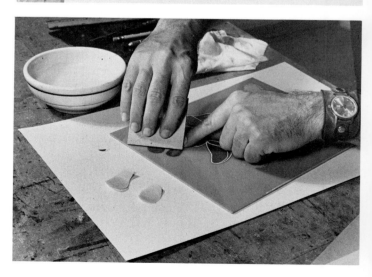

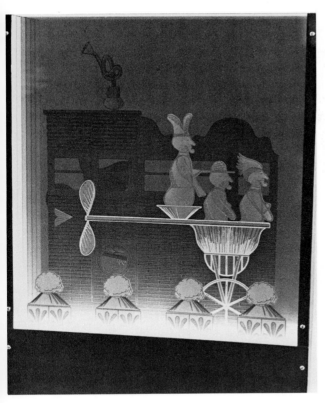

Walter Askin, "Lyrical Descent." Five acrylic planes of transparent acrylic with vinyl decals enclosed in an acrylic box containing showcase lights that are timed to go off and on in 2¼-minute intervals. (Use of tube activated timing device Amperite 115c-75-115c 180 relax bulbs.) 16″ × 15″ × 5″.

Walter Askin, "Dictum." Five various colors of acrylic with vinyl decals and lighted case. 14″ × 16″ × 5″.

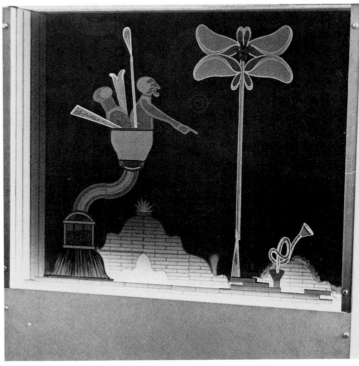

PRINTING A TRANSFER
ELEMENT, OR DECALCOMANIA

Most transfers or decals are printed by lithography or silkscreen processes. They have particular significance when small repetitive units are to be applied on a smooth surface. Surrealist Max Ernst used this technique in his paintings.

To make a decal, the lithography or silkscreen inks must be printed on decal paper to form films that can be transferred to almost any surface. (Most silkscreen supply companies sell the basic paper.)

Traditionally, the porous decal paper has had a coating of starch and gum arabic or starch, albumin, and glycerine. Sometimes a coating of dextrin is used between paper and ink, as well. When ink is deposited on the surface, it forms a thin layer that can be slid off the paper onto another surface.

Most of the time the decal paper also contains a coating of clear lacquer or an opaque white pigment to make it more receptive to ink and to hold together separate color elements and allow it to slide off in one piece.

If one is silkscreening elements, the type of screen blockout used should be determined by the type of ink to be used and the surface to finally receive the decal. Ceramic decals, for instance, should be printed with mineral pigments that will fuse to the clay glaze when fired.

Except for ink considerations, printing of the design on the decal paper is the same as standard silkscreen or lithographic processes. When many colors are used, register marks should be used. The decal is finished with a coat of water-soluble glue called stickative.

After printing has been completed, the decal can be cut from the backing in general contours. When a decal is to be transferred from its paper to another surface, the decal unit is soaked in tepid water (room temperature) for about a half minute, until it begins to slide. Then the image is slid off the backing paper onto a clean surface. The stickative becomes water resistant soon after application. Prolonged soaking will cause the decal to float away.

When decals are being applied, no air should be allowed to remain underneath. Use a roller, brush, or preferably a sponge to gently press out trapped air and ensure good adhesion.

Ron Davis, "Cube I." Multiple object five-color photo-offset laminated to plastic. Laminated Mylar overlay. Mylar and paper adhered to ABS (acrylonitrile butadiene styrene) plastic. 1971. 30″ × 40″. *Courtesy: Gemini G.E.L.*

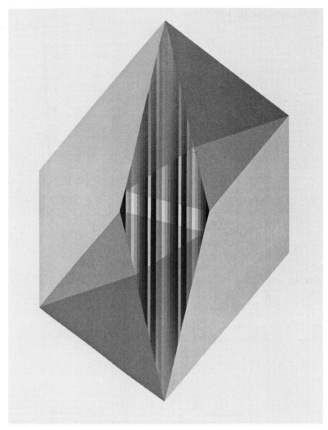

Robin Vaccarino, "Alki Point III" from *Gemstone Series*. Color of pearlescent ink changes, depending upon what visual angle one takes. New images and planes flip-flop in space, activating the planes. *Courtesy: Robin Vaccarino. Photo by Kenneth Peterson*

Josef Albers, "JHC II." Engraving on plastic. *20″ × 26″. Courtesy: James H. Clark, Dallas, Texas*

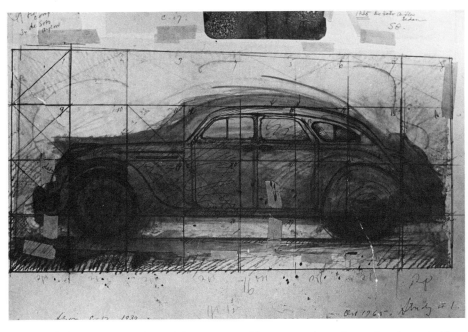

The original working drawing of Claes Oldenburg's "Airflow."

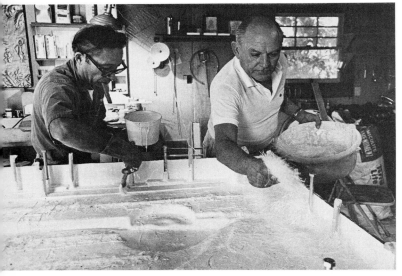

Making the female (and male) molds for "Airflow" in Jim de Shazor's workshop. The original model was a wooden relief.

The completed male and female molds awaiting hand finishing.

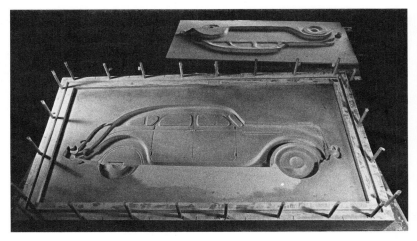

The male and female molds in place, ready for molding.

Claes Oldenburg with a flexible, transparent polyurethane casting.

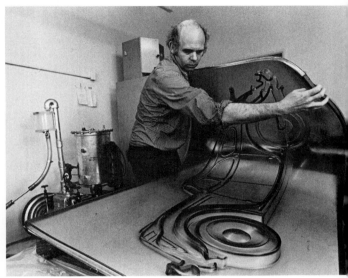

Claes Oldenburg, "Profile Airflow." Molded polyurethane relief over a two-color lithograph. 33½″ × 65½″. (Edition: 75.) *Courtesy: Gemini G.E.L. Photo by Malcolm Lubliner*

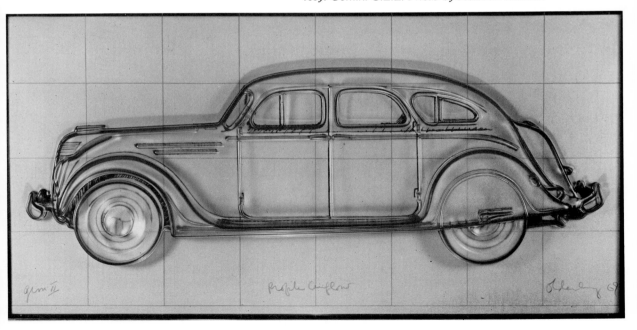

Radiography

In a sense, a transparent series, as in Masterson's and Askin's work, is simultaneous viewing of the external and internal elements of a form. These approximate what various X rays can produce and record by radiography. (A radiograph is an X-ray picture.)

It is quite possible to use X-ray equipment to generate another type of image. When X-ray-sensitive film or sheet (all film actually is sensitive to X rays) is placed between a subject (of varying opacity) and an X-ray source, after exposure and development, emulsions will be darkest where the subject was the least dense or most absent, much as in a photogram. The process is very simple, but we must be respectful of it. Since radiography does impose inherent dangers, safety precautions must be observed as they are every day in industry, in hospitals, and in dentists' and doctors' offices.

X-ray machines come in various configurations: some resemble small ovens with all "activity" contained in a cabinet; some come with an accessory fluorescent screen for visual examination; others have exposed heads. Radiation produced by higher voltages has much greater penetrating power than does lower voltage radiation.

Image contrast can be controlled by filters, as in light photography. The filters, in this case, are thin sheets of various metals that selectively absorb certain wavelengths, thus affecting the penetrating power of the remaining radiation.

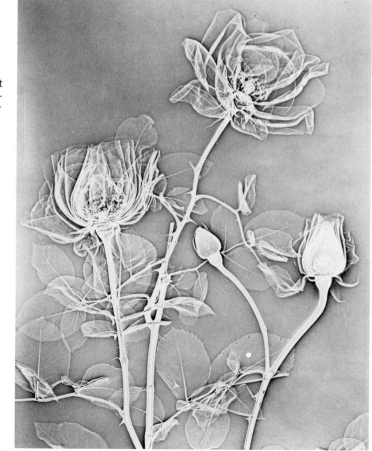

Ernest L. Hall with assistance of Robert Speizer (Xerox Corporation in Pasadena), "Roses." Xeroradiograph. *Courtesy: Dr. Ernest Hall*

There are many offshoots of the radiography field that have applicability to print-making. One is called xeroradiography. It is a type commonly used for breast cancer detection. The technique uses an ordinary X-ray generator to radiate the object and expose a charged electrostatic plate. The electrons on the plate perform an edge enhancement (similar to photographic unsharp masking) by charge repulsion in areas of transition. The charged plate covered with a paper emulsion and (in the example shown here) a blue toner is deposited at the discharged locations. The xeroradiograph of the roses shown here was done by Dr. Ernest L. Hall (University of Southern California).

Computed tomography (CAT or CT) is another variation. It is a revolutionary new medical diagnostic technique that produces a cross section of the brain or other parts of the body. The illustration shown here, also produced by Ernest Hall, is of the brain and shows a tumor in the lower-left portion.

To describe the highly sophisticated computerized tomography in simple terms, it is an X-ray technique that images serial 13-millimeter planes of a body, head, or whatever. Opposite the X-ray tube is an array of sodium iodide crystals that emit visible light when struck by X rays. A tube-detector assembly moves around the person/object and makes an exposure every 10 degrees—eighteen exposures for a 180-degree scan of the 13-millimeter "slice." The visible light emitted from the sodium iodide crystal detector is registered on a photomultiplier tube that measures it and passes the reading on to a computer that digitizes the X-ray intensity.

The computer then pieces together the information to form a cross-section view of that particular "slice" and projects it on a TV-like screen. At that point, the contrast of the image can be adjusted and the image can be photographed from the screen.

Ernest L. Hall (with Gerald Huth and Robert Levis), "Computer Tomography Brain Scan." (The brain shows a tumor in the left portion.) *Courtesy: Dr. Ernest L. Hall*

Tyler James Hoare, "Culinary Viewpoint." 3M color. 1972. 8½″ × 11″.

Facsimile Printmaking: Photosensitive Systems— Electrophotography

Use of silver halide film has dominated photography because of its high-speed light sensitivity. But, as we have seen, there are numerous light-sensitive systems that do not use silver. Many of these have recently been revived as printmaking processes. Another group of systems—electrophotographics—have until now been limited to microfilming, office copying, and advertising design.

In principle, electrophotography employs photoconductive substances that decrease in electrical resistance when light falls upon them. The process utilizes the phenomenon of electrostatic force—the same force that causes a spark to jump from your fingers to an object that you touch after walking across a carpet (discovered by Chester Carlson in 1938).

Xerography

Photoconductive materials (semiconductors such as selenium), which conduct electricity upon exposure to light but behave as insulators in the dark, are applied in layers to a conducting plate or drum. That surface is electrostatically charged, in the dark, and light pattern is projected onto it. In the illuminated areas of the design, the electric charge is dissipated, whereas the unilluminated areas retain a residual charge. The charge is then made "visible" by dusting the plate with a powder ("ink") that contains some thermoplastic resin. Paper is laid upon the powder image, which is transferred to it by an electrical charge passing from the back. The charge causes the powder to adhere while heat (or vapor) is applied to melt the thermoplastic powder particles, and makes the powder image permanently adhere to the paper. This is, in essence, xerography (in Greek *xēros* means "dry" and *graphein* means "to write").

The Xerox 6500 Color Copier, the 3M Color-In-Color, and the Itek are similar systems involving dye transfer. All systems employ three process colors (usually magenta, yellow, and cyan), which are applied to a continuous roll of aluminum foil. As the image is exposed, the appropriate filter determines the amount of each color in each area. These quantities are transferred to the surface of the copy from the foil.

Color settings can be adjusted so that different amounts of each color will be printed. It is possible, then, to use very little or none of a color. By controlling settings, color copies also can be made from black-and-white originals.

Many artists use these processes to refine, manipulate, and duplicate photographs or collage-montage pieces. If a photograph is run many times through these processes, tonal values can be reduced to leave the strongest darks as linear effects. Further manipulation of adjustment controls can create other deviations.

Tyler James Hoare, who thinks of the copy machine as one would a printing press, creates his images by combining cutout elements that have already been printed into a

collage-montage and then Xeroxing them. The original cutout is placed on the Xerox machine (color copier), adjustments are made, and out comes a facsimile.

These can be produced as positives on paper. But if a transfer (shiny-surfaced) paper is used, the image can be transferred to acetate or cloth through the heat of an iron or dry mount machine at 270° F. Hoare sometimes returns the piece to the paper carrier and prints a second layer of color over the first, causing a heavier color buildup. He also varies the kinds of paper—Reeves or Arches—and sometimes employs these images three-dimensionally.

Stanley Bowman laminates Xerox prints onto particle board. Pat Tavenner combines Xerox elements with stamps—glued on and stamped on. James H. Sanders applies Xerox iron-on transfer to cloth and combines it with other elements—silk embroidery, photosensitized fabric prints, and Pentel dye crayons.

Warren Knight manipulates photo images by applying calligraphic inserts and manipulating the color mixture through Xeroxing on 100-percent rag paper. Andre Haluska, also uses 100-percent rag-content paper (Reeves) and combines Xeroxed elements with Kodalith images in stereoscopically accurate prints. After the toner has been deposited electrostatically, he sometimes intervenes and manipulates the particles before they are fixed by heat (or vapor).

Black-and-white images can also be transmitted through ordinary telephone lines and via low-energy laser (such as the Xerox Telecopier 200 Transceiver), and combined with the principle of xerography, to receive images on ordinary, unsensitized paper. It takes two to six minutes to transmit an 8½″ × 11″ graphic.

XEROX PRINTMAKING
with Tyler James Hoare

(Collage/montage paper plates become prints via the Xerox machine.)

The paper plate collage elements are placed on the copying plate of the Xerox 6500 Color Copier.

Dials are regulated; buttons (the three on the right regulate color—magenta, cyan, and yellow) are pressed . . .

. . . and in a few seconds, out comes a color print.

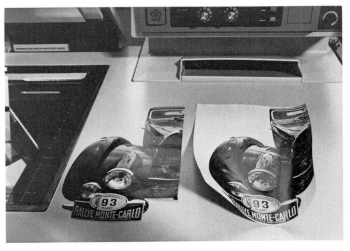

Color fidelity is compared and any adjustments necessary are made.

The print elements are assembled into "Classic" by Tyler James Hoare. Color Xerox on formica, 1976. 16″ × 11″ × 4″. (Edition: 10.) *Courtesy: Tyler James Hoare*

Tyler James Hoare, Two figures. 3M color. 1973.

Tyler James Hoare, Untitled. Color Xerox.

Stanley Bowman, "Twelve Hands." Xerox on particle-board, 1975. 1′ × 8′. *Courtesy: Stanley Bowman*

Pat Tavenner, "Hand-Stand." Xerox, photo stamps, rubber stamps, and
Pentel pen. 1972. 8″ × 10″. *Courtesy: Pat Tavenner; copyright: Pat Tavenner*

James H. Sanders III, "Satyr Pillow (with Bag)," from *Attic Image Series*. Bag: color Xerox iron-on transfer image in cotton, quilted with drawstring. Pillow: photosensitive dye (Kwik Proof) on muslin, dye crayoned, Procion Dye Paint, embroidery, piped and stuffed. 1976. *Courtesy: James H. Sanders III*

Andre Haluska, "Rowley St." Xerography Kodalith (*left*) and two Ektachromes (transparencies) combined, machine stitched, Reeves paper. Stereoscopically accurate. 1972. 5″ × 7″. *Courtesy: Andre Haluska*

Warren Knight, from *Photoscript Series*. Montage and Xerography. The calligraphic elements negate the personal element in the figures. 8″ × 10″. *Courtesy: Warren Knight*

Warren Knight, from *Photoscript Series*. Montage and Xerography. 8″ × 10″. *Courtesy: Warren Knight*

Warren Knight, from *Postscripts Series*. Lithographic color process machine and color Xerography on 100 percent rag paper. *Courtesy: Warren Knight*

Wire Photo

Transmitting photographs is not a new phenomenon but was a tool limited to wire photo agencies. Now it is more widely available. The process, as utilized by William Larson, is based upon the principle of transforming a photograph into sound that can then be transmitted by telephone. A photoelectric cell records the fluctuations of brightness and converts them into electrical oscillations. After the sound has been transmitted by telephone, it is converted back, not into a photograph but into a facsimile of the original at the receiving machine.

Once Larson transforms the photo into an electrical code, which the teleprinter does by scanning the original picture and assigning variations in voltage according to the gray levels it sees, it becomes much more compatible with other information-processing systems. When the information has been transferred to audio-signals, it can be stored on tape becoming a library of potential images. The information can be altered and transformed by the artist at this point.

Larson combines these stored photographic/now sound images with words and other sounds. These elements then share the same format and are woven into "a kind of complex tapestry of personal visual preferences." The information is integrated electronically as it is transmitted via telephone to the receiving machine where separate parts are accumulated sequentially on a paper that consists of three layers. One layer is a backing, the top is a fine white paper surface, and sandwiched between these is a layer of carbon. As various voltage levels reach the paper, a stylus burns the image,

line by line, through the surface to the carbon below. Higher voltages create darker images. The paper continues to be receptive to further processing until the surface turns (burns) completely black. In this manner, one can "draw" on the paper by adding burned-on images.

Size is a limitation—about 9″ × 12″—but transmission can encompass any two points on the earth that can be bridged by telephone and receiver.

It may be possible to effect different combinations of images through intervention of other machines. Why not the computer?

William Larson, from *Fire Flies*. Image transmitted by Graphic Science Teleprinter. *Courtesy: William Larson*

William Larson, from *Fire Flies*. Image transmitted by Graphic Science Teleprinter. *Courtesy: William Larson*

Kenneth Knowlton and Leon Harmon, a sixteen-level gray scale that consists of miniature patterns, each with a different gray scale value. Each pattern is defined by dot occupancy in an 11 × 11 roster; produced by a microfilm printer. *Courtesy: Kenneth Knowlton*

After the Great Departures: Computer Art

Computer systems are another group of machines that can function for the artist as a means toward achieving significant form. Since man the toolmaker first wielded a piece of stone, tools and machines have been an extension of his powers. In the hands of artists, their potential and the diversity of art forms have been expanded. This was the case with the brush, chisel, potter's wheel, and printing press. However, the relationship between artists and technologists has always been an uneasy partnership.

The more automatic the machine, the more threatened and uncomfortable the artist. It can be disturbing to discover that a mechanical device can quickly perform a task as well as a person who had to work hard to attain those skills. Eugène Delacroix expressed his consternation at this in his journal on August 3, 1885: "I went to the Exposition; I noticed the fountain which spouts giant artificial flowers. The sight of all those machines makes me feel bad. I don't like that stuff which, all alone and left to itself, seems to be producing things worthy of imagination."

The concept of programmed machines is not exactly a mid-twentieth-century invention. The fountain Delacroix wrote about was one. The music box with its perforations or pins on cylinders and the player piano with its hole-punched paper rolls were others —and not too different in concept from punched cards of the computer.

The Jacquard card-reading looms of the early nineteenth century produced complex weavings made possible by use of a punched hole in a card to represent a number and control the operation of the loom. Herman Hollerith, in the late nineteenth century, inspired by the Jacquard system, invented the punched card, combining it with electromagnetics. His system was one forerunner of the modern computer. (In fact, the companies with which Hollerith was associated later became I.B.M.)

Besides use of punched cards, programs for weaving looms operate on a grid similar in principle to some computer programs. (One of the major differences is that the computer is faster and more accurate.)

Curiously, artists such as Seurat, Duchamp, Braque, Gris, and Picasso in cubism, pointillism, and futurism simultaneously developed some of the systems and results being explored by technologists.

Seurat constructed the composition of his paintings according to mathematical ratios of the golden section and "digitized" his spots of color. Cubists dissected forms into essential planes. Futurist Duchamp, in "Nude Descending a Staircase, No. 2," stopped motion as did Muybridge with stroboscopic photography.

Through an intuitive process, artists often reached solutions—or explored concepts—in a manner parallel to that of scientists. Surprisingly, their experiments and discoveries occurred simultaneously, although the congruence may not have been immediately apparent, since their spheres and goals were different.

Ken Knowlton, a computer engineer at Bell Telephone Labs who has a deep under-

standing of the ways of making art, speaks of the differences in thought processes of artists and computer engineers and some of the concomitant difficulties.

Just how we are to go about producing "art" by computers is not immediately obvious. What we probably need is a new breed of artist-programmer, a rather unlikely, or at least a rare phenomenon. I say this because in my experience artists and programmers are rather different groups. Both groups are creative, imaginative, intelligent, energetic, industrious, competitive, and driven. But programmers, in my experience, tend to be painstaking, logical, inhibited, cautious, restrained, defensive, methodical, and ritualistic. Their exterior actions are separated from their emotions by enough layers of logical defenses that they can always say "why" they did something. Artists, on the other hand, seem to me to be freer, alogical, intuitive, impulsive, implicit, perceptive, sensitive, and vulnerable. They often do things without being able to say why they do them, and one usually is polite enough not to ask. I expect, therefore, that art will continue to come from artists or perhaps artists working closely with programmers—I do not expect

Stan Vanderbeek with Kenneth Knowlton, frame from a film produced by TARPS, which uses coarse resolution made of BEFLIX (126 × 92 characters). This picture is made of blanks, quotation marks, α and β's. Individual characters contain certain gray values and can be used to form images. *Courtesy: Kenneth Knowlton*

much art to come directly from programmers who have devised clever gimmicks for doing cute things. We ought, therefore, to develop a good deal of collaboration between artists and programmers in order to develop meaningful, understandable, and useful sets of tools and ways of using them.*

Few artists, to date, have learned to write their own computer programs. Most require the intervention of a computer programmer. Although one does not necessarily have to be a mathematician to use a computer, for complex algorithm it certainly helps to have a deeper understanding of the process.

In collaboration with artists, computer programmers have developed systems to create visual elements. EXPLOR is just such a system, developed in 1970 by Dr. Knowlton, for producing a wide variety of designs from *explicitly provided two-dimensional patterns, local neighborhood operations, and randomness.

*Ken Knowlton, "Collaborations with Artists—A Programmer's Reflections," *Graphic Languages*. (Amsterdam-London: North-Holland Publishing Co., 1972), pp. 399—418.

Kenneth Knowlton, same approach as above. The text is printed successively in different characters, following a diagonal path downward and to the left, then right, and up to center. *Courtesy: Kenneth Knowlton*

Despite some formidable problems in producing exact visual elements that are imagined by the artist, the basic principle of the computer is surprisingly simple. The computer memory may be thought of as an electronic surface consisting of a thin sheet containing millions of small electronic elements called bits. A bit is the smallest unit of information. The number of bits necessary to express something is a measure of the complexity of the information to be encoded. For example, one letter of the alphabet may be encoded with five bits.

Each of these small electronic elements has its own electronic field. Programming bits to respond along different axes will affect different patterns, values, and shapes. Typically, it takes thousands and sometimes millions of bits to encode material.

Once information has been encoded and stored in the computer memory, programs may be employed to manipulate and retrieve it. Computer programmers devise procedures to manipulate symbols. These symbols can mean whatever the artist wants them to; they may be numbers, letters, or shapes.

Kenneth Knowlton, an example from EPLOR, "Illustration of probablistic treatment of rectangular arrays of subareas." *Courtesy: Kenneth Knowlton*

Ken Knowlton's EXPLOR builds and stores pictures in raster-scan format* retaining information pertaining to each x, y coordinate position. In this system, the program allows for the manipulation of shapes, colors, and the angles from which the elements are seen. In short, once information and concepts have been encoded and programmed, other aspects of the program allow the artist enormous flexibility in the way information is retrieved and combined.

In another of the many approaches to utilizing computer capability, it is possible to begin with a photographic print or negative. A digitizer scans the image and digitizes or codes the information in discrete symbolic elements on a fine grid, such as 256 points

*The raster-scan format is a means of encoding a picture the way television does: information about every spot in the picture is indicated by horizontal scan lines, each of which is divided into discrete spots that can each represent a predetermined number of symbols. If there is a two-dimensional array of 500 horizontal lines and 500 spots on each line, the computer must be programmed to account for 250,000 pieces of information on the screen, in order to create an explicit and complete picture.

Kenneth Knowlton. Designs that have been based on explicit patterns encoded in octal numbers. *Courtesy: Kenneth Knowlton*

Lillian Schwartz, "Mandala I" created by computer-controlled Gerber Plotter Device. The Gerber Plotter Device consists of a big flatbed that contains a mechanism that controls a fine beam (in pinpoint fashion). The operator can change the size and direction of the beam. The image can be recorded on film—and from the film image one can create etchings, silkscreens, and so on. *Courtesy: Lillian Schwartz*

along each axis or coordinate. A digitizer codes by evaluating the light-intensity scores at each grid point on the surface, which are then mapped in the computer memory.

In one implementation, scores may range from 0, which is pure black, to 127, which is pure white. These light-intensity scores then are recorded on magnetic tape. This recorded information may be recalled in many ways and forms. The light intensities may be assigned characters or symbols—such as &, #, !, N, X, 0—of many types, with the density of each correlated to the intensity of the reflected light. The gray scale might contain eight values, as in Sheila Pinkel's desert scene, or 22, as in other systems.

The result is not unlike a slightly enlarged halftone in which one can see the dots, or it is like the graphing of a weaving design. Other computer systems utilize plotters that draw on paper using different color pens; or one can draw with a light pen on a cathode ray tube. A computer stores this information for later recall.

Lillian Schwartz, "Mandala II." Image created by Gerber Plotter Device. *Courtesy: Lillian Schwartz*

After a digitized image that is fed into a computer is photographed from a TV monitor, the resulting slide can be fed into a color Xerox machine to reproduce a positive. Or some of these images can be printed out in gray shades on a computer line printer. The image can then be level sliced (so all information along a particular line is indicated) and printed in pseudocolor using silkscreening techniques. To do this, the information from the digitizer (scanned by the computer) that is assigned for 256 shades of gray is translated into information that is stored on magnetic tape. The tape is then played into a color TV set (Pseuda Color). Unique colors are assigned to each of the 256 shades of gray and displayed on the Spectrovision color TV set. The TV image is broken down into electronic dots as in a halftone. When activated, the TV permutates the colors according to predetermined rotational schema. These permutations are photographed on high-speed color film such as Ektachrome (to obtain a slide) at one- to two-second exposures at F/4. A Nikon equipped with a 200-millimeter telephoto lens was used by Sheila Pinkel to correct for parallax of the TV screen. Finally, the color slides are projected into a color Xerox machine and prints are made.

Kenneth Knowlton, two attempts to build remarkable "three-dimensional" imagery via the computer. *Courtesy: Kenneth Knowlton*

Opposite page:
Top: Lillian Schwartz, "Soaring." Image created by Gerber Plotter Device. *Courtesy: Lillian Schwartz*

Bottom: Lillian Schwartz, "Papillons #2." Computer program by John Chambers. From contour plot displayed on A. MIRATEL television-scanned color display, driven by a DDP-224 Computer. The computer program controls 500 × 500 points on the screen. A "joy" stick manipulates mixture of three colors—red, green, and blue, as the image appears on a color-TV-like monitor. *Courtesy: Lillian Schwartz*

Kenneth Knowlton and Leon Harmon, a photograph proc-
essed through the above system consisting of 112 × 45
cells. Micropatterns in this case were small maze elements ar-
ranged so that they could be joined from cell to cell, produc-
ing solid values in appropriate areas. *Courtesy: Kenneth
Knowlton*

Lillian Schwartz and Kenneth Knowlton, "Nude." Same
process as the above, using a different assortment of sym-
bols. *Courtesy: Kenneth Knowlton*

Opposite page: Sheila Pinkel with program by Alan R.
Bormuth. "Tommy Trojan." This picture containing edge
structures, texture patterns, and a human form is a famil-
iar symbol of the University of Southern California cam-
pus. The image was digitized and printed out by the com-
puter using special-edge enhancement and a gray-scale
line printer program. The printout was then photo-
graphed, pseudocolor enhanced, and silkscreened by
Sheila Pinkel. *Courtesy: Sheila Pinkel and Ernest Hall*

Sheila Pinkel, "Landscape." The original photograph of a
Western scene was first digitized into an array of numbers
and printed out in shades of gray on a computer line printer.
It was then level sliced and printed in pseudocolor using
silkscreening techniques. *Courtesy: Sheila Pinkel and Er-
nest Hall*

TRANSLATING A PHOTOGRAPH INTO A COMPUTER-GENERATED IMAGE
with Sheila Pinkel and Ernest Hall

The original image is a continuous tone photograph, a lightwork (photogram), made by contacting a glass cube to a piece of photographic paper and shining light through the image to the sensitive paper.

Sheila Pinkel places the photogram on the drum of a computer. As the drum rotates, the image is scanned for 256 shades of gray and is translated into a code that is stored on electromagnetic tape.

After the tape is played into a color TV set (Pseudo color), Dr. Ernest Hall points out significant information about the specific spectral color display appearing on the screen. The band width and color placement in this rotational schema determines the colors actually displayed in the image when it appears on the screen. There are thirty-one specific spectral color displays programmed into this machine.

Sheila Pinkel is looking through a magnifying glass to see the red, green, and blue dots that make up the color on the screen.

Dr. Hall calls out various color combinations of images by typing instructions to the computer, and Sheila Pinkel records the permutations of images on high-speed Ektachrome film using a Nikon equipped with a 200-millimeter telephoto lens to correct for the parallax of the TV screen. She uses exposures over one-thirtieth of a second, which is the length of time the TV screen takes to generate one complete image.

The slides of those TV images are now projected into the color Xerox machine at Xerox Corporation with the help of Mike Spievak. The dial near Sheila Pinkel's hand is used to manipulate brightness intensity. The three descending dials on the right control the percent of cyan, yellow, and magenta that go into making the image.

Sheila Pinkel, the original photogram of a glass cube.

June M. Bonner, "Aperture." Dye transfer. *Courtesy: June M. Bonner*

John D. Whitesell, "Lorelei." Multiscreen photo-silkscreen. *Courtesy: John D. Whitesell*

Randy Sprout, Untitled. Photogravure and etching. *Courtesy: Randy Sprout*

Judy Chicago, "Butterfly." Cast paper. *Courtesy: Atelier Royce*

Merry Moor Winnett, "Pier Group." Photoetching on Fotofoil-A plate. *Courtesy: Merry Moor Winnett*

Walter Askin, "Lyrical Leader." Polyplanograph photo-screened decals on layers of tinted acrylic. *Courtesy: Walter Askin*

Mural-sized Graphics

Another use of the computer is what 3M called Architectural Paintings. These are computerized full-color reproductions possibly enlarged to monumental proportions. Computerized equipment reads small photographic transparencies and, through four programmed spray guns, sprays the image onto a canvas or paper as it is rotating on a huge drum.

The computer-controlled spray gun is driven by a scanner that reads the photographic transparency, and through a fine airbrush head, four colors—cyan, magenta, yellow, and black—are spurted in minuscule droplets in rapid order on the rotating drum.

The computer, when set to the desired size, determines scale and color balance. An original transparency can be enlarged 24, 36, 48, or 72 times. Pigments used are more stable than photographic dyes.

Although the preferred starting point is a good (35 millimeters or larger) transparency, the original art can be a color negative (35 millimeters or larger), a photographic print (4″ × 5″ or larger), art layups, prints, or whatever.

Various kinds of substrates can be selected from a range of standard base materials: paper (dense filled bond), paper-backed jute, finely woven cotton, cotton-backed vinyl, paper-backed nylon, paper-backed rayon, and so on. The textures and basic colors of these substrates influence the quality of the final painting in color and texture.

Completed 3M Architectural Paintings are oversprayed with a clear penetrating protective rosin to bind the fibers and improve soil resistance of the surface.

The only access to this patented system is 3M. In fact, all of these computerized systems, because of the expensive array of equipment, require patronage—from universities, large industry or research centers, and collaboration with computer engineers.

MAKING OF MURAL-SIZED PAINTINGS AT 3M

The 3M Architectural Paintings process begins with a "Machine Ready Transparency" (MRT), a specially prepared color transparency of the subject, which is placed on an optical scanning device.

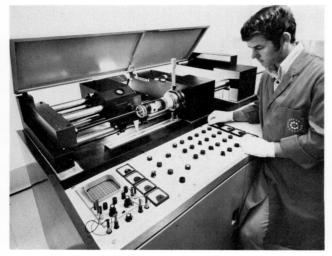

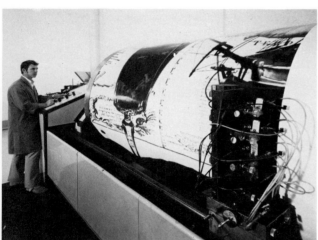

Top, left: The MRT is read by a computer, being adjusted here by the operator. As the small drum on which the MRT is mounted rotates, the various colors in the transparency are read by the computer, which then sends signals to a battery of four paint guns, facing a larger drum on which the final painting is made. The large drum rotates in synchronization with the small drum on which the MRT is mounted.

Top, right: The battery of four paint guns dispensing the three process colors—magenta, cyan, and yellow plus black—are shown in operation at close range. Notice that the two center guns are spraying paint onto the substrate, which is wrapped around the large drum.

Center: The operator is checking the progress of the work. Notice that the painting is nearly completed.

Bottom: The operator is ready to remove the reproduction as a second operator applies a transparent spray protective coating to another painting.

The completed "painting." *Series Courtesy: 3M Company*

A Bicentennial mural in Philadelphia. *Courtesy: 3M Company*

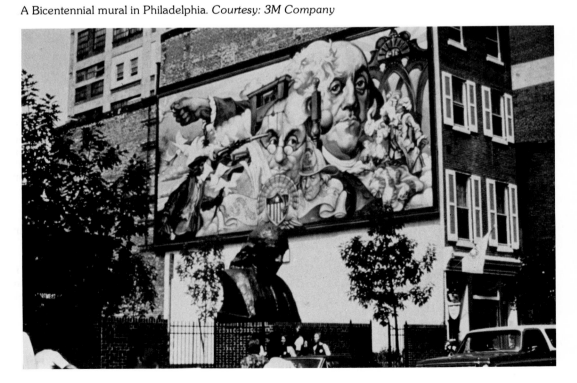

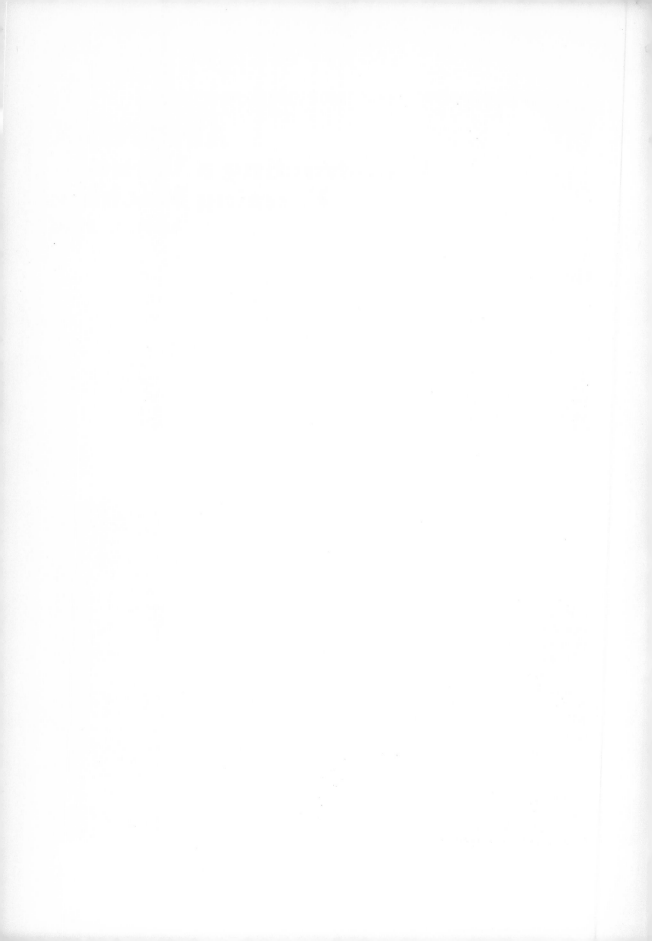

APPENDIX
Constructing a Vacuum-Forming Machine
by A. E. Moll

General Instructions

Framework and the frame that retains the plastic sheet during heating and forming operations are built from materials (1 to 14b). Most of the structural elements of the framework are cut from (1). (2) is cut to two 3-foot lengths and fitted with clips to attach to the lower section of the plastic-holding frame to adapt to smaller frame sizes. Cut two 6-inch lengths from (3) and weld to each a 4-inch length of (5) to make idler sprocket brackets. (4) is used for diagonal bracing of the frame. A 14-inch length (4), plus two 4-inch lengths (5) and one (14) collar are assembled to make a crank. The remaining length of shaft (5) is used to mount upper sprockets, counterweight pulley (15), using bearings (6). Plastic frame is cut from (1), mitering corners. Outside dimensions should be 3 by 4 feet. Hinges (14a) are welded to the trolley side of the frame, and the vise grip clamps are attached to the opposite side. Four shaft collars (14) are used to retain lower sprockets (8) on their respective brackets. These brackets are mounted with bolts (11). Drill ¼-inch holes in frame, ⅜-inch holes in brackets (oversize to allow shifting bracket to adjust chain tension). Bolts (12) are used to mount plastic frame to trolleys. Since clearance between tracks may be slightly greater than needed, washers (13) may be placed between trolley and plastic frame to separate trolleys enough to fit the distance between tracks.

Counterweight, which is designed to balance the weight of the movable frame, is simply a V-pulley (15) mounted on shaft, with a length of cable with a weight attached. As the frame is lowered, cable is wound up on the pulley, lifting the weight. The cable is attached to the pulley through a small hole drill at the edge. A visit to a junkyard might save some money when obtaining the counterweight. The one described is a piece of a junked shaft, about 30 pounds.

Trolleys are made by welding a length of 2-inch bar (20) to a length of 3-inch bar (19) to form an L shape. Rollers (18) are bolted to the top and bottom of the 3-inch leg of the inverted L, spaced so that they will fit the track. The holes may be drilled slightly oversize to allow adjustment. Note that the "heel" of the L projects slightly, to allow the roller chain to be attached so that there will be no interference between chain and trolley. Chain links are disassembled by grinding off the end of a rivet and punching it out. Measure length so that range of adjustment provided by limited movement of the lower sprocket brackets can take care of slack. With trolleys and chain installed, clamp the lower section of the plastic frame in position and drill ⅜-inch holes through both trolley arm and frame and install bolts, using shims if necessary so trolleys ride on tracks properly.

Heater is dimensioned so that the plastic frame will fit over the edge when it is raised to the heating position. It is simply an insulated sheet-metal box, and if the general

arrangement is followed, variations would work. We have found that nichrome wire heaters are the most efficient. Infrared lamps will not work. The nichrome elements can be arranged to concentrate heat where needed. The greatest loss is at the periphery of the heater, and by coiling the portion of the elements at the edge, more energy is concentrated there. The total power consumption of the four elements in the heater is less than 30 amps. Any porcelain insulators may be used. The spool-type indicated are generally available and can be adapted to the specific mounting pattern required. Be certain to obtain asbestos-insulated wire of the type used for electric ovens for the electrical connections between terminal board and power switch. Conduit must be large enough to contain four leads without cramping, to allow cooling.

Worktable is either a platform or a shallow enclosed box with outer dimensions slightly less than the opening of the plastic frame, to allow the softened plastic sheet to be stretched over the edges. Painting of all except the working surfaces of the worktables is recommended since plywood is somewhat porous.

Vacuum system hookup depends upon the specific pump used. With appropriate fittings, connect the intake of the pump to the tank/tanks. Install a vacuum gauge on tank. A valve should be installed in the line between tank and worktable. The most convenient valve is an electric solenoid valve operated by a foot switch. If not available, a quick-acting valve (gas cock) should be installed where it can be reached easily by the operator. The pump may be operated continuously while unit is in use. No pressure switch is needed for pump motor.

List of Materials

Reference Number	Amount	Description
		Framework and Plastic Frame
1	110 lin. ft.	Angle iron, 1½″ × 1½″ − ⅛″
2	6 lin. ft.	Channel iron (or channel formed from 14 ga. blk. iron sheet). 1″ × 2″ × 1″, i.d. channel about 1¾″
3	2½ lin. ft.	Iron, HF, rect. bar, ¼″ × 3″
4	20 lin. ft.	Iron, HF, flat, ⅛″ × 1″
5	6 lin. ft.	Shaft, CF, steel, ⅝″ round
6	2 ea.	Bearing, pillow block, sleeve, ⅝″ bore
7	2 ea.	Sprocket, c. 3″ dia. × ⅝″ bore, with set screw
8	2 ea.	Sprocket, c. 3″ dia. × ¾″ bore, with bronze bushing to reduce to ⅝″ bore, for idler sprockets
9	16 lin. ft.	Chain, roller, to fit sprockets, with sufficient connecting links
10	2 doz.	Bolts, stove, RH, ¼″ × ½″
11	1 doz.	Bolts, stove, RH, ¼″ × 1″
12	4 ea.	Bolts, machine, ⅜″ × 1½″
13	2 doz.	Washers, ⅜″ i.d. (for use as shims to mount trolleys)
14	5 ea.	Collar, shaft, ⅝″ bore
14a	2 ea.	Hinge, butt, 3″, loose pin
14b	2 ea.	Pliers, vise grip (type) small size

Reference Number	Amount	Description
		Counterweight System
15	1 ea.	Pulley, Vee, 5″ dia. × ⅝″ bore
16	6 lin. ft.	Cable, woven steel, ⅛″ to ³/₁₆″ diam.
17	1 ea.	Weight, steel, 4″ diam. round bar, about 10″ long
		Trolleys
18	8 ea.	Rollers, c. 2″ o.d., ¼″ to ⅜″ bore. (Roller-skate wheels are satisfactory.)
19	1 pc.	Iron, HF, rect. ¼″ × 3″ × 3′
20	1 pc.	Iron, HF, rect., ¼″ × 2″ × 3′
21	8 ea.	Bolts, machine, 2″ length to mount rollers on trolleys
		Heater
		Metal boxes may be ordered from a tinsmith, to be made according to specifications in drawings, or built from parts listed below. All sheet-metal parts from 24 ga. galv. sheet metal.
29	2 ea.	End pieces, 35″ long, formed, using sheet-metal brake
30	2 ea.	Side pieces, 48″ long, formed, using sheet-metal brake
31	1 ea.	Heater top, 46½″ × 34½″, 8″ × 8″ access opening for wiring, centered
32	1 ea.	Heater wiring mounting panel, 31″ × 43″, 6″ × 8″ opening, centered, for mounting 8″ × 10″ transite terminal board
33	1 ea.	Cover, wiring access opening, 10″ × 10″
		Terminal Board
34	1 pc.	Transite board, 8″ × 10″, with bolts to mount to wiring mounting panel
35	4 ea.	Bolts, brass, ¼″ × 2″
36	12 ea.	Nuts, brass, ¼″
37	2 doz.	Washers, ¼″
		Wiring from Terminal Board to Switch
38	16 lin. ft.	Wire, one conductor, asbestos insulation, #10
39	1 ea.	Switch box, fused, 220 v. with bolts to mount to heater
40	As needed	Conduit, 1″, to reach from switch to wiring access cover plate
41	As needed	Wiring to power source (220 v.)

Reference Number	Amount	Description
		Heater elements
42	4 ea.	Nichrome V, 22. ga., resistance wire, 15″ lengths, or other comparable wire to cut to proper length for 7 to 8 ampere heaters
43	80 ea.	Insulator, porcelain, spool-type, with ¼″ to ⁵/₁₆″ hole
44	As needed	Wire to form standoff mounts for insulators
45	1 gross	Screws, sheet metal, #8 × ½″
		Miscellaneous
46		Fiberglass wool or other comparable heat-proof insulation to make a volume of about 2″ × 3½′ × 4½′ for heater
		Work Surface
47	1 pc.	Plywood, ¾″ birch, 30″ × 42″
48	1 qt.	Paint, epoxy
49	1 ea.	Flange, 1″ pipe
50	1 ea.	Nipple, 1″ pipe, 6″ length
51	1 ea.	Elbow, 1″ pipe
52	1 ea.	Union, 1″ pipe
53	2 ea.	Nipple, 1″ pipe, 12″ length
54	1 ea.	Valve, fast-acting (gas cock), or electric solenoid valve, 1″ pipe thread
55	1 ea.	Vinyl caulk, tube
56	As needed	Plumbing parts to connect to vacuum tanks

Some applications require a hollow box worktable (vacuum manifold). Following is parts list:

Reference Number	Amount	Description
57	2 pcs.	Plywood, ¾″ birch, 30″ × 42″
58	16 lin. ft.	Lumber, birch or maple, 3.4″ × 2″ net dimension
59	As needed	Glue
60	As needed	Epoxy paint
		Vacuum Pumping System
61	1 ea.	Motor, electic, ¾ hp
62	1 ea.	Pump, compressor, 1½ hp rating or comparable refrigeration or vacuum pump
		Pulleys, belt, mounts, bolts, etc. to set up pump with motor
		Fittings and hoses to connect pump intake to vacuum tank
63	1 ea.	Gauge, vacuum
		Storage tanks to make a total of 100 to 150 gal. volume. Salvage tanks may be used since pressures involved are low, and tanks cannot explode since they are subjected to vacuum only.

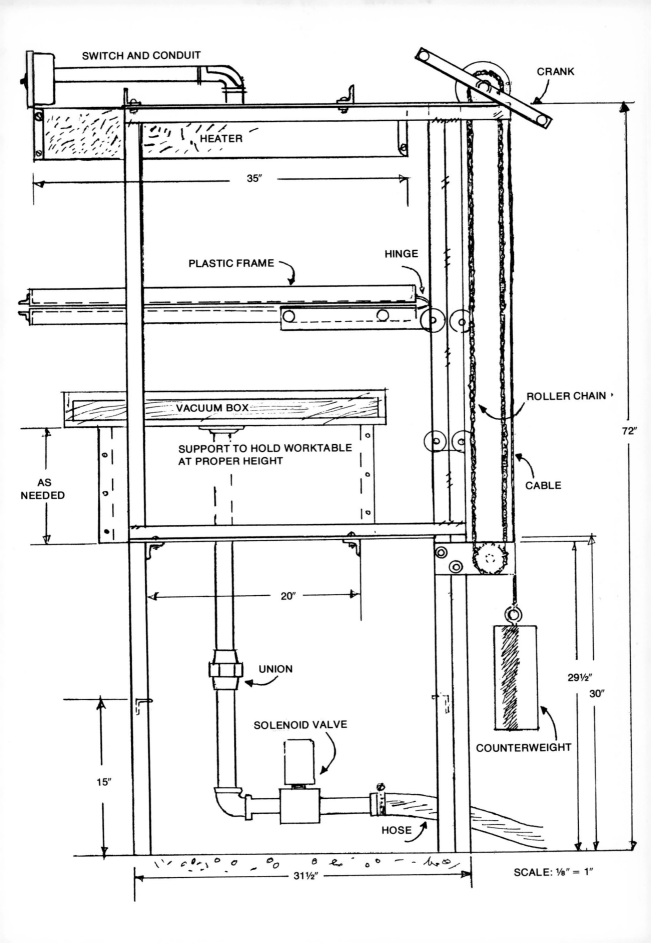

SWITCH AND CONDUIT

CRANK

HEATER

35"

PLASTIC FRAME

HINGE

ROLLER CHAIN

VACUUM BOX

SUPPORT TO HOLD WORKTABLE
AT PROPER HEIGHT

CABLE

AS
NEEDED

72"

20"

UNION

29½"

30"

SOLENOID VALVE

COUNTERWEIGHT

15"

HOSE

31½"

SCALE: ⅛" = 1"

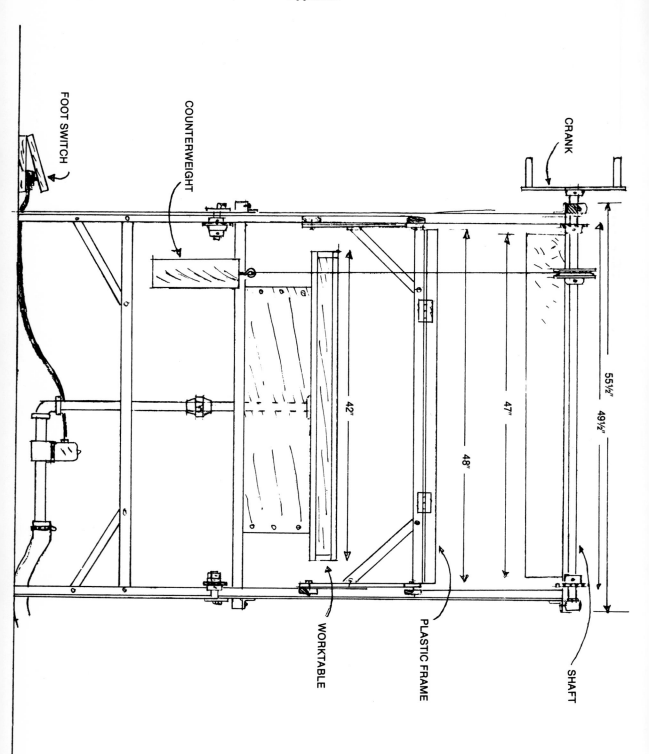

FRAMEWORK: PARTS DIMENSIONS

55½"

55½"

56"

55½"

55½"

51½"

51½"

14"

4" × 10" ROUND BAR

4"

4"

14"

36"

72"

31½"

72"

3" × 6"

MAIN FRAMEWORK, SHOWING RELATIONSHIP OF PARTS, AND ASSEMBLY.
SOME PARTS OMITTED IN DRAWING TO MAKE CLEARER. NOT TO SCALE.

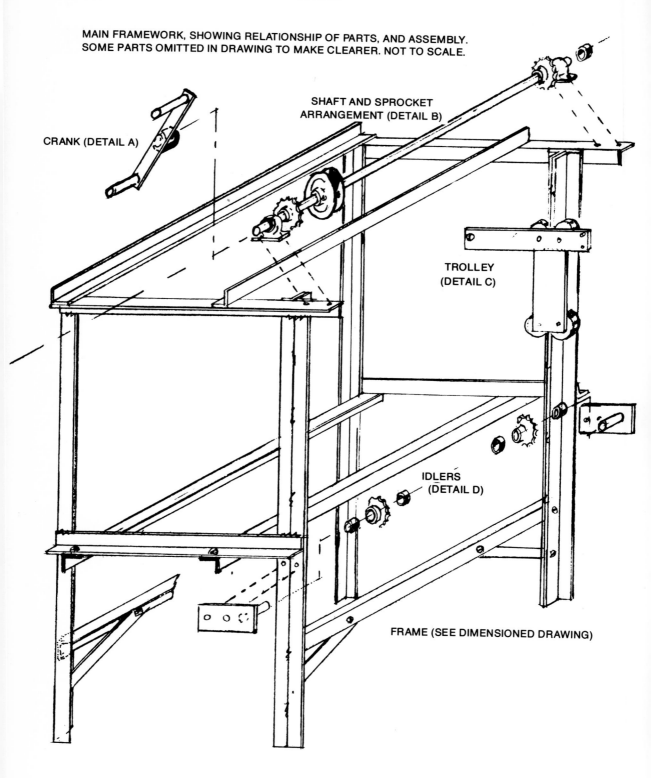

CRANK (DETAIL A)

SHAFT AND SPROCKET
ARRANGEMENT (DETAIL B)

TROLLEY
(DETAIL C)

IDLERS
(DETAIL D)

FRAME (SEE DIMENSIONED DRAWING)

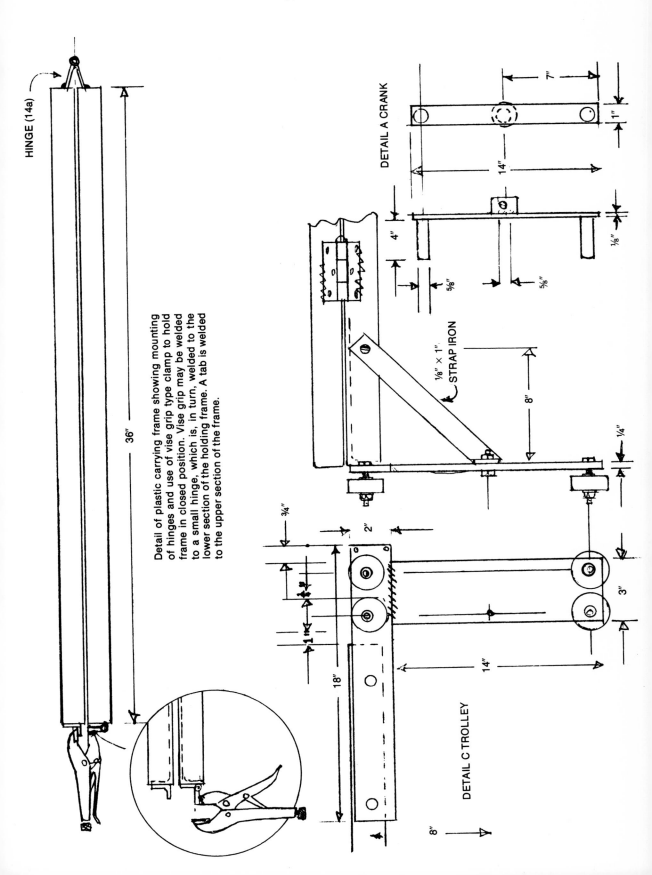

HINGE (14a)

36"

Detail of plastic carrying frame showing mounting of hinges and use of vise grip type clamp to hold frame in closed position. Vise grip may be welded to a small hinge, which is, in turn, welded to the lower section of the holding frame. A tab is welded to the upper section of the frame.

DETAIL A CRANK

7"

1"

14"

4"

⅛"

⅝"

⅝"

⅛" × 1" STRAP IRON

8"

¼"

¾"

2"

1"

18"

14"

3"

8"

DETAIL C TROLLEY

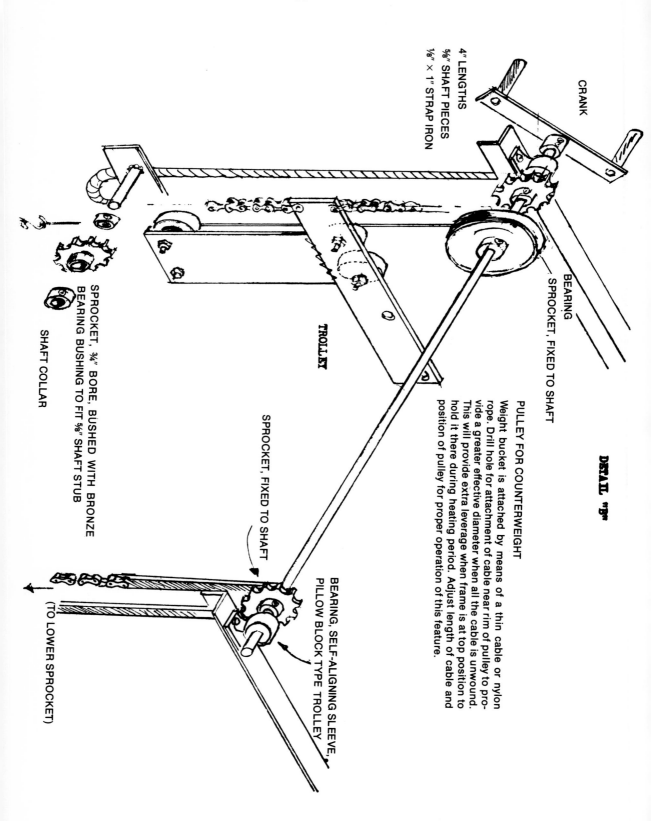

CRANK

BEARING

SPROCKET, FIXED TO SHAFT

DETAIL "B"

PULLEY FOR COUNTERWEIGHT
Weight bucket is attached by means of a thin cable or nylon rope. Drill hole for attachment of cable near rim of pulley to provide a greater effective diameter when all the cable is unwound. This will provide extra leverage when frame is at top position to hold it there during heating period. Adjust length of cable and position of pulley for proper operation of this feature.

4" LENGTHS
⅝" SHAFT PIECES
⅛" × 1" STRAP IRON

TROLLEY

SPROCKET, ¾" BORE, BUSHED WITH BRONZE
BEARING BUSHING TO FIT ⅝" SHAFT STUB

SHAFT COLLAR

SPROCKET, FIXED TO SHAFT

BEARING, SELF-ALIGNING SLEEVE,
PILLOW BLOCK TYPE TROLLEY

(TO LOWER SPROCKET)

HEATER: SHEET-METAL PARTS (ALL 24-GAUGE GALVANIZED SHEET METAL)

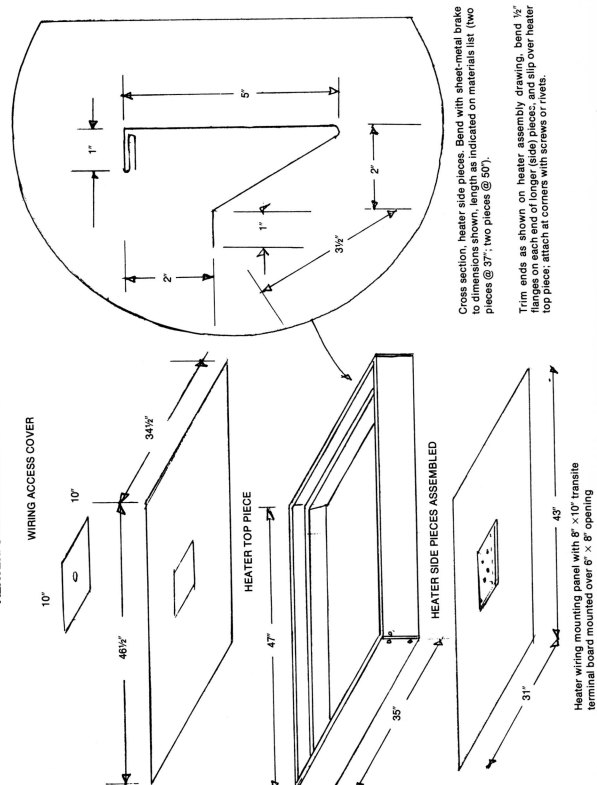

Cross section, heater side pieces. Bend with sheet-metal brake to dimensions shown, length as indicated on materials list (two pieces @ 37"; two pieces @ 50").

Trim ends as shown on heater assembly drawing, bend ½" flanges on each end of longer (side) pieces, and slip over heater top piece; attach at corners with screws or rivets.

5"

1"

2"

2"

1"

3½"

WIRING ACCESS COVER

10"

10"

34½"

46½"

HEATER TOP PIECE

47"

HEATER SIDE PIECES ASSEMBLED

35"

43"

31"

Heater wiring mounting panel with 8" ×10" transite terminal board mounted over 6" × 8" opening

(A) END PIECE: TRIM TOP CORNER TO 45° TO REMOVE SHADED PORTION.

45°

(B) SIDE PIECE: TRIM SHADED PORTIONS AS SHOWN, BEND FLANGE 90°.

2½"

½"

45°

B

BEND TAB 90° TO FORM ½" FLANGE

HEATER SIDES; CORNER ASSEMBLY TOP VIEW

BEND ½" TAB 90° TO FORM FLANGE

2"

FASTEN CORNER FLANGE WITH SCREWS OR RIVETS

END PIECE

37"

TOP PIECE

50" SIDE PIECE

END PIECE

HEATER WIRING MOUNTING PANEL

INSULATION FILLED

HEATER TOP

FUSED SWITCH (220 V., 30 AMP.)

¾" CONDUIT

HEATER ASSEMBLY

10" × 10" ACCESS PLATE

8" × 10" TRANSITE TERMINAL BOARD

¼" × 2" BOLT, BRASS
6 EACH BRASS WASHERS
3 EACH ¼" NUTS
(MOUNT FOUR OF THESE TERMINAL POSTS ON TRANSITE BOARD.)

HEATER: WIRING PLAN

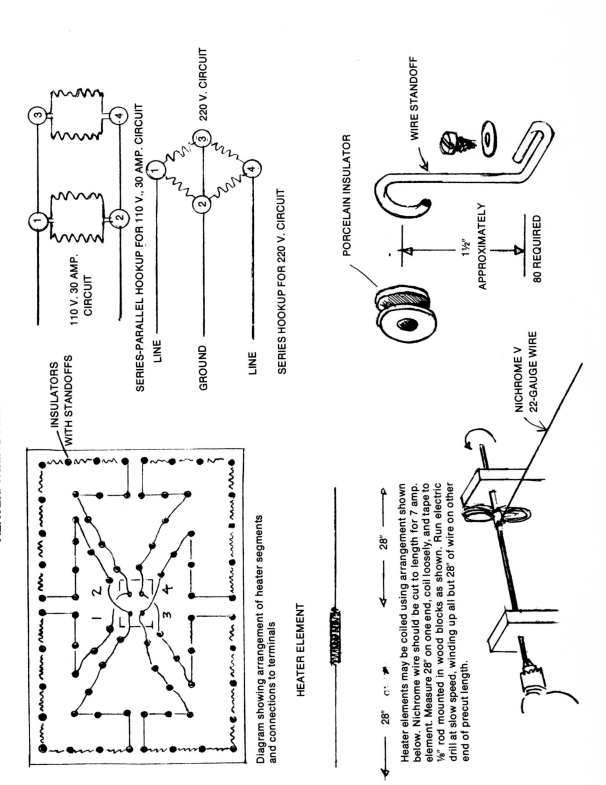

INSULATORS WITH STANDOFFS

110 V. 30 AMP. CIRCUIT

SERIES-PARALLEL HOOKUP FOR 110 V., 30 AMP. CIRCUIT

220 V. CIRCUIT

LINE

GROUND

LINE

SERIES HOOKUP FOR 220 V. CIRCUIT

PORCELAIN INSULATOR

WIRE STANDOFF

1½" APPROXIMATELY

80 REQUIRED

Diagram showing arrangement of heater segments and connections to terminals

HEATER ELEMENT

28" 28"

NICHROME V 22-GAUGE WIRE

Heater elements may be coiled using arrangement shown below. Nichrome wire should be cut to length for 7 amp. element. Measure 28" on one end, coil loosely, and tape to ⅛" rod mounted in wood blocks as shown. Run electric drill at slow speed, winding up all but 28" of wire on other end of precut length.

TWO TYPES OF WORKING TABLES

Equipment

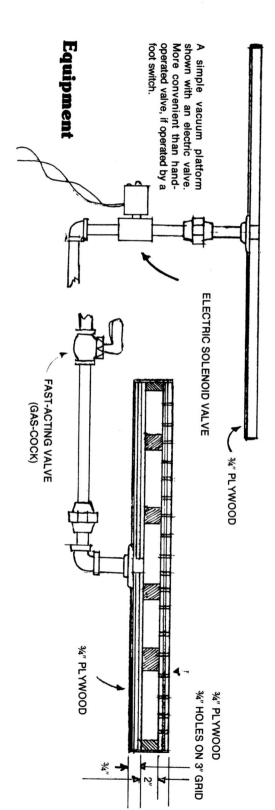

A simple vacuum platform shown with an electric valve. More convenient than hand-operated valve, if operated by a foot switch.

ELECTRIC SOLENOID VALVE

¾" PLYWOOD

FAST-ACTING VALVE (GAS-COCK)

¾" PLYWOOD

¾" PLYWOOD
¾" HOLES ON 3" GRID

¾"

2"

This table must be used with molds as shown below. The mold becomes the vacuum box. The valve is opened as soon as softened plastic sheet makes contact with the top edges of mold box. The mold is usually made from fiber glass or well-reinforced plaster, sealed into the box. The box is sealed to the platform with tape.

AIR EXHAUST

PLASTIC SHEET

A box-type vacuum table. Top surface is perforated to allow air to be drawn through. Shown with a manual valve, which must be mounted at a convenient height for operation when the plastic sheet is brought into position on the table. This table is used for applications such as the one diagramed below. Objects may be placed on the surface, and the heated plastic sheet is brought down to make contact with the edges of the table. May be used for reliefs that are about the size of the worktable.

AIR EXHAUST

Bibliography

Antreasian, Garo Z., with Adams, Clinton. *The Tamarind Book of Lithography: Art and Techniques.* New York: Harry N. Abrams, Inc., 1971.

Biggs, John R. *The Craft of Woodcuts.* New York: Sterling Publishing Co., Inc., 1963.

Brommer, Gerald F. *Relief Printmaking.* Worcester, Mass.: Davis Publications, Inc., 1970.

Caza, Michel. *Silk Screen Printing.* New York: Van Nostrand Reinhold Co., 1973.

Chieffo, Clifford T. *Silk-Screen as a Fine Art.* New York: Van Nostrand Reinhold Co., 1967.

Eppink, Norman R. *101 Prints.* Norman, Okla.: University of Oklahoma Press, 1971.

Gassan, Arnold. *A Handbook for Contemporary Photography.* Athens, Ohio: Handbook Co., 1974.

Gilmour, Pat. *Modern Prints.* London: Studio Vista/Dutton Pictureback, 1970.

Hayter, S. W. *New Ways of Gravure.* London: Oxford University Press, 1966.

Ivins, W. M., Jr., *How Prints Look.* Boston: Beacon Press, 1943.

Johnson, Elaine L. *Contemporary Painters and Sculptors as Printmakers,* New York: The Museum of Modern Art, 1966.

Knowlton, Ken. *"Collaborations with Artists—A Programmer's Reflections."* In *Graphic Languages.* London: North-Holland Publishing Co., 1972.

Laliberté, Norman, and Mogelon, Alex. *The Art of Stencil.* New York: Van Nostrand Reinhold Co., 1971.

Leavitt, Ruth, ed. *Artist and Computer.* New York: Harmony Books, 1976.

Mayor, A. Hyatt. *Prints and People.* New York: The Metropolitan Museum of Art, 1971.

———. *Modern Art in Prints.* New York: The Museum of Modern Art, 1973.

Moore, Keiko Hiratsuka. *Moku-Hanga: How to Make Japanese Woodblock Prints.* Washington, D.C.: Acropolis Books, Ltd., 1973.

Peterdi, Gabor. *Printmaking.* New York: The Macmillan Co., 1961.

Photo/Synthesis, catalog of Exhibition at Herbert F. Johnson Museum of Art. Ithaca, N.Y.: April—June, 1976.

Picasso, *45 Gravures Sur Linoléum.* New York: Catalog of Saidenberg Gallery, 1960.

Ross, John, and Romano, Clare. *The Complete Printmaker.* New York: The Free Press, 1972.

Ruggles, Joanne and Philip. *Darkroom Graphics.* Garden City, N.Y.: Amphoto, 1975.

Rumpel, Heinrich. *Wood Engraving.* New York: Van Nostrand Reinhold Co., 1972.

Russ, Stephen. *Practical Screen Printing*. New York: Watson-Guptill Publications, 1969.

Stevenson, George A. *Graphic Arts Encyclopedia*. New York: McGraw-Hill Book Co., 1968.

Wenniger, Mary Ann. *Collagraph Printmaking*. New York: Watson-Guptill, 1975.

Woell, Fred J. "Photography in the Crafts," Bangor, Me.: Furbosh-Roberts, 1974.

Supply Sources

Equipment

American Screen Printing Equipment Co.
400 N. Noble St.
Chicago, Ill. 60622

Rack-King®
Cameo
Screenprinting presses

Designs Plus
P.O. Box 4354
San Rafael, Calif. 94903

Rapid Rack

Galaxy Industries, Inc.
25 Proctor Hill Rd.
Route 130
Hollis, N.H. 03049

Full range of printmaking equipment,
presses, brayers,
rolls, levigator

New Art Form Printer
PM Color Inc.
3401 W. Division St.
Chicago, Ill. 60651

Vacuum process screen printers

Plasti-Vac Inc.
1901 N. Davidson St.
Charlotte, N.C. 28205

Vacuum-forming machine

Printmaker's Machine Co., Inc.
724 N. Yale Ave.
P.O. Box 71
Villa Park, Ill. 60181

Sturges etching press, Dickerson
combination press, Printmaker's
Litho press

Rembrandt Graphic Arts
The Cane Farm
Rosemont, N.J. 08556

Etching presses, files, racks, tables,
and so on

Saks Arts & Crafts
207 N. Milwaukee St.
Milwaukee, Wis. 53202

Low-cost vacuum-forming machine

The Wright Press
Grand Junction, Mich. 49056

Intaglio, relief, and lithography press

General Supplies for Printmaking

(Forks, ink, paper, accessories, and some equipment)

Advance Process Supply Co.
400 N. Noble St.
Chicago, Ill. 60622

Write for your nearest branch

Cincinnati Screen Process Supply Co.
1111 Meta Dr.
Cincinnati, Ohio 45237

Craftool Company
1 Industrial Rd.
Woodbridge, N.J. 07075

Graphic Chemical and Ink Co.
P.O. Box 27
728 N. Yale Ave.
Villa Park, Ill. 60181

Hunt Manufacturing Company Speedball Products
1405 Locust St.
Philadelphia, Pa. 19102

Rembrandt Graphic Arts Company
The Can Farm
Rosemont, N.J. 08556

Sam Flax, Inc.
25 E. Twenty-eighth St.
New York, N.Y. 10016

Talas
Division of Technical Library Service
104 Fifth Ave.
New York, N.Y. 10011

Inks—Pigments and Dyes

Advance Process Supply Silkscreen inks, metallics, vinyl, etc.
400 N. Noble St.
Chicago, Ill. 60622

Fezandie and Sperrle Inc. Complete line of pigments and dyes
103 Lafayette St.
New York, N.Y. 10013

Iddings Paint Company Aqua-process silkscreen colors
45-30 Thirty-eighth St. and transparent base
Long Island City, N.Y. 11101

The Naz Dar Company Full range of inks including inks for
1087 N. Branch St. plastics and vacuum forming
Chicago, Ill. 60622

PM Color Inc. Inks especially formulated for the
3401 W. Division St. Artform Printer and for sublimation
Chicago, Ill. 60651 printing on synthetic fabrics

Pierce & Stevens Chemical Corp. Foamcoat—three-dimensional ink
Box 1092
710 Ohio St.
Buffalo, N.Y. 14240

Rembrandt Graphic Arts Hanco inks (Handschy Chemical Co.)
The Cane Farm for lithographic and relief printing
Rosemont, N.J. 08556

Rupert, Gibbon and Spider Deka dyes for printing, airbrushing, and
470 Maylin St. stenciling
Pasadena, Calif. 91105

Sinclair and Valentine 14930 Marquardt Ave. Santa Fe Springs, Calif. 90670	Inks for lithography
Superior Printing Company 297 Lafayette St. New York, N.Y.	

Miscellaneous

Abbeon Cal Inc. 123-21 AB Gray Ave. Santa Barbara, Calif. 93101	Hot wire cutters for Styrofoam®, Styrofoam® sheeting and a wide range of equipment
Advance Process Supply Company 400 N. Noble St. Chicago, Ill. 60622	Metalite—metalized polyester for screen printing
Anthony Ensink and Company 400 W. Madison St. Chicago, Ill. 60606	Paper plate process for lithography
Hunt Manufacturing Company 1405 Locust St. Philadelphia, Pa. 19102	Speedball products including Flexible printing plate, brayers, and cutters
Sculpture Associates 114 E. Twenty-fifth St. New York, N.Y. 10016	Cutting tools and materials for mold making

Papermaking Supplies

Charles Hilger 530½ Ocean Santa Cruz, Calif. 95060	Cotton linters for papermaking
Cheney Pulp and Paper Company Franklin, Ohio 45005	Cotton linters for papermaking
Cities Service Company Columbia Carbon Division 3200 W. Market Street Akron, Ohio 44313	Imperial Paper Color for coloring paper
Talas 104 Fifth Avenue New York, N.Y. 10011	Papermaking materials

Photographic Process Materials

Eastman Kodak Company Rochester, N.Y. 14650	Full range of photographic supplies
Miller Dial 4400 N. Temple City Blvd. El Monte, Calif. 91734	Foto Foil—photosensitive plates for metal graphics

Porter's Camera Store, Inc. Porter's U-Spread Emulsion (same as
Box 628 Rockland's Products)
Cedar Falls, Iowa 50613

Rockland Colloid Corporation Liquid photographic emulsions
599 River Rd.
Piermont, N.Y. 10968

3M Company Various photosensitive materials for
St. Paul, Minn. 55101 printmaking

Ulano Blue-Poly and other photosensitive films
210 E. Eighty-sixth Street
New York, N.Y. 10028

Printing Surfaces

ACRYLIC AND OTHER THERMOPLASTIC SHEET:

Ain Plastics Wide range of sheets, resins, and findings
65 Fourth Avenue
New York, N.Y. 10003

Cadillac Plastics Full line of plastics and supplies
148 Parkway
Kalamazoo, Mich. 49006
(outlets throughout the country)

Industrial Plastics Wide range of sheets, resins, and findings
324 Canal St.
New York, N.Y. 10013

FABRICS AND NON-WOVEN BASES:

Bel Art Company Fibr-art, a nonwoven acrylic base material
327 Main St.
Hackensack, N.J. 07601

Dharma Trading Company Cottons and rayons
P.O. Box 916
San Rafael, Calif. 94902

PAPER:

Andrews/Nelson/Whitehead Full line of papers
7 Laight St.
New York, N.Y. 10013

Rembrandt Graphic Arts Arches, German Etching, Rives,
The Can Farm Tableau, Transfer, and so on
Rosemont, N.J. 08556

Technical Papers Corporation Tableau papers in sheets and rolls
29 Franklin St.
Needham Heights, Mass. 02194

Zellerbach Paper Company Variety of printmaking papers
234 S. Spruce St.
San Francisco, Calif. 94118

Index

Acid, 7, 13, 17
Acrylic. *See* Plastics
À *la poupée*, 23, 27
Albers, Josef, 47, 153—55, 234, 245
Allen, Jesse, 25, 26
Alps, Glen, 156
Appel, Karel, 163, 164
Aquatint, 13, 22, 24, 60, 85, 123, 153, 170
Arcay, W., 40
Architectural Paintings, 277—79
Askin, Walter, 234, 240—43, 248
Asphaltum, 17

Babcock, John, 174, 193
Baker, Marion, 135—39, 144
Bas relief. *See* Embossing; Relief
Battenberg, John, 190
Beardsley, Aubrey Vincent, 21
Bed, printing, 23, 27
Bellange, Jacques, 8
Biasi, Alberto, 226, 227
Bird, Annette, 135, 139
Bite, 7, 13, 86, 127
Blacklow, Laura, 135, 141
Blake, William, 12
Blanket, 27, 53, 59, 61, 158, 207
Block, 1, 2, 6, 129
Blocking agents. *See* Stop outs
Block outs, 30
Block prints, 12, 19, 63, 129, 144, 145
Blueprinting, 108—112, 116, 135
Bolton, Thomas, 17
Bonnard, Pierre, 30
Bonner, June M., 111, 114, 131
Books, 12, 141
 block books, 3
Bosse, Abraham, 6
Bowman, Stanley, 197, 211, 252, 255
Braque, Georges, 40, 156, 263
Brayer, 22, 25, 26, 98, 157
Brownprinting, 116—19, 135, 143
Burg, Patricia Jean, 226, 230
Burin, 22
Burke, Gay, 136, 148
Burnishing, 12

Callot, Jacques, 7, 8, 9
Calman, Wendy L., 197, 210, 234, 238
Calotype, 17, 67
Camera, 17
Canaletto, Giovanni Antonio, 10
Caraccio, Kathleen, 141
Carbon tissue, 63
Carving, 2
Cassatt, Mary, 19
Castiglione, Giovanni Benedetto, 12
Cast paper, 163—93
CAT (Computer tomography), 249
Ceramic, 77, 119, 219
Chamberlain, John, 212, 213, 215
Chéret, Jules, 15
Chiaroscuro, 6, 9
Chicago, Judy, CP
Chinese, xii, 2, 39
Chromolithographs. *See* Lithography
Cliché-verre, 65
Collage, 22, 64, 70, 102, 103, 133, 135, 148,
 156, 163, 164, 172, 194, 220, 251,
 252
Collagraph, 156—62, 163
Collagraph plate, 139, 162, 164
Collotype, 54, 96—101, 105
Color, 3, 6, 15, 19, 22, 23, 25, 40, 46, 49,
 106, 122, 129, 153, 168, 221, 240,
 251, 277, 278
Combined techniques, 40, 53, 92, 94, 104,
 128, 129, 170, 220, 247
Computerized, 1, 63, 249, 262—79
Continuous tone, 96, 105
Copper plate. *See* Plate
Corot, Jean-Baptiste, 65
Cranach, Lucas, 6
Cross-hatching, 5
Cyanotype, 112—15, 116

Daguerre, Louis-Jacques-Mandé, 17
Daguerreotype, 17, 136
Daumier, Honoré, 15
Davis, Ronald, 168—70, 244
Definition, printmaking, 1
Degas, Edgar, 12, 19, 20, 22

Delacroix, Eugène, 13, 263
De Lattre, Catherine, 116, 117, 119
Delaunay, Sonia, 32
De Leon, Michael Ponce, 23, 156
Developing, 83, 126
Dine, Jim, 40, 218
Ditto. *See* Spirit duplicating
Doctor blade, 63, 128
Drawing, 21, 29
Drypoint, 5, 9, 22, 153, 170
Duchamp, Marcel, 263
Dürer, Albrecht, 4, 5, 6
Dye transfer, 128—33

Eakins, Thomas, 66
Edgerton, Harold, 66
Edible prints, 3, 78
Electronic processes, 63
Electronography. *See* Electrostatic screen
 printing
Electrophotography, 251—61
Electrostatic screen printing, 58
Embossing, 23, 26, 27, 89, 153—61, 163,
 195, 197, 206—9
Emulsion, 55, 69, 70, 79, 115, 120, 121, 141,
 145, 146, 151
Engraving, 1, 2, 4—8, 17, 20, 22, 135, 141,
 153, 156, 245
Eskimos, 38, 39
Etching, 1, 5—12, 20, 22—29, 40, 60, 63,
 65, 79, 105, 129, 136, 137, 145, 152,
 153, 156, 170, 195, 205, 229, 230
Eversley, Fred, 221

Fabric, 43—45, 77, 110—12, 117, 118, 120,
 133—51, 203, 252, 257, 277
Facsimile process, 3, 63, 251—61
Falkenstein, Claire, 174, 195, 198—202
Ferrocyanotype, 105
Ferroprussiate. *See* Blueprinting
Film. *See* Photographic film
Flocking, 12
Foamcoat, 203, 204
Foo, Wilbert, 190, 191
Fragonard, Jean Honoré, 11

GAF template emulsion, 120
Gates, Jeff, 97—101
Gauguin, Paul, 19, 30, 31
Gelatin, 12, 54, 63, 69, 79, 96—101,129
Géricault, Théodore, 13, 14
Girard, André, 40
Goldsmiths, 4, 5
Goode, Joe, 135, 136, 145, 146
Goodwin, Hannibal, 17
Gothic, 14
Goya, Francisco de, 13
Gravure, 1, 63, 105. *See also* Intaglio
Gray scale. *See* Values
Gris, Juan, 156, 263
Grossman, Tatanya, 51
Ground, 7, 22
Guild craftsmen, 3
Gum bichromate. *See* gum process
Gum process, 67, 103, 105—8, 112, 124,
 126, 134, 135, 144, 145
Gypsograph, 156

Hackman, Vida, 23, 27—29
Haden, Sir Francis Seymour, 20
Hahn, Betty, 106, 135, 143, 144
Hajdu, Etienne, 23
Halftone, 9, 17, 68, 92, 94, 96, 105, 122,
 123, 140, 145
Hall, Dr. Ernest L., 248, 249, 275, 276
Haller, Susan, 116—18, 135
Haluska, Andre, 252, 257
Hamilton, Richard, v, 33, 50, 92
Hanson, Jo, 195, 205
Harnunobu, Suzuki, 18
Havell, William, 65
Hayter, Stanley William, 22, 23, 51
Herschel, Sir John, 108
Hilger, Charles, 174—87
Hilton, Lida, 157—59
Hiroshige, 19
Hoare, Tyler James, 250—55
Hokusai, Katsushika, 19
Holy pictures, 3
Howell, Douglas, 174

Hundertwasser, Fritz, 40, 194
Hurst, Carol, 41—45

Impressions, 2
India, 3, 135
Indiana, Robert, 40
Ink and inking, 1, 2, 6, 7, 12, 13, 15, 19, 22, 23, 25, 40, 53, 55, 56, 60, 87, 94, 98, 129, 136, 154, 162, 195, 197, 200, 205, 232, 240, 244, 245
Inkless intaglio, 59—62, 102, 155
Intaglio, 1, 5, 22—29, 59, 63, 79—92, 139, 145, 153, 156, 200, 228
Ives, F. E., 17

Japanese prints, 19, 38, 39, 41—45
Johns, Jasper, 40, 197, 207, 209

Kallitype. *See* Brownprinting
Kandinsky, Wassily, 30, 31
Keinholtz, Ed, 195, 196
Kempf, Franz, 24, 32
Kim, Bong Tae, 23, 29, 152
Kindermann, Helmmo, 64, 119, 120
Kitaj, R. B., 67
Klee, Paul, 156
Klein, Earl D., 67, 68
Kline, Vivian, 146
Kluge, Gordon, 140
Knife, 41, 42
Knight, Warren, 258, 259
Knowlton, Dr. Kenneth, 262—67, 271, 272
Kodalith, 71, 72, 97, 110, 114, 140, 210, 239, 252, 257
Koller, John, 168, 169, 171, 172, 174

Laid-line screen. *See* Mold, papermaking
Larson, Brooke, 140
Larson, Catherine Jansen, 136, 149
Larson, William, 259—61
Lead, 197, 206—9, 211
Leather, 30, 197, 204
Letterset printing, 59, 63
Levine, Les, 34
Lewis, Golda, 164

Lichtenstein, Roy, 67, 94—96, 155, 215—17
Light, 221—23, 225
Limestone, 2, 15
Limited edition, 20
Lindroth, Linda, 136, 147
Lines, 7, 9, 12, 21, 24, 25, 44, 153, 251
Lithography, 1, 13—16, 29—38, 40, 51, 53, 65, 92--96, 105, 164, 194, 195, 197, 204, 234, 247, 259
Locey, Jean, 106, 134, 135
Lowe, Marvin, 48, 49, 225, 226, 228

Mackaig, Janet B., 70, 120, 121, 146, 151
McMillan, Jerry, 197, 209
Mandelbaum, Lyn, 112—16, 150, 151
Mansfield, Pat, 112, 114
Mantegna, Andrea, 6
Martineau, John P., 49, 69
Masson, André, 22
Master, E. S., 4
Masterson, Darla, 222, 223, 248
Matisse, Henri, 30
Meeker, Dean, 58, 156
Metal lithographic plate, 92
Mixed conventions. *See* Combined techniques
Moholy-Nagy, László, 66
Mold, 207, 246, 247
Mold, papermaking, 171—73, 175—78, 181—93
Moll, A. E., 231, 281—94
Monoprint, 66. *See also* Monotype
Monotype, 12, 20
Montage, 102, 252, 258
Motherwell, Robert, 37, 38
Movable type. *See* Type, movable
Multiple copies, 1, 213—20
Munch, Edvard, 19
Muybridge, Eadweard, 65, 66, 263

Negative, 17, 54, 68, 71, 97, 102, 105
Nesch, Rolf, 22, 23, 156
Nevelson, Louise, 174, 197, 215
Norizome. *See* Resist
Numbering, 20

Oberkampf, Christophe Philippe, 12
Offset, 12, 22, 23, 53, 54, 59, 92, 100, 104
Oldenburg, Claes, 40, 213, 214, 219, 234,
 246, 247
Oliveira, Nathan, 197, 206
Optical effects, 221—47
Oster, Gerald, 226, 227
Overprinting, 19, 24

Painting, 17, 20
Paolozzi, Eduardo, 53, 67
Paper, 2, 9, 12, 17, 29, 32, 61, 100, 105,
 107, 108, 113, 116, 117, 119, 135,
 145, 153, 154, 160, 163, 166, 200,
 252, 277
 See also Cast paper; Paper pulp
Paper pulp, 168, 169, 173
Papier collé, 33
Parchment, 30
Parmigiano, 7
Paste resist, 43
Pearson, Henry, 226, 229
Perspective, 3
Peterdi, Gabor, 66
Phillips, Matt, CP
Photoemulsion. *See* Emulsion
Photoengraving, 6, 89
Photoetching, 79—92, 123, 197, 209
Photogelatin process. *See* Collotype; Gum
 process
Photogram, 66, 102, 105, 107, 248, 276
Photographic film, 55, 71, 79, 81, 82
Photographic images. *See* Photography
Photography, 2, 17, 64—134, 149, 195, 220,
 222, 234, 238, 239, 275, 277
Photogravure, 63, 122
Photolithography, 92—96
Photomechanical, 1, 96
Photomontage, 66, 102
Photo-offset, 54, 104, 244
Photosensitive, 17, 67—69, 145, 251—61
 See also Sensitizing
Photosensitive dye, 142, 257
Photo-silkscreeen. *See* Silkscreen

Picasso, Pablo, 40, 46, 156, 263
Pinkel, Sheila, 107, 112, 113, 271, 273—76
Piranesi, G. B., 11
Planographic, 1, 29—38, 240—43
Plaster print, 22
Plastics, 29, 59—61, 63, 74, 99, 135, 141,
 145, 146, 160, 168, 195, 197, 205,
 207, 208, 212, 213, 215, 220, 222,
 224, 226, 227, 229—34, 238, 239,
 242—47
Plate, 1, 4, 7, 9, 12, 17, 22, 23, 25, 27, 30,
 32, 37, 54, 59—61, 63, 79, 80, 83,
 90, 98, 99, 123, 136, 137, 153, 156,
 158, 162
Pollock, Jackson, 23, 46
Pollaiuolo, Antonio, 5
Polymers, 30, 40, 64, 160, 161
 See also Plastics
Polyplanograph, 240—43
Poster, 15, 40
Press, 17, 22, 23, 27, 61, 92, 97, 154, 156,
 174, 197, 207, 208
Printing, 3, 53, 58, 59, 87, 122, 137, 224
Printing surfaces, 30, 33, 36, 53, 128
 See also Paper
Proof, 37, 94

Radiography, 66, 248, 249
Raimondi, Marcantonio, 6, 7
Rainbow mixing, 25, 26
Raphael, 6
Rauschenberg, Robert, 32, 33, 40, 67, 104,
 132, 133, 135, 164—67
Ray, Man, 66
Redon, Odilon, 29, 30
Register, 19, 37, 74
Relief, 1, 2, 22, 29, 63, 152—61, 172, 195,
 197, 228
 See also Embossing
Rembrandt, 9
Renaissance, 4, 12
Renoir, Pierre Auguste, 30
Reproduction, 20, 21
Resist, 43, 125—27, 145

Risseeuw, John L., 3, 77, 78, 226, 232, 234—37
Rivers, Larry, 40, 67
Rockland surface sensitizing, 119, 120
Roitz, Charles J., 234, 238, 239
Roller. *See Brayer*
Romano, Clare, 156, 160
Rose, Roslyn, 59—62, 229
Rosenquist, James, 67
Rosin, 12, 85, 86, 123
Ross, John, 156, 161
Rotogravure, 63, 96
Rouault, Georges, 122
Roulette, 12
Royce, Richard, 23, 24, 25, 173, 174, 200—202
Rubbing, xii, 4, 39, 195, 205
Rupert, Prince, 12
Ruskin, John, 13

Salt printing, 116
Sanders, James H., III, 135, 142, 252, 257
Sanders, Jeff, 213
Savage, Naomi, 89, 102, 103, 105, 106
Schongauer, Martin, 4, 5
Schwartz, Lillian, 268—72
Schwitters, 156
Screen, 17, 40, 55, 63, 69, 75
Screen print. *See* Silkscreen
Sculpture, 17, 19, 195, 198, 213, 219
Seeman, Debra, 203, 204
Senefelder, Aloys, 13, 29, 92
Sensitizing, 55, 67, 69, 80, 103, 105, 107, 108, 114, 116, 118—20, 124, 125, 135, 145, 146, 149, 195, 252
Serigraphy. *See* Silkscreen
Seurat, Georges, 263
Seventy, Sylvia, 112—15
Shahn, Ben, 48
Silkscreen, 2, 38—50, 53, 55—58, 65, 67—79, 104, 105, 121, 135, 140, 146, 150, 151, 155, 195, 197, 204, 222, 223, 225, 227—30, 232, 234, 236, 238, 240, 271, 273, 274

Soft print, 111, 135—51
Solarization, 66, 85, 102
Solvents, 30, 195
Soulages, Pierre, 22
Spear, Shigeko, 41—45
Spirit duplicating, 54
Split fountain, 75
Sprout, Randy, 79—88, 106, 122—30
Squeegee, 40, 55, 75
Stasack, Edward, 156
Stasik, Andrew, 234, 237
Steg, James, 156
Stella, Frank, 171, 172
Stencil, 1, 2, 3, 22, 38, 39, 41—46, 48, 55, 67, 68, 73, 74, 139, 140, 195, 224, 237
Stock. *See* Printing sufaces
Stone. *See* Limestone
Stop outs, 30, 40
Stuffed prints, 121, 134, 135, 137, 141, 148, 149
Subject matter, 17, 19
Sugar lift etching, 199, 200
Supergraphic, 225, 228, 277—79
Sutton, Ann, 93

Tablets, 2
Talbot, William Henry Fox, 17, 66, 67, 116
Talbotype. *See* Calotype
Tarlatan, 60, 136
Tavenner, Pat, 77, 252, 256
Textile printings, 2, 39, 110—12, 135
 See also Fabrics
Texture, 12, 15, 19, 29, 35, 273
Three-dimensional, 135, 139, 146, 148, 149, 151, 164, 194—213, 252, 271
Tiepolo, Giovanni Battista, 10
Toner, 58
Tones, 12. *See also* Values
Toulouse-Lautrec, Henri de, 15, 16, 30
Transfer, 67, 97, 129
Transfers, iron-on, 135, 145, 244, 252, 257
Transparent, 215, 221—23, 226, 230, 234, 238, 239, 247, 248

Tullis, Garner, 174, 191, 192, 206
Tusche, 29, 36, 37
Two-dimensional, 1, 135
Tyler, Ken, 37, 51, 94, 153, 168, 213
Type, movable, 3
Typesetting, 63

Unique pieces, 1
Utamaro, Kitagawa, 18, 19

Vaccarino, Robin, 234, 245
Vacuum, 55—57, 71
Vacuum-forming, 78, 231, 232, 233, 234—37,
 281—94
Values, 6, 9, 22, 29, 30, 35, 96, 122, 262,
 271, 273, 274
Vanderbeek, Stan, 264
Van de Velde, Jan, 12
Van Gogh, Vincent, 163
Van Meckenem, Israhel, 5
Van Stelle, Mary, 109, 110, 112, 114
Vasarely, Victor, 40, 47, 226
Viscosity, 22, 129
 printing, 25, 26

Vuillard, Edouard, 30

Walker, Melanie, CP
Wallpaper, 12, 195
Warhol, Andy, 40, 67
Weisberg, Ruth, 30, 35, 36, 197, 204
Wesselmann, Tom, 67
West, Benjamin, 14
Whipple, David, 174, 188, 189
Whistler, James Abbott McNeill, 19—21
Whitesell, John D., 71—76, 226, 228
Winnett, Mary Moor, 90—91
Wiping plate, 9
Wireless transmission, 2
Wire photo, 259—61
Wood blocks, 2, 3, 6, 17, 19, 63, 97
Woodcuts, 2, 3, 4, 5, 7

Xerography, 112, 115, 135, 145, 248,
 251—59, 271, 276
X ray, 248, 249

Zen, Some Ya Yu, 38, 40
Zigrosser, Carl, 40